PIXEL PHOTOGRAPHY

Robert McMahan

Photography, Robert McMahan

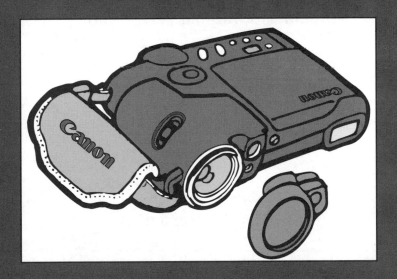

THE OLIVE PRESS

1993

PIXEL PHOTOGRAPHY

THE OLIVE PRESS, JUNE 1993

For information address:
The Olive Press, P.O. Box l94,
Lake Hughes, California 93532.

ISBN No. 1-881656-01-2

Printed in the United Sates of America

First Printing

To my wifc, Jacqueline who eternally asked, "Just one more question," and who wrote, edited, and listened to more about *Pixel Photography* than she ever thought she could, and made great salsa.

Acknowledgements

From the very beginning, and before the beginning, Antelope Valley College, was in full support of the desktop publishing program and the digital imaging program. Special thanks go to Dean of Fine Arts, Dr. Dennis White, the "brains behind the paperwork" and who sought out grants to finance a state-of-the-art computer lab that provided the "fire in the belly" motivation for everyone concerned, most of all me.

My thanks to Barbara McLaughlin whose knowledge of computers is extensive, protective, and so intimate it is almost scary. It was and is Barbara's talent that keeps the computers in the lab humming. If they are not humming, she kicks everyone out including me.

My thanks to Tawnya Dunning, the elegant model for the cover and some of the inside shots.

My thanks to Herbert Dunning whose brain had an inside track to the functioning of computers and who patiently attempted to teach me the inside tracks.

My thanks to all my students who at times have taken up residence in my computer lab. Their excitement over learning a new science was what motivated me greatly in writing this book. Thank you for holding me accountable for my wild claims about what computers can do!

My thanks to one of my most dedicated students, Mike Smith, for his extensive work on the Glossary and Index for this book. The Index is comprehensive but at times we felt it should be executed at dawn.

My thanks to old friend, Jerry George, who has worn many hats and played many roles important to this book,that of storyteller-bushman-bearded editor-sailor.
My thanks to the experts, Seymour Bloom of Samy's Camera and Richard Bellamy at Canon Still Video for being superb sources of tecnical information and providing the best cameras and equipment.

Contents and Chapters

Chapter V, Digital Cameras

INTRODUCTION

PIXELS, TOUCHSTONE OF DIGITAL WORK

The key to understanding digital photography, is understanding the way pixels work. I have yet to encounter a definition of pixels which is satisfactory. The first law of pixels is that they, by their very nature, defy a pat definition. First you see them and then you don't. Pixels are the units of light and darkness which create a matrix of dots on your computer screen or monitor. Your eyes reinterpret the distribution of dots as a total picture and not pixels next to pixels.

DEFINITION OF A PIXEL

Pixels, the magical dots that you are going to learn to manipulate, symbolize the fleeting images that play across your television screen and computer monitor. Pixels are ephemeral images that do not exist when the screen or monitor is off. Only when the screen is turned on do the pixels come to life. At this time, they can be printed or separated for reproduction, giving evidence of their existence.

NEW AGE OF PHOTOGRAPHY

At this moment there is a revolution taking place, beckoning photographers onto the electronic battlefield which many have resisted for years. In the near perfect world, photographs would be finalized in as near as possible form to the original shots. Photographers would be the overseers to the end products. Dream on. This perfect world only exists in someone's imagination especially where printed matter is concerned. The real-world photographer has often been way back at the beginning of the food chain.

Due to radical changes taking place in electronic image making, the photographer is now more than ever involved in determining the outcome of his photograph. Imagery and reproductions no longer have to be filtered through a series of middlemen.

Now is the time for traditional photographers and graphic artists to stand up and be counted and enter the field of electronic imaging while it is still trying to define its role. Photography, as we know it, is poised on the doorstep of drastic changes as digital imaging offers the control, heretofore known by graphic artists, over fixed images.

LINKING TRADITIONAL PHOTOGRAPHY TO DIGITAL PHOTOGRAPHY

The way they are doing this is through PIXEL POWER. The digital image now overshadows the traditional photograph in the commercial world. Most photographs that make it into print have been transformed into electronic images. Photographers, working at their microcomputers have some of the power of oldtime photo editors who determined the ultimate size, shape, and cropping of published photographs.

Digital photography is coming of age through its application commercially. For the sake of communication, when I speak of this new art-science, I will refer to it as Pixelgraphy and Pixel Photograph.

A special camera known as a digitizer takes electronic pictures which are translatable onto a computer monitor in the form of black and white dots, those irrepressible pixels again. As already mentioned, your eyes see the pixels as a pattern similar to the screen dot pattern of a newspaper photo when viewed with a magnifying glass; however, there is a distinct difference between the two patterns.

The dots of the newspaper photo are different shapes but the dots (pixels) on your computer screen are rectangles of equal size. A digitized picture is created from these tiny pixels the way a wall mural's

thousands of ceramic tiles combine to make a complete picture. The pixels can be manipulated as though they were the tiles of a mural. The resultant imagery only looks like a photograph. It is really an assemblage of pixels.

During the process of pixelgraphy, the image such as a photograph, is held in the digital state so that it can be manipulated by the computer and then fixed on hard copy via paper or film. Obviously, pixelgraphy requires the traditional photographer to acquire more technical knowledge and training, but in turn, it offers the photographer creative control at an exciting level. Do not think of pixelgraphy as cramping your style as you learn to deal with computers but rather enhancing your style.

Pixelgraphy is one of the most exciting mediums to have been introduced into commercial photography in this age and yet it is one of the most misunderstood and misrepresented. This book was developed through my experiences as well as those of my students as we learned to forge our way through pixels together. I will describe not only how to make computer-generated photographs but how to predict potential problems. This is a "Do it first. Ask questions later." I will accompany you through the acquisition of necessary equipment, setting it up, and using it to make pixel photographs.

Consider this book a tool or simply a means towards the end of developing your style of pixelgraphy. You will be joining the formative stages of this new art-science in the early days of pixelgraphy. We can compare ourselves to photographers working prior to 1860, performing visual magic in a vast field of untapped possibilities. I welcome you as a fellow pioneer to join in the excitement of being involved in the beginning

HOW A PIXELGRAPH EVOLVES INTO A PIXEL PHOTOGRAPH AND BECOMES A BOOK COVER

All the popular, wildly held notions concerning the fingertip magic of computer technology are almost all true. You can tamper with reality. If you don't like a shadow, remove it. If your subject needs a facelift, make her happy. Image processing is one of the most exciting of the new desktop applications.

Pixel imaging consists of the importation of a photograph, its modification, enhancement, and eventual output in the form of a pixelated photograph. Once the photograph is scanned in and becomes a computerized image, it can be adjusted a number of ways and even combined with the parts or total images of other photographs. Using this electronic process, I created the design for the cover of **Pixel Photography.**

PHOTOGRAPHS FOR ELECTRONIC IMAGING

Your first question may be what kind of photograph is required? You can use a negative, a positive, or an electronic image from a digital camera. The photographs combined into a composite for this book cover were made up of a slide, a negative, and an electronic image taken with a digital camera.

To start with I thought that the digital camera would be good enought to shoot and put together a cover. What I found was that the amount of information which a still video digital camera was able to put on disk (1 MB.) was not enough information for an 8 x 10 cover. The other problem was that the camera had no strobe attachment. The face of the model required sophisticated studio lighting. I relied on a conventional 35mm. camera and a Norman strobe to accomplish the lighting effects. The shots of the blue sky were taken using 35 mm. slide film with a polarizing filter to get the best contrast.

The next step was to use a slide scanner to scan in at low resolution the image of the sky (a slide) and the model's face (a color negative) so that I could combine them without using too much memory on the computer at the planning stages. Now with the images stored on the disks or the hard drive, they were ready to be retrieved as needed. First Photoshop was opened on the Macintosh, then the scanned images were opened. You can have multiple images open at the same time so that they may be combined or parts of an image combined to create a composite image such as the cover.

Small details like the model's purple fingernails clashed with her red lips so I picked up the color of the lip's pixels and moved the red over the offending purple. In the beginning stages, I was still unsure of my final composite. I played with moving the face and the sky and the lips. I probably changed my composite 5 times. Now we're talking about the magic of pixelgraphy. One of the great advantages of using the computer is that you can change and recreate the images many times with no risk of losing the original images should you want to return to them at any time.

You need to protect your original negatives and any disks from your digital camera because you will ultimately need to rescan them into a 20 megabite file for the finished cover. All the work up to this point has been at low resolution. Before the final print- out of my cover on a 4-color image setter, I needed to reassemble the composite image and scan the final piece at high resolution. The hard drive, with the final file, was then hand carried to a print house, to be processed on the image setter in 4 individual sheets of color, the cyan-magenta-yellow-black.

These 4 sheets of film were used to expose the 4-color printing plates which were placed on the offset printer creating the actual book cover.

STEPS TO A PIXEL COVER

Step #1- First digital photo of preliminary idea for cover

Step #2- Clouds shot on 35mm slide film 200 ASAwith polarizing filter.

Step #3- Studio photo of model, Tawnya Dunning shot with 35mm negative color film using strobe lights, soft box, and strobe meter.

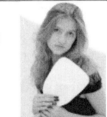

Step #4- Photo of fan, shot with still video.

Step #5- The film was digitized using the Barneyscan for low resolution working images and stord on a Bernoulli 90.

Step #6- Photoshop opened. All images opened on desk top. Pen tool used to encircle face so that it could be rotated and fit into fan shape.

Step #7- Cut lips out using pen tool again. Hold lips in memory. Replace lips on face using paste tool.

Step #8- Use blend and soften tool on crisp edges around the face.

Step #9- Proofs of cover variations.

Step #10-Final page make up in PageMaker.

Step #11- Print four color negatives for offset printing.

Step #12- Print on CMYK.offset color press.

Step #13- Final cover.

History of the World	History of Photography	History of the Computer

17000+ B. C. First dated cave paintings in France

3600 B. C. Blou Monument combines images and early writing

3100 B. C. Early Sumerian pictographic scripts on clay tablets

3000 B. C. Copper tools and weapons in use

2500 B. C. Great Pyramids at Giza

1600 B. C. Bronze in general use

1300 B. C. Books on papyrus scrolls

1100 B. C. Iron is widely used for weapons and tools

197 B.C. Rosetta Stone

570 A. D. Birth of Mohammed

1000 A. D. Gunpowder in use in China

1150 A. D. Compass is invented

1265 A. D. Marco Polo in China Where he intoduces spaghette

1448 Gutenburg Press

350 B.C. Aristotelian writings about device for forming "pinhole" images. It later became known as the *camera obscura,* a term introduced by the Italians meaning "a dark room. The first step in the history of photography was the practical application of the *camera obscura* as an aid to artists. It is likely that most of the great painters of the Italian Renaissance used the *camera* obscura. Leonardo da Vinci first noted the possibilities of the camera obscura in **1490** when he recommended viewing the image of a sunlit scene in a dark room where a small hole allowed light reflected from the subject to pass on to a thin piece of paper

History of the World	History of Photography	History of the Computer

1600 Dutch scientists develop telescopic lenses
1608 Galileo builds first astronomical telescope

1646 Magic lantern
First projection lantern

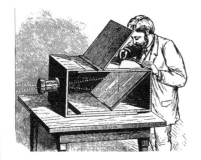

1544 A.D. The first-published illustration of a camera obscura showed its use to register a solar eclipse. Eclipse watchers noticed that the image was sharper when the hole was smaller.
 In the sixteenth century, lenses and mirrors were added to the camera obscura, it became an artist's tool. The devices were actual rooms, portable, but large enough for persons to work within. In time the camera obscura emerged as a small box, only large enough for the artist's hands to work within.

1630 A smaller, tent camera was invented
1657 The camera had two lenses and adjustable focus, which functioned by means of two boxes, one sliding within the other. In England, Robert Boyle introduced a box camera which contained a sheet of oiled, transparent paper on which the image was projected. Johann Sturm, in **1676**, added a small mirror set at an angle of 45° to the lens, which reflected an upright rather than inverted image and a hood to improve visibility.This was the first portable reflex camera, it was improved upon, when the oiled paper was replaced with opal glass, and a telescope lens was added.
 To make the images permanent, it was necessary to trace them with pencil and brush.

1820's A variety of camera shapes and sizes evolved cameras which could be fitted over the head, others which were incorporated into the design of a sedan chair, and most important of all, a small box camera that could be carried under the arm.

1642 French mathematician Blaise Pascal invented mechanical adding machine.

1671 Leibniz developed machine that could add, subtract, multiply and divide.

History of the World	History of Photography	History of the Computer
1800 Eli Whitney makes muskets with interchangable parts, Library of Congress formed	**1826 View from his studio window,** earliest known photograph, it shows a view from Niepce's attic workroom and is generally regarded as the earliest surviving photograph.	**1799** Frenchman Joseph Marie Jacquard developed what is considered to be one of the most elegant inventions in history, a mechanical loom that used punched copper cards to ensure a consistent patern.
1814 Koenig, steam-powered press invented.		
1819 Florida became a State of U S	**1826** Niepce, 1st photograph from nature	
	1835 Tolbot, 1st photographic negative	**1834** Charles Babbage invents the principle of the "analytical engine" (modern computer)
1823 Monroe Doctrine	**1835 The Daguerreotype**	

In **1835** by accident, he discovered that processing the plates in mercury vapor produced a stronger image. Later he learned how to make the image permanent.

Daguerre, arranged for the French Academy of Sciences to announce the process which he named the daguerreotype. The French government bought the rights and made them public .

1839 The publication of 2 different processes: the daguerreotype of Louis J.M. Daguerre and N. Niepce and the collotype of Henry Fox Talbot. The daguerreotype was extremely popular. It lost favor after invention of collodion in **1850's.** The daguerreotype is mirror-like picture, which for viewing, has to be adjusted to one's eye in relation to source of light (ridding it of reflections). Without the photograph, plate is just a mirror of polished silver.
COLLOTYPE

1839 Charles Goodyear develops "vulcanization" which made commercial use of rubber possible

1841 Talbot patented an improved paper negative process which he named collotypy. Exposure time was 1/2 min to 1 min. A piece of paper was dipped in silver nitrate-and-potassium iodide, then exposed and developed in potassium bromide. Then fixed. The paper, or negative, was then washed, dried and waxed to render it as translucent as possible.

Fox Talbot's box camera obscura

History of the World	History of Photography	History of the Computer
1844 Morse, telegraph **1845** Annexation of Texas **1848** First safety matches, first appendectomy, gold discovered in California **1851** Isaac Singer devised the continuous stitch sewing machine **1859** LincolnPresident **1859** Darwin, Origin of Species **1861** U S Civil War begins **1865** Lincoln assassinated	**1844** Talbot, Pencil of Nature **1847** Archer, wetplate colloian process. Three basic factors occupied early experimenters in photography: permanence, definition, and speed. The wet collodion technique resulted from experiments with the use of glass as a base for photographs, in place of metal plates. Glass, as with wax paper, had no overall texture and pattern and was lighter and cheaper than metal. So sensitive was the new emulsion in its wet state that exposures of less than three seconds became possible. Exposures were rigidly linked to the dark room process..It became necessary for location photographers to carry their equipment with them, including a tent, boxes of plates, and dozens of bottles to dip glass plates. **1850** Ambrotypes and tintypes are widely used **1855** Ambrotype-was made on glass and backed by black velvet or paint and could be viewed from almost any angle. A thin negative was bleached so that the silver deposit was light in color. The back of the plate was painted black, and this background showed through the clear glass of the shadows. **1858** Nodor, first aerial photography **1861-65** The pioneer in the technique of mass coverage of a war was the American photographer Mathew Brady, photographer and daguerreotypist who correctly forecast the need for news pictures and financed a team of 20 photographers to record the American Civil War. His assistants Alexander Gardner and Timothy O'Sullivan took some stunning and horrifying pictures including O'Sullivan's	**1852** a Frenchman named Martin Corteuile patented an organ that was programmable. The upright Steinway was made in 1860 and used a roll of programmed paper. darkroom tent 1870

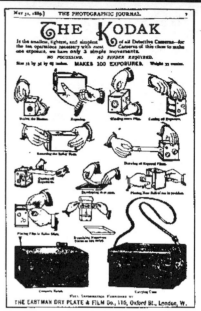

1869 Suez Canal opens, J. W. Hyatt invents celluloid

1872 Yellowstone National Park

1876 Bell, telephone

1879 Edison, electric light

1886 Statue of Liberty
1886 Megenthaler Linotype

1888 National Geographic Society

1889 Van Gogh, Starry Night

1897 Thompson discovers the electron

1898 Curie discovers radium

1903 Wright Brothers, 1st airplane flight
1904 First telegraphic transmission of photographs (first scanned image)

1905 Einstein, Theory of Relativity
1906 San Francisco earthquake

1908 The Model T Ford is introduced

famous picture "The Harvest of Death." O'Sullivan was a photographer in the true pioneer spirit. He went to New Mexico, Arizona, Colorado and followed the 49'ers to Nevada where he photographed the famous Comstock Lode mines with the aid of magnesium flares

1867-69 O'Sullivan, geological expedition

1871 Moss, photo engraving

1873 Dr. Richard Leach Maddox, made an emulsion of gelatin mixed with cadmium bromide and silver nitrate (plastic backing instead of glass). Dr. Maddox is generally considered to be the inventor of photographic film.

1875 Gillot, first French photographic printing plates

1877 Muybridge, sequence photography

1880 Horgon, experimental halftone screen

1880's. Dry plates replace wet plates

1885 Ives, halftone screen

1887 first roll film on plastic (Gelatin)

1888 Eastman, Kodak Camera makes photography "every person's art form"

1891 Edison kinetoscopic camera

1895 Lumiere Bros., Cinematography

1898 Printing from an etched copper cylinder using the intaglio principle was first done by Karl Klic. This process is known as rotogravure, and utilizes thousands of tiny cells engraved to different depths, depending upon how much ink is needed for the density of desired images. It is one of four major printing methods used today.

1900 Kodak Brownie camera

1907 Color Photography—
The first practical color process—Autochrome—was invented by Louis and Auguste Lumiere in 1907. Their

1890 Herman Hollerith used punched cards to conduct U. S. Census

1904 Arthur Korn develops scanner to send photographs by telegraph

10

History of the World	History of Photography	History of the Computer

History of the World

1914 World War I begins

1917 Russian Revolution begins

1918 World War I ends;

1919 U S Prohibition begins

1920 U S women gain vote

1925 John Logie Baird invents television

1926 NBC 1st national radio network

1927 Lindbergh, solo flight across the Atlantic

1928 Warner Brothers, 1st sound motion picture

1929 Stock market crash

1931 Empire State Building

1932 Roosevelt elected President

1936 Roosevelt reelected
1936 Robert McMahan born
1937 Marietta Blau useed a photographic plate to examine cosmic radiation
1938 Lajos Brio invented the ballpoint pen

1941 Japan attacks Pearl Harbor

1944 Allied invasion of Normandy (D-Day)

1945 Roosevelt dies; A-bombs dropped; World War II ends

History of Photography

"additive" process required that the exposure be made to a glass plate coated with a screen pattern of red, green, and blue dots.

1912 George Smith designed a camera that would use 35-mm motion picture film.
1914 Oskar Barnack had developed a prototype of his Leica camera, which would later transform the industry. The Leica went into full scale production following World War 1, equipped with a f/3.5 Elmar lens and a lens-coupled rangefinder for accurate focusing.
1925 Leitz -Leica precision 35mm camera
1935 35mm color photography was invented by two young musicians who, fortunately, did not know what they were doing. Leopold D. Mannes and Leopold Godowsky took as unquestioned fact that red, green, and blue are the primary colors. As they went about rehearsing their music and conceiving the film ultimately introduced as Kodachrome, they naturally thought the thing to do was to have emulsions of three different sensitivities sandwiched together on a single piece of film. One layer would be sensitive to blue, one to green and one to red light. The first and still the very best color film might have never have been made.
1938 Electrophotography
(Xerography)
The process that helped make possible a copier and Laser Writer was invented in 1938 by Chester F. Carlson. Xerography, or "dry writing," was accomplished by reflecting the image of an original document from a mirror onto an electrically charged selenium drum. A copy was created as special dry-ink powder, attracted to the dark image on the drum, was transferred and fused to paper.

History of the Computer

1942 Colossus Computer built in Great Britain. With over 20,000 vacuum tubes it occupied two floors and could do four mathematical functions: Addition, Subtraction, Multiplication, and Division. Only one piece of this first electronic computer exists today. It was designed specifically to break German codes.

1944 Mark 1, World's first automatic digital computer built at Harvard University by Howard H. Aiken with assistance from International Business Machines Corporation (IBM)..

1945 ENIAC (Electronic Numerical Integrator and Computer) was the first wholly electronic computer for general purpose use. Built in Aberdeen, Maryland, it was invented by J. Presper Eckert and John Mauchy. Two stories high with 18,000 vacuum tubes, it had a failure every two days and weighed 30 tons.

1947 Transistor invented by William Shockley. This was to allow for the replacement of vacuum tubes and made miniaturization and high capacity computers possible.

1948 M. E. Conway used first English abbreviations in computer program, thus replacing all number programming requirements. This greatly advanced programming.

1951 UNIVAC, first commercially available computer which gained general acceptance in the fields of science, the military, and very large corporations.
1952 Color Television introduced to the general public. Forerunner for quality, economic computer display screens.

11

History of the World	History of Photography	History of the Computer
1950 Korean War begins	**1955 Color Separation Scanning** Printing Developments, Inc., a subsidiary of Time-Life, Inc., produced the first commercially available electronic color scanner in 1955. Although films for four-color printing had been produced on cameras and enlargers for some time, the scanner greatly speeded the process. The device scanned each original slide (transparency) with a beam of light, converting each tiny area of the image into color signals. These signals—separate records of the amount of yellow, red, blue, or black needed to reproduce each area of the original image—were used to expose four pieces of film. These films had to be exposed through a halftone screen to produce printable dots for each color.	**1953 Miniature transistor** invented by Bell Laboratories allowed vacuum tubes to be replaced. Design of computers became much more efficient and smaller with greater capacities and capabilities.
1952 Eisenhower elected President; **1953 Masers and Lasers** An American physicist and engineer, Charles H. Townes, developed a device in 1953 that was capable of concentrating and amplifying microwaves, thus making possible highly accurate transmission of communications signals over long distances. His first maser (microwave amplification by stimulated emission of radiation) operated by electronically "exciting" ammonia molecules as they passed through a cylinder made of charged metal rods.		**1958 Integrated circuit** invented. It replaced multiple transistors with tiny slices of etched silicon. This ushered in the "Chip" which became known as the computer on a chip. Concept made room size computers of the 1950's and 60's desk size and eventually desk top size and lap top and/or Mac PowerBook computers of the 80's and 90's.
1957 USSR launches 1st earth satellite, Sputnik **1960** Kennedy elected President **1960** An optical maser (laser) was developed by Theodore Maiman. It consisted of a synthetic ruby cylinder into which was coiled a flashtube. The device amplified the light waves into a thin, highly intensified beam. Uses for lasers in today's communications graphics include color separation, typesetting, plate and cylinder exposure and die cutting.		**1963** First computer film made by Bell Laboratories. Product was the forerunner of computers in the Film Industry. **1964** Mouse input device invented at Stanford University. It would become the dominant input device by the 1990's.
1963 Kennedy Assassinated; Johnson becomes President		**1967** First United States picture processing via electronic scanning and transposing of photographs took place at Bell Laboratories. It would eventually allow for the replacement of chemical photography as the dominant form of photography.
1967 Christiaan Barnard performed the first heart transplant		**1971** "Computer-on-a-chip" microcoprocessor developed with simple core of logic for general purpose use. Chip became the size of a child's fingernail.
1967 Jacqueline and I married in San Miguel de Allene, Mexico.		**1975** Mits Corporation, owned by Ed Roberts and Bill Gates, developed the "First true home computer," the **Altair.** It provided product prototype for high resolution color graphics capabilities. Bill Gates and Paul Allen founded the **Microsoft Corporation.**
		1977 First commercially successful microcomputer by Apple Corporation, formed by Steve Jobs and Steve Wozniak, truly launched the age of a computer in every business and household.

History of the World	History of Photography	History of the Computer
1968 A previously unseen moon is discovered to be orbiting Pluto	**1981** Sony Mavica digital still video camera introduced Sony demonstrated Mavica, a consumer-oriented, filmless electronic still video camera. Ushered in the use of electronic imaging which eventually will replace chemical photography as the photographic system of choice.	**1973** The Apple II personal computer had a 12" monochrome green display screen with 32 bits of RAM and a single sided floppy disc with 64 bits of storage space. Software was limited to word processing, data base, and a very simple spreadsheet
1968 Richard Nixon, President		
1973 Ian and Erinn McMahan born		
1974 Watergate scandal forces President Nixon to resign. Gerald Ford becomes 39th president	**1981 Space** Shuttle FIRST PHOTOS FROM SPACE TAKEN BY MAN	**1978** First programmable video game system introduced by Fairchild Electronics. .
		1978 First hard disc storage drives for microcomputers were sold. These units held up to 5 MegaBytes of data.
1980 Ronald Reagan, President		
1988 George Bush, President		
1990 Information sent to earth through Hubble telescope	**1990** Slide & Flat bed scanners to bring photos into electronic form	**1981** Tunable laser developed by Allied Corp. eventually allowed high end laser printing.
1990 Berlin Wall destroyed	**1990** Northrop Corp. B-2 division goes to digital photography	**1981 IBM** PC Personal Computer, the Datamaster with MS-DOS as its standard operating system, was introduced. First "portable" computer was introduced by Osborne Corp.
	1991 Color Separations on micro computers (Mac family) in desktop publishing using PhotoShop & a Photo Image Setter	
1992 Los Angeles Riots, April,		**1982** TIME magazine names the computer its "Man of the Year". This is a graphic reflection of the importance of computer technology to all levels of our society.
1992 Barcelona Olympics	**1993** Developments since that time include twin-lens and single-lens reflex designs, variable focal length and zoom lenses, automatic exposure systems, and a host of special-purpose cameras and attachments. In little more than a century and a half, photography has advanced from Niepce's first crude heliograph of his pigeon loft to NASA's computer-enhanced images of Jupiter's moons, transmitted through millions of miles of space. And the dance goes on. Electronically generated images stored on magnetic media, laser-generated images, holograms, digital images, computer enhancements - there is no limit to the possibilities.	
1992 Soviet Union becomes non-Communist		
1992 NASA uses digital images to communicate into space		**1983** Apple introduced the LISA with a new **Graphic User Interface** Expensive and slow, it was a flop
		1985 MacIintash introduced
		1985 300 dpi laser printer and Pagemaker
		1990
1992 Gulf War in Middle East, 1992		**1993** Electronically generated images stored on magnetic media, laser-generated images, holograms, digital images, computer enhancements - there is no limit to the possibilities.
1993 Bill Clinton, President		

The System I wish I had at home

CHAPTER I, A BEGINNING

Some time before the first human stepped down onto the moon, I completed an art degree and was hired as a part-time photographer for an evening paper. Overnight I learned how to change a photo to a reproduction by halftone.

Lesson one was that a beautiful photograph may not reproduce as well as one designed specifically for reproduction. High contrast black and white was my kind of photo, real art. But I found myself explaining my preferences in the editor's office while the head of the print shop stewed in the doorway over yet another

green photographer. My practical education was over in minutes as I was informed that my photo was holding up the front page because it had no grayscale. What gray scale meant to this wet-eared black and white art photographer was an unprintable negative, not a pretty sight to someone used to hanging his stuff on the walls of art galleries. But the print shop of a newspaper demanded flat gray scale. Newspaper photo reproductions, halftones, were done by Fairchild etching machines, which increased contrast substantially making it necessary to start with lower contrast photos than I preferred. I had to grit my teeth and send out the flat ugly shots knowing that these were what ultimately reproduced better.

I never really gave up on having high contrast photographs. Some years after that initial sacrifice of art for reproduction, I was able to use a graphic arts camera to make my own halftones, thereby determining the effects I wanted. The Ortho film used by the graphics arts camera is not sensitive to blue and is either dense or opaque with no gray scale. To create an illusion of a gray scale, you rephotograph the original through a halftone screen onto the Ortho film, leaving tiny dots that create the illusion of a real gray scale. This process, called offset printing, gave me the ability to print finer dots so that the original photograph could have more contrast and still reproduce well with ink and newsprint. The offset press reproduced a better gray scale with more details. I could finally have my beloved high contrast photograph that also reproduced well.

More years passed, many years, until the notion of processing images with computers finally delivered reproduction control into the hands of this no longer young

── COMPLETE Image Processing System ── for Your Apple II

$995

FOR
- Education
- Industry
- Medicine
- Home

COMPUTER GRAPHICS – IMAGE DATA-BASES – PORTRAITS – IMAGE ANALYSIS – NAPLPS – EXPERIMENTATION – AMATEUR RADIO – LOW RESOLUTION FACSIMILE – INVENTORIES – PLUS MUCH MORE

The PI-101 PhotoImager system transforms your Apple II into a sophisticated black-and-white and color image processing system. The PI-101 includes **everything*** you need to take, display, communicate, and store high-resolution gray scale and color photos—camera, video digitizer and display boards, and extensive integrated software.

*PhotoImager requires a 48KB Apple II, II+, or IIe with 1 disk drive. The Epson FX/MX and Imagewriter printers are supported through several interface cards. A color composite monitor is recommended. An FCC-approved coupler may be required to connect SSTV modem to telephone lines or digital modems may be used.

18

My First image Processor that worked the Apple II, converted video images to digital pictures on the monitor

photographer. It was as if a time machine had been preset to make sure that I was smacked in the head. My battles for control over gray scale were just preludes to a digital future.

THE GRAY SCALE WAR LEADS THE WAY INTO THE COMPUTER AGE - FROM DOTS TO PIXELS

Most of what we see as pictures are not actual photographs but reproductions. Just as the individual images projected on a movie screen fuse into an impression of continuous motion, dots of ink converge into light and dark areas on paper con-

The first poster made using a digitized computer image for a magazine, the image is dithered

THE PHOTOGRAPHER OF THE FUTURE, AN IMAGE-MAKER

Photography has reached beyond the craft that we are familiar with and has entered a new technological era. What we think of as a photograph is rapidly disappearing before our eyes. The picture itself may look the same but the way it is produced is vastly different. This new photograph portrays an image whose shapes and colors are digitized and scanned on a computer. Neither film nor darkrooms are necessary. The New Age photographer is an image-maker with much greater control over his work which in a negative sense can be reminiscent of a George Orwell world where he can create a person and drop that artificial individual into the image he wants to portray. Remember the fiasco of the television guide where Oprah Winfrey's head was superimposed over Ann-Margret's body? In a positive sense, the image-maker has many creative options at his or her fingertips with endless possibilities of colors, textures, and shapes. The flaws that might have forced a photographer back into the field, can be omitted at the flick of a keyboard without ever leaving the studio or office.

vincing our eyes that they are looking at a complete picture, rather than a minutely fragmented image. Look at any magazine photograph through a magnifying glass and you'll see what I mean.

Imagine my surprise on learning that a computer also breaks up images - just like the dots in a halftone - only the computer's dots are called PIXELS.

Several years ago I read a review for a photoboard, a system that turns video images into electronic images on the computer. We purchased it for use in our program at the community college where I teach and it was an immediate hit. It was the first time any of us had seen a photograph broken down into pixels. A pixel is essentially a beam of energy on the computer screen.

We can only hope that as photography grapples with its new level of image-making that the people touching those keyboards can still leave their mark, a mark with half the poignancy of an ancient black and white Eugene Atget photograph of a man walking his dog in 1920 Paris.

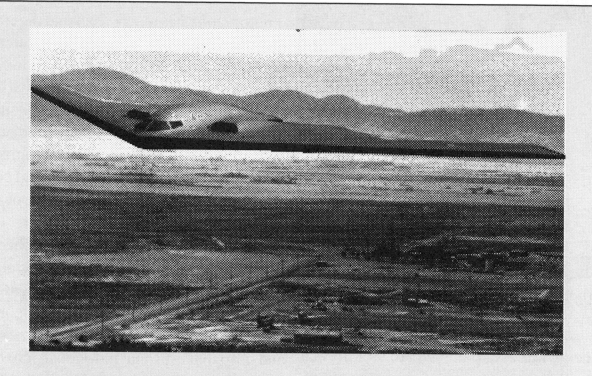

STEALTHING THE STEALTH

Several years ago when computer imaging was in its infancy and the Air Force's Stealth bomber was a topic of open speculation but not yet ready to fly silently over the Southern California desert, a newspaper asked if it were possible for me to create a composite image of the bomber that placed it in flight without the shot looking doctored. Using a black and white flatbed scanner, I digitized a photograph of a recognizable desert airport then repeated the procedure for a promotional photo of the stealth. I trimmed the background away from the bomber shot with a photo processing computer program, superimposed the plane over the airport, printed the composite shot on a laser printer, then sent it to the newspaper which ran it on their front page.

For days I waited for the F.B.I. to come knocking at my door but they never came.

As anyone who looks at the grocery store tabloids can tell you, altering photographs is nothing new. You may recall the fiasco when it was discovered that Oprah Winfrey's head had been placed on Ann-Margaret's body. With digital pixelgraphy that kind of manipulation is easy, but what does it mean about believing what one sees. Good question. The very same technology offers pixelgraphers the tools to correct flaws without reshooting or pre-exposure planning for the same kind of heightened reality that made Ansel Adams famous.

20

My tools I use at home which I need to do page lay-outs, illustrating and creating photo art covers for books and touching up photos.

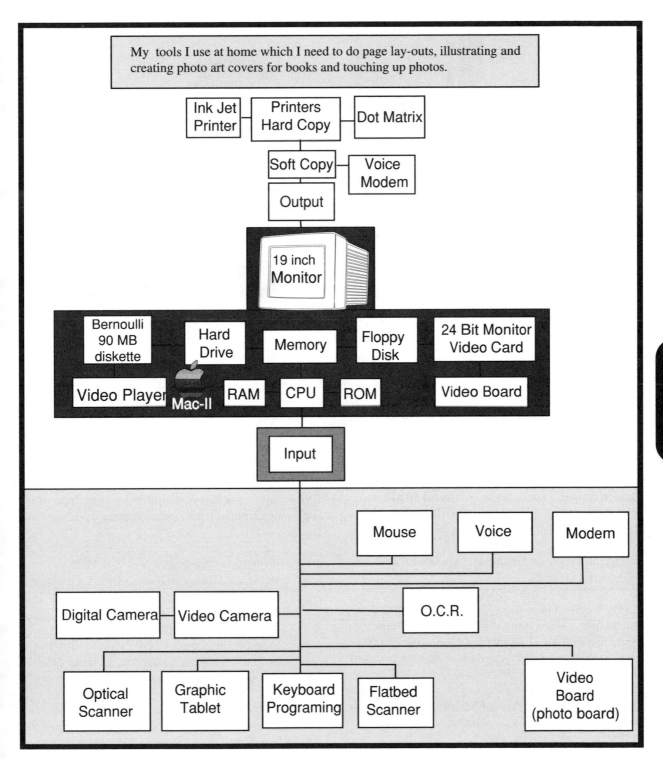

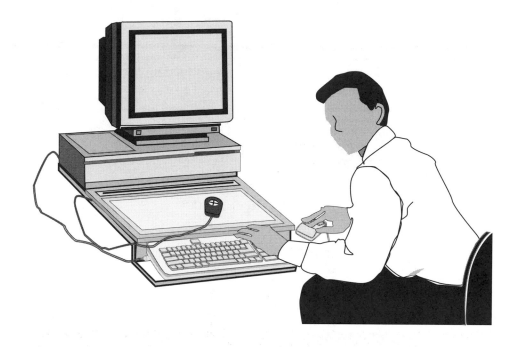

BOB'S SYSTEM

The tools I use at home are the minimum which I need to do page lay-outs, illustrating and creating photo art covers for books and touching up photos. I will give you my system plus what I wish for in the future.

A. The base is my reliable **MAC II** which has lived through many changes. It has an internal 80 MB hard drive and an 808020 processor chip with 8 MBs of RAM. I use system 6.8 and system 7.1.

B. The monitor is a 13 inch color **Apple** with an 8 bit video card.

C. My **Neotec Video Grab Card**, used for pulling still photos from a video camera, is the best tool I have after the computer itself. I also have a **Computer Eyes Card**, which works well at bringing a photo into the computer from the canon 570.

D. As an external hard drive I have a **Bernoulli 90,** for moving large files to a service bureau.

E. I have a **Microtek** color flatbed scanner, used almost every day for scanning photos as a *Pict template* for Adobe Illustrator, OCR for using with my **Dove Fax**.

F. I have a **Kerta** 12x17 graphic tablet.

G. The **Dove** Fax & modem.

H. As a printer I have a **Hewlett/Packard Inkjet** color printer.

I. One camera is a **Xapshot** with a copy stand and wide angle and telephoto lenses and Computer Eyes Import Board.

J. The next piece of equipment I use is a high resolution,19inch 24bit color monitorReal Tech with a 24 bit video card, for full-page layout.

K. The **Microtek 35mm** Slide Scanner would be a needed piece of equipment if I didn't have two available to me. I use them every day. I use a lot of slide film for taking and separating photos.

L.**Printers** You notice that I didn't mention printers, the reason is that I use a service bureau. This allows me to put my money into the equipment that creates the image and let the experts print it for me with a Laser print or a Lino print, a slide, or a film for color separation, I do have a Hewlett Packerd inkjet for proofing.

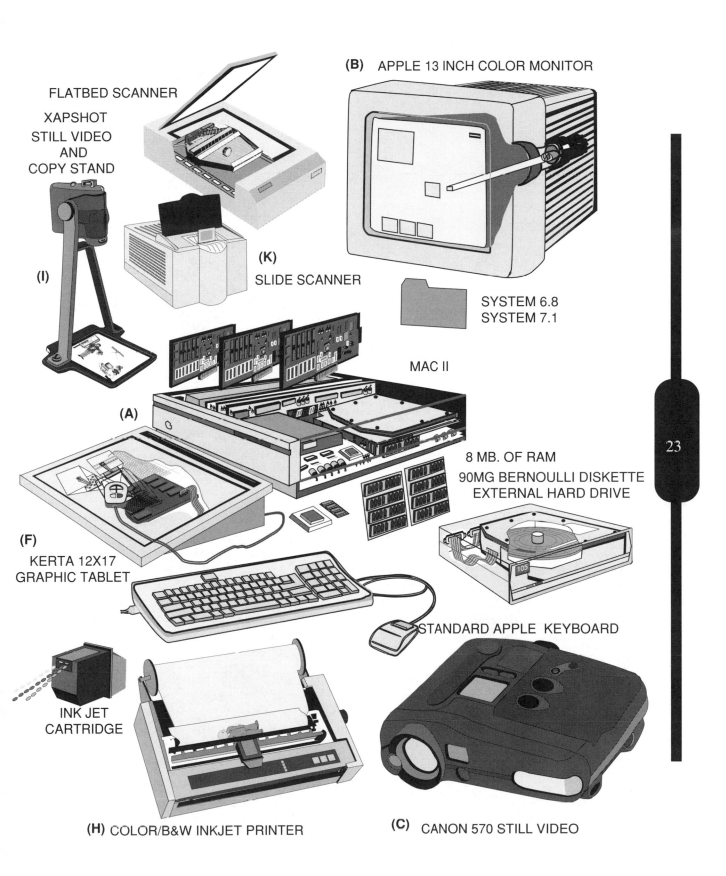

FLATBED SCANNER

XAPSHOT
STILL VIDEO
AND
COPY STAND

(I)

(K)
SLIDE SCANNER

(B) APPLE 13 INCH COLOR MONITOR

SYSTEM 6.8
SYSTEM 7.1

MAC II

(A)

8 MB. OF RAM
90MG BERNOULLI DISKETTE
EXTERNAL HARD DRIVE

(F)
KERTA 12X17
GRAPHIC TABLET

STANDARD APPLE KEYBOARD

INK JET
CARTRIDGE

(H) COLOR/B&W INKJET PRINTER

(C) CANON 570 STILL VIDEO

23

> **It has been said that the eye is that portion of the brain that penetrates the skin.**

CHAPTER II, SEEING

The first great mind to catch a glimpse into how we see color was Sir Isaac Newton. Having experimented with a prism, he was convinced that seven colors comprise light. As far as anyone can now tell, the main reason for his conclusion was mysticism. Light streaming through a prism does not separate into discrete units. But old Sir Isaac was a bit of a mystic, and he believed in the special power of the number seven. Newton also imagined, never checking, that at each point in the eye there was a separate receptor for each of the many frequencies of light. He thought there was a direct nervous connection from each of these myriad receptors to the brain. Oops. Newton was off by quite a bit. Color vision is complex, but Newton's idea made it about 10,000 times more complex than it really is.

Most of the time since Newton the tri-color theory (RGB) held sway. Its author was an Englishman, Thomas Young. Young, after examining Newton's ideas with pure reason, concluded that the old boy's theory of a different receptor for

each wavelength was nonsense. It was Young who first proposed the notion that the eye contains a limited number of receptors, each kind sensitive to a primary color. But he had trouble making up his mind what the primary colors were. He guessed at first that they were red, yellow, and blue. Then he changed his mind and published that they were red, green, and blue. That was in 1802. Red, green, and blue stuck. Ever since, most of the world has believed that this was the way we see color. Red, green, and blue sensing elements in the eye send signals to the brain which tell us what the world is like.

Mr. Young was wise in entertaining doubt. At the risk of alienating readers from some long-cherished certainty about color, due consideration compels us to conclude that the theory is wrong.

Wrong as it is, it has always had a beauty to it. In practical demonstration it works. James Clerk Maxwell was the first to show us this. About 1850 he demonstrated that white light could be synthesized with red, green, and blue light. That done, the production of intermediate colors by mixing the three lights was a step away. Then followed, eventually, color printing, color photography (including some specialized process that preceded Kodachrome), and color television.

Another beauty to the red, green, and blue theory was that you could make all kinds of measurements with it.

26

NOW THE TRUTH:

Color is a sensation; that is, it's something that takes place within you. It is not an attribute of things. The sensation of color may be stimulated by the way things react with light. If they transmit, radiate, or reflect light to your eyes in certain ways so as to cause color sensation, they may seem to have color. But this interaction with the light is a cause of color and not color itself. Color is the effect within you.

Experts say that the whole visual process, including color vision, must be regarded as an entity hence the statement - the eye is that portion of the brain that penetrates

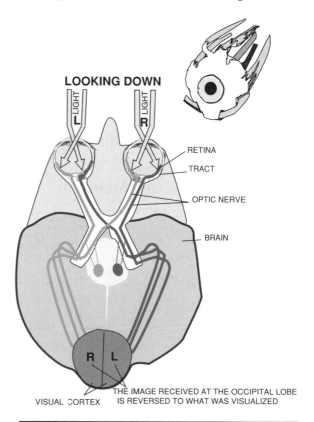

LOOKING DOWN

RETINA
TRACT
OPTIC NERVE
BRAIN

R L

VISUAL CORTEX

THE IMAGE RECEIVED AT THE OCCIPITAL LOBE
IS REVERSED TO WHAT WAS VISUALIZED

A diagram of how the brain receives
information from the eyes

the the skin. While this may be a slightly revolting figure of speech, it makes the point that the functions of the eye and the brain are so interwoven that one dare not consider either alone. This is especially true when trying to put together a picture of color vision.

Another truth - the eye is not a camera nor is the camera really like an eye. This analogy has done untold damage to the process of camera design. If there is any comparison at all, the camera is a staggering over-simplification of the eye.

Disregarding, for the moment, the unique optical arrangements in the eye, let's look at the eye part usually compared with photographic film: the retina. You can actually see the retina by looking through the pupil, which normally we see as the black part of the eye. Partly the blackness is an illusion because of our looking at the window of a chamber. The pupil looks black in the same way that a freshly cleaned window of your neighbors' house looks black in the noonday sunlight. The pupil looks black because when you are close enough to see through it, your head is blocking out the light. In the twilight of the laboratory with special illumination, you can see through to the inside of the wall of the eye and find that it is blood red, odd as this may sound.

Many of you have first-hand experience with this red color. When a flashbulb is near the lens and your subject is staring straight at the camera, the retinal color can become obvious in the finished picture. In fact it can be dazzling, with fire-red pupils; the very brightest high-light in the picture.

Cornea
Iris
lens
White of the Eye
Sclera
Optic Disc
Blind Spot
Pigment
This small area at the back of the eye is an extension of the brain and is a information processing center
Optic Nerve

Parts of the eye

27

The effect can occur in black-and-white pictures, but naturally, "red-eye" looks much more devilish in color slides or prints. Alignment—of the light, the camera lens, and the subject's eyes—is quite critical for a really pronounced effect, so it is hard to get except accidentally.

The retina is clearly the origin of normal color sensation, but only a small portion of it is given over to this purpose. Most of it is devoted to peripheral vision, which is substantially colorless.

The light-sensing elements of the retina are minute cells. Taking both eyes into account, there are some one-third of a billion of these cells. They can easily be classified into two types. The names of the two types—rods and cones—describe shapes, but they should not be taken too literally.

The nerve cells in the network are interconnected in such a way as to lead experts to believe a great deal of brain work goes on right in the eye. Evidently, when the pigment in a rod or cone fades ever so slightly, that chemical change fires a nerve signal to an adjoining nerve cell. This signal is sometimes amplified, sometimes attenuated, sometimes combined with the signals that arise from other receptor cells. This complex activity takes place within a very thin and transparent, but richly involved layer of cells overlying the rods and cones, within the retina of the eye itself.

Ultimately, of course, the information that was captured when the light was absorbed by the rods and cones is translated to nerve signals which leave the eye along the path of the optic nerve, eventually to reach the central nervous system and the brain.

It looks at first like a one-way street. But it is wrong to think that the retina serves only to supply information to the brain. The connection between the central nervous system and the eye carries messages to the retina as well as transmitting messages from it. One of the powers of the brain evidently is to suppress or extinguish a signal from one or a group of the light sensitive cells. Thus even at the most rudimentary levels, vision seems to be subjective, and not a cut-and-dried, mechanistic phenomenon.

People just entering photography are surprised that they need conversion filters because daylight and tungsten room light are very different in color. They are surprised because their color vision works so quickly to adjust to the color balance of any scene they encounter. We do not need a TypeB retina or a special filter over our glasses to keep everything in our living room from looking reddish under artificial illumination. We catch sight of the illuminant and effortlessly and automatically adjust our color vision accordingly. Unconsciously we strive for constancy.

The optics of the eye are uncorrected for color dispersion. You could not sell a camera lens to a self-respecting amateur unless it was quite elaborately color-corrected. The result of a lack of color correction is color fringing around objects, for one thing, and deterioration of sharpness for another.

But no such problems are evident to us as users of the uncorrected lenses in our eyes. The reason seems to be that we correct for color dispersion by refocusing every time we look at a different color. We do it so quickly and so effortlessly that we can easily fool ourselves into believing that we do not refocus at all, that everything just stays sharp. Our self-deception in this respect is so complete that it comes as a surprise when we try to focus on two colors of a very different wavelength simultaneously. The worst offender is red lettering on a blue field. The letters dazzle and dance so actively we sometimes cannot read the words. The phenomenon is called vibration. Of course, it is not the subject that is vibrating. It is our superautomatic focusing mechanism, trying to do something that cannot be done: make two different image planes fall on the retina simultaneously.

It is hard to define what "white light" is ? Normal daylight varies in its composition according to latitude, time of year, and time of day. The concept of "color temperature" provides a way of resolving these problems. Physicists can specify the glow given off by an ideal substance at various temperatures. A sample at 5,600° K (about 5,300° C or 9,600° F) gives off a glow with about the same spectrum as June sunlight at noon in the temperate latitudes. Northfacing sky is more bluish and has a color temperature around 7,500° K, and morning or evening sky is redder and has a lower color temperature. Paper (or any other opaque surface) is white if it reflects most of the light and reflects all wavelengths equally. Printing inks are made of particles of colored pigments suspended in a transparent medium. The particles reflect certain wavelengths and absorb others. This has the effect of extracting only a limited set of wavelengths from light.

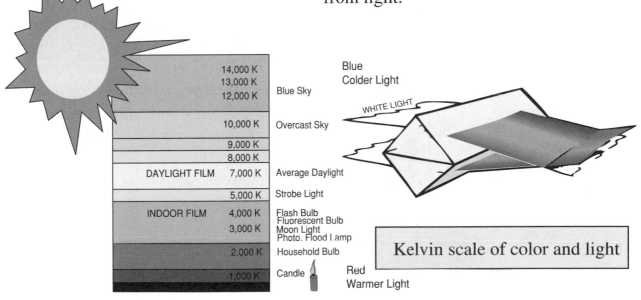

Kelvin scale of color and light

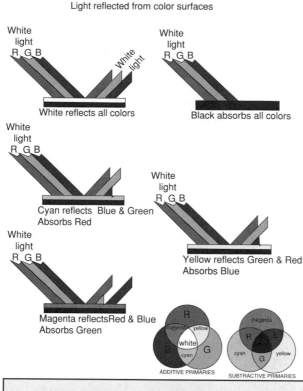

Light reflected from color surfaces

White light R G B — White reflects all colors

White light R G B — Black absorbs all colors

White light R G B — Cyan reflects Blue & Green Absorbs Red

White light R G B — Yellow reflects Green & Red Absorbs Blue

White light R G B — Magenta reflects Red & Blue Absorbs Green

ADDITIVE PRIMARIES SUBTRACTIVE PRIMARIES

Colors of light being reflected and absorbed

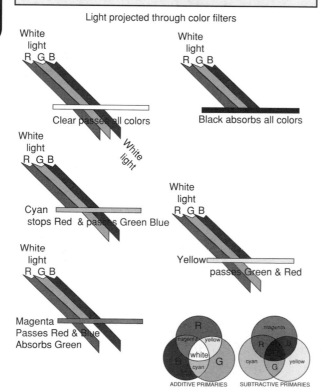

Light projected through color filters

White light R G B — Clear passes all colors

White light R G B — Black absorbs all colors

White light R G B — Cyan stops Red & passes Green Blue

White light R G B — Yellow passes Green & Red

White light R G B — Magenta Passes Red & Blue Absorbs Green

ADDITIVE PRIMARIES SUBTRACTIVE PRIMARIES

30

If you mix inks whose particles have different absorption, then most of the light will encounter both kinds of particles, and both sets of wavelengths will be removed from the reflected light. This phenomenon is called "subtractive" mixing, because all the wavelengths are subtracted (absorbed) by the individual pigments. The same kind of subtractive mixing occurs when transparent inks are printed on top of one another. This is exploited in the four-color printing process. Each of the three colors yellow, cyan and magenta removes a portion of the spectrum of the light that falls on it. Yellow removes the blue portion, cyan removes a portion centered on orange, and magenta removes the green portion. By using these colors in various proportions, a specific group of wavelengths can be extracted from the light. In this way, subtractive mixing can create the appearance of nearly any desired color. All of the colors in a photograph can be reconstructed using this three-pigment approach. In practice, inks aren't perfect, causing the loss of some saturated colors and requiring the addition of black. When printed in the proper proportions they can create a color that looks like the original shade.

Subtractive color is based on removing wavelengths from light. So the light you view the object by must have have a light source similar to the one it was photographed by.

EACH COLOR HAS ITS OWN FOCUS

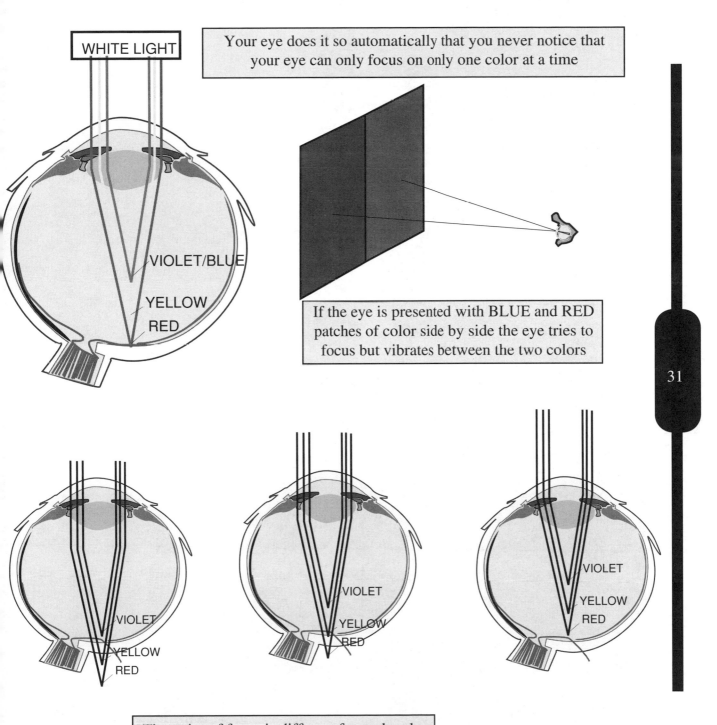

WHITE LIGHT

Your eye does it so automatically that you never notice that your eye can only focus on only one color at a time

VIOLET/BLUE

YELLOW

RED

If the eye is presented with BLUE and RED patches of color side by side the eye tries to focus but vibrates between the two colors

VIOLET
YELLOW
RED

VIOLET
YELLOW
RED

VIOLET
YELLOW
RED

The point of focus is different for each color

An example of how the eye has to re-focus as it looks at different colors

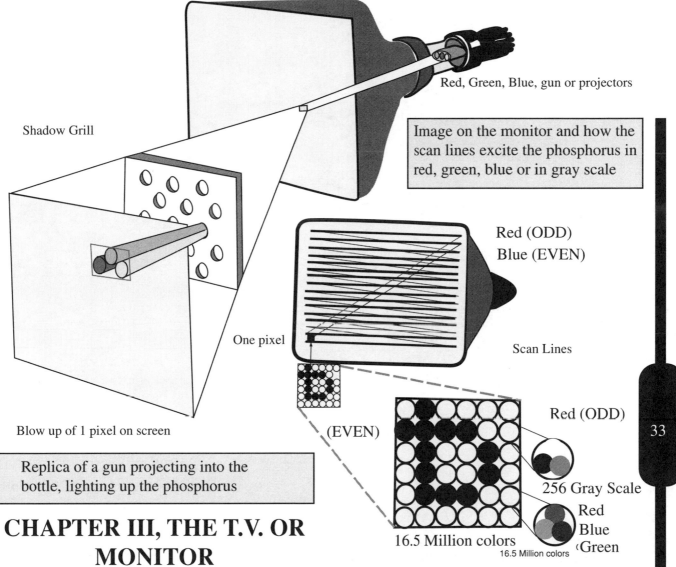

Shadow Grill

Red, Green, Blue, gun or projectors

Image on the monitor and how the scan lines excite the phosphorus in red, green, blue or in gray scale

Red (ODD)
Blue (EVEN)

Scan Lines

One pixel

Blow up of 1 pixel on screen

(EVEN)

Red (ODD)

256 Gray Scale

Red
Blue
Green

16.5 Million colors

16.5 Million colors

Replica of a gun projecting into the bottle, lighting up the phosphorus

CHAPTER III, THE T.V. OR MONITOR

In simple terms, a TV set is a box of electronics and a big, empty glass bottle called a PICTURE TUBE, technically a CATHODE RAY TUBE or CRT. We stare at the bottle's flat bottom while inside its neck a tiny electronic gun fires electrons at the bottle's base. This gun shoots a beam of electrons at the inside face of the TV screen which is covered with phosphor dust. Where the electrons hit the phosphor, the screen glows. To make a picture, this gun sweeps across the screen from side to side, much as your eyes sweep across each line of this page and eventually cover the entire page. Special circuits tell the gun how fast to sweep and when to sweep as well as when to stop shooting at the end of a line (just as you stop reading at the end of a line and zip back to the beginning of the next line.) When the gun's sweep reaches the bottom the screen, it re-aims at the top and starts shooting again.

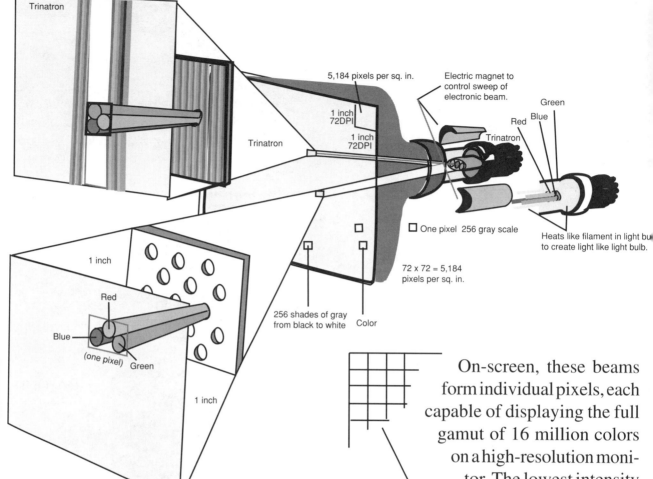

Trinatron

5,184 pixels per sq. in.

Electric magnet to control sweep of electronic beam.

Green
Blue
Red

1 inch
72DPI

1 inch
72DPI

Trinatron

Trinatron

One pixel 256 gray scale

Heats like filament in light bulb to create light like light bulb.

72 x 72 = 5,184 pixels per sq. in.

1 inch

Red

Blue

(one pixel) Green

1 inch

256 shades of gray from black to white Color

512

256 256

8 8

256

color

8 8

256

4 x 8 = 32 bit color

Diagram of a monitor and trinitron

The colors on a monitor are created by electron beams shooting onto the surface of the screen through red, green, and blue phosphors. These beams are produced by electron guns that translate a numerical setting in software (level 126 of red, for example) into an exact measure of intensity, thus producing a specific color. Changing intensities of the three beams dictate the changing colors as the electron gun travels across the screen.

On-screen, these beams form individual pixels, each capable of displaying the full gamut of 16 million colors on a high-resolution monitor. The lowest intensity of these beams produces black on-screen and, theoretically, full intensity produces an all-white screen.

Ideally, when a program specifies 20-percent red, 50-percent blue, and 30-percent green for example, the same color should be produced at all times on the monitor. The eye will see differently a computer screen which is projected as to a photograph which is reflected light.

COLOR CRT

In a conventional color CRT, three electron beams (one each for red, green, and blue) shoot out of the neck of the tube toward the phosphor coated screen. Three separate electron guns and focusing lenses are arranged in a triangular configuration. This arrangement requires 3 very small lenses, which create beam-focusing and alignment problems.

As the three beams approach the screen, they converge and pass through a mask that makes sure each beam hits only one phosphor color at a time. In conventional tubes, this shadow mask is a metal plate riddled with tiny holes—one hole for each phosphor dot.

In contrast, Trinitron CRTs use a single gun to produce 3 identical, horizontally aligned beams which are focused by a single large lens. This lens reduces beam error and produces smaller beam spots. The Trinitron uses a grille, which has long, vertical slits rather than holes. The electron beams pass through the slits at different angles but in the same horizontal plane. In addition, the phosphor is laid down in vertical stripes rather than dots. The aperture grille allows more of the beam to pass through, creating a brighter picture.

Conventional tubes have a spherical surface, like the side of a balloon. Trinitron screens are cylindrical, like the side of a bottle. Thus, while a spherically shaped screen is round in all directions, a Trinitron curves only in the horizontal direction; its vertical axis is straight. This reduces both image distortion and glare.

One gun trinatron screen lighting up pixels from top to bottom. Shows how Macintosh single gun delivers energy to phosphorus at 1/60th of a second

MAKING BEAMS INTO PICTURES

As the beam zigzags across the screen, another signal tells the gun to shoot harder (more electrons) or weaker (fewer electrons) depending on whether it is tracing a lighter or darker part of the picture. By turning up the brightness control on your TV, you tell the gun to shoot more electrons at the screen thus lighting up the phosphors brighter. This gun zips its beam across the screen about 1 5,750 times each second starting at the top 60 (NTSC) times each second. The phosphors keep glowing until the next time the beam comes around and hits them again. Thus the screen appears smooth and flicker free. European TVs, retrace themselves only 50 (PAL) times per second and as a result, European TV flickers more noticeably than American TV.

Actually, when the electron gun sweeps its lines across the screen, it doesn't do all the lines at once. First it does the odd-numbered lines leaving empty spaces for the even-numbered lines. Then it goes back and fills in the even-numbered lines. In the first sixtieth of a second, it will sweep lines one, three, five, seven, and so on, making a total of 262 1/2 lines on the

36

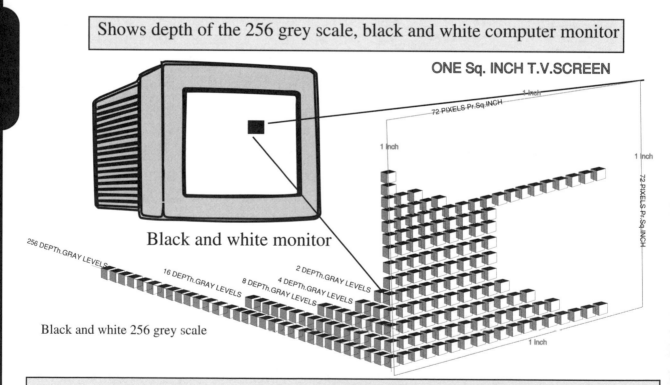

Shows depth of the 256 grey scale, black and white computer monitor

ONE Sq. INCH T.V. SCREEN

1 inch

72 PIXELS Pr.Sq.INCH

1 inch

1 inch

72 PIXELS Pr.Sq.INCH

Black and white monitor

256 DEPTh.GRAY LEVELS

16 DEPTh.GRAY LEVELS

8 DEPTh.GRAY LEVELS

4 DEPTh.GRAY LEVELS

2 DEPTh.GRAY LEVELS

1 inch

Black and white 256 grey scale

One pixel of phosphorus has the possibility of 256 energy levels which create different intensities of the grays on the black and white monitor, but on the color monitor the 256 energy levels are multiplied x 3, then create a pixel with red, green and blue. Each pixel then has the possibility of 16 million color variations

screen. This is called the ODD FIELD. In the next sixtieth of a second, it draws lines two, four, six, eight, and so on, making another 262 1/2 lines on the screen. This is called the EVEN FIELD. Therefore, it really takes a thirtieth of a second to draw each complete picture. The complete picture is called a FRAME. Each of these frames are still, but because they go by so quickly, (30 per second) they make the picture appear to be moving.

HOW COLORS ARE DISPLAYED ON A SCREEN

In a darkened room, aim a red flashlight at a white wall and you'll see red; turn it off and you'll see black. Shine a blue light on the wall and you'll see blue. Shine green and you'll see green. Shine red and blue together and the colors will mix to create a new color, magenta. Shine red and green together and you'll see yellow. Shine all three and you'll get white. All the other colors can be made from shining various proportions of these three primary colors A monochrome (black-and-white) TV set

A color monitor with 256 red, green, blue (R.G.B) phosphorus 16 mil.colors

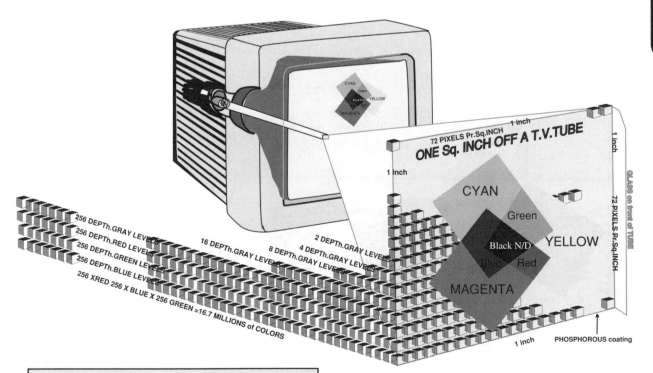

Color monitor with 16 million colors

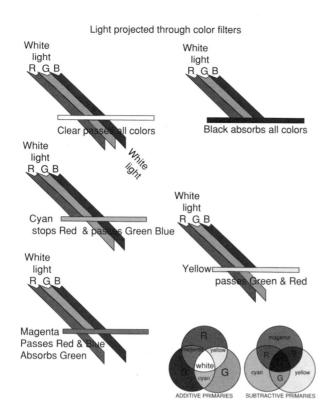

Light projected through color filters

White light R G B — Clear passed all colors

White light R G B — Black absorbs all colors

White light R G B — White light — Cyan stops Red & passes Green Blue

White light R G B — Yellow passes Green & Red

White light R G B — Magenta Passes Red & Blue Absorbs Green

ADDITIVE PRIMARIES — SUBTRACTIVE PRIMARIES

makes its picture by electronically projecting black and white onto a screen in various proportions. As it scans, it turns on and off in order to create black or white dots called pixels. Each pixel is a square, approximately 1/74 of an inch on a side. A color television makes its picture by creating three images on its screen: one red and black, another green and black, and the third blue and black. Where only red is projected, you see only red. Where red and green pictures overlap on the screen, you see yellow. Where all three pictures are black, you see black. Where all three colors converge with equal strength, you see white. The picture tubes in color TV sets have three electron guns, one for each color. The face of the color TV screen is made of dots or bars of phosphor which shine red, blue, or green when hit by electrons. Look really closely at your TV screen while it's displaying a white picture and you'll be able to see the tiny colored dots

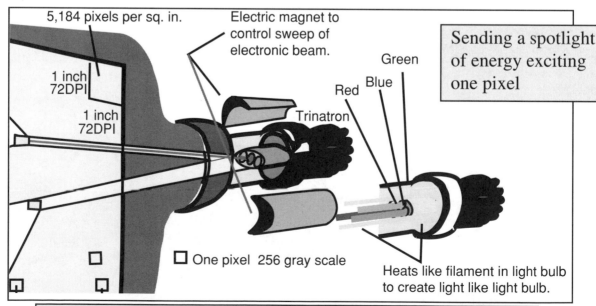

5,184 pixels per sq. in.

Electric magnet to control sweep of electronic beam.

Green
Blue
Red

Trinatron

1 inch 72DPI

1 inch 72DPI

Sending a spotlight of energy exciting one pixel

☐ One pixel 256 gray scale

Heats like filament in light bulb to create light like light bulb.

Close up of a single and double gun in back of a glass bottle

or stripes which make up the whole colored picture. The electron gun for the blue color is arranged so that it can only hit the blue phosphorus on the screen. The red

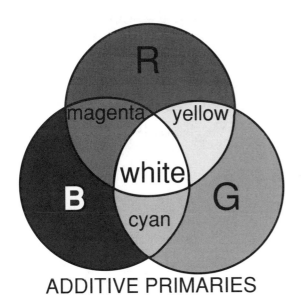

ADDITIVE PRIMARIES

gun can only hit red, and the green gun, only green. The three guns independently scan a picture onto the screen, and the three pictures overlap to create a dazzling color view.

COMPUTERS AND COLOR

Computers operate on a binary system of "on" or "off". On a black and white monitor the pixel is either on, white, or off, black. A single "bit" of information is programmed, is on or off for each pixel on the screen. Color images require at least four bits per pixel, one for each red, green, blue,and black. For this reason, some con-

sider color to be a memory hog. At least four times the amount of data must be processed to present each picture to the screen. We say "at least" becaues the color you see on a four bit screen is narrow in its range. To get more than the simple colors of the rainbow you must use one of the newer monitors advertising 8, 16, 24 and 32 bits per pixel. And with each increase in pixel depth there is a more than equivalent increase in required data to be processed for each image in order to paint an image on the screen.

SELECTING YOUR MONITOR

Without a doubt, sharpness is the most complicated, confusing, and difficult-to-measure quality of color monitors. It is related to resolution, but not directly. More pixels (picture elements) can improve sharpness. A higher resolution photograph can look sharper, for example, because more small features can be seen in the picture. Sharpness is also affected by the number of colored phosphorus dots on the screen. A 1:1 dot-to-pixel ratio is best.
A good grey scale monitor is sharper than an equivalent quality color monitor. Grey scale monitors are excellent choises for desktop publishing and many graphics applications, especially those using scanned images or black and white photographs. If you don't really need the color, it can be a waste of money.

RESOLUTION

Your most important consideration in choosing a color monitor, after price, should be resolution. Resolution is simply the total number of pixels (picture elements) you can see on-screen at one time. It affects usability more than any other factor, since it determines how much photo information the monitor can display. If you'd like to see more of your photograph, then a high-resolution monitor may be for you. Understand that high resolution doesn't necessarily mean improved sharpness, especially for text.

A monitor's vertical resolution is given in lines and its horizontal resolution in pixels per line. Apple's high res RGB monitor has 480 lines of 640 pixels per line (normally listed as 640 x 480). On a 9-inch screen, that's 72 pixels per inch (ppi).

At first, Macintosh display architecture was simple and uncomplicated. Screen were 342 x 512 pixels in black and white only. Then the Mac 11 came along with Color QuickDraw. Screens have become not only taller and wider but also deeper. This third dimension is not something you can measure with a ruler, but it has a dramatic impact on the realism of a color image.

Depth refers to the number of different colors or grays that can be used for any pixel on the screen. For the MacIntosh, this number is based on a binary representation. For example, an ordinary monochrome screen requires one binary digit (1 bit) to represent two colors, black and white. On the other hand, 8-bit color video has 8 bits of information associated with each pixel. These 8 bits give you 2 to the power of 8, or 256, choices or 32 bit 16.7 mil. colors at one time.

In the Color QuickDraw implementation currently provided with the Mac II,each pixel contains a binary value that is 1, 2, 4, 8 or 32 bits deep. This value does not directly indicate the color but is used instead as an index to the Color Look Up Table (CLUT). For example, if a binary value of 8 represents blue green, then the PixMap would look up color information for a pixel with that value from the eighth position in the CLUT. The PixMap is the RAM version of the screen image.

The CLUT describes each color with 48 bits, 16 bits each for the red, green, and blue (RGB) components—although most existing hardware and software use only 8 bits for each component. Each color on the screen must be stored as an indexed value in the CLUT. With an 8-bit video card, only 256 different colors can be stored (and displayed) at one time. Thus, the CLUT is actually a subset of the 16.7 million colors possible with Color QuickDraw.

Apple has announced it will be providing fully chunky color, in which each 24-bit value stored within a contiguous 32 bits. Its main advantage is speed of drawing.

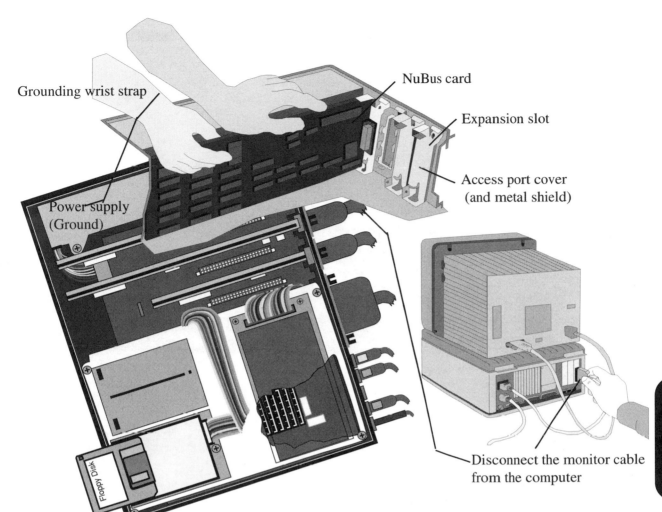

Grounding wrist strap

Power supply
(Ground)

Floppy Disk

NuBus card

Expansion slot

Access port cover
(and metal shield)

Disconnect the monitor cable
from the computer

INSTALLING VIDEO BOARD

If you are unfamiliar with the Macintosh or have never installed a NuBus card, please refer to the Apple manual that came with your computer. Follow the instructions that apply to your Macintosh model:

1. Turn off the Macintosh and monitor.Leave the Macintosh plugged in for proper grounding.Important If you have been using your Macintosh, wait five minutes after switching it off before you proceed or system can be damaged.

2. Disconnect the monitor cable from the computer.

3. Remove the cover from the Macintosh.
To remove the cover from a Quadra 900, place the computer on its side, press the two cover release buttons, and lift the cover.

4. Attach a grounding wrist strap.

5. Choose the expansion slot you wish to use.

Your choice does not affect the performance of the board.

6. Remove the plastic access port cover (and metal shield, if present) of the slot you plan to use.

7. Remove the board from its anti-static bag. Handle the board by its edges and by the metal bracket at the end. Avoid touching the connector pins on the bottom of the board.

8. Insert the board into the expansion slot. With the bracket toward the open access port, align the connector on the bottom of the board. Push down and gently rock the board lengthwise until the board is firmly seated.
Important. Don't force the board. If there is resis-tance, remove the board and try again.

9. Remove the wrist strap (ground) and replace the lid of the Macintosh.

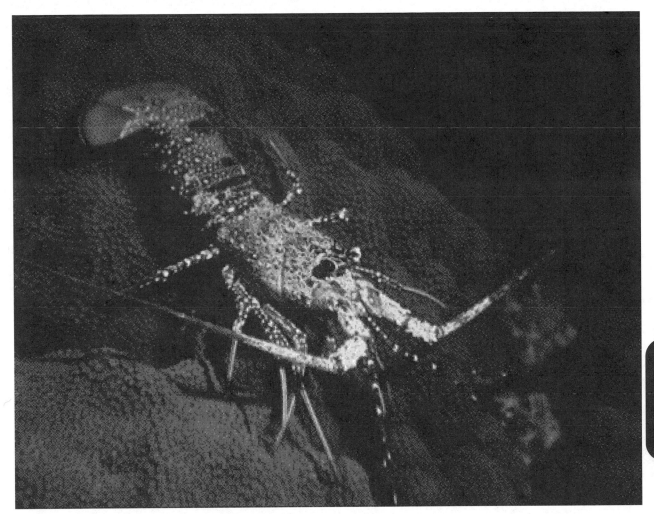

CHAPTER IV, COMPOSITION AND LIGHT

A WORKING RELATIONSHIP
WITH YOUR CAMERA

What separates a fine photograph from the average snapshot? Sentimentality and craftsmanship can go hand in hand but snapshots usually have more of a personal as opposed to a universal appeal, with the subject (a grandchild and his pet) being of utmost importance; whereas the fine photograph achieves clarity, sharpness of detail and lighting while focusing on a subject of more universal interest. The craftsman-photographer makes the camera work for his purpose. His product is no accident.

10 - QUICK TIPS

1.Place focal points intentionally off center for a much more compelling photograph.

2.Note any background distractions before you begin photographing your subject. The proverbial surprise such as the little boy sticking out his tongue or a passing junk barge may be lurking in the corner of your frame. Make sure that excess paraphanalia is stowed out of view.

3.When possible, shoot for dramatic effect by what you include in the frame. When clouds are available, include them in the frame for added dimension. Remember, cropping is easy with a computer. Make sure every element is captured within the frame.

4. Dramatic effects can also be created with filters. By using a polarizing filter for color film, the sky will appear a darker blue with whiter clouds. With black and white film, a red filter will make the sky appear a deeper gray, giving the clouds more definition and contrast. Photographs of water can be plagued by a multitude of grays making filters a necessity if you want to add contrast.

5.Since everyone assumes a photograph to be the truth, no verbal account can be as convincing as a picture.

6.Photographs taken from high or low angles will also produce good visual effects.

7.Don't be afraid to develop a personal style. You may gravitate toward telling a photo story while someone else may prefer to take the more classical austere photographs .

WIDE ANGLE

NORMAL

LENS COVERAGE WIDE ANGLE TO TELEPHOTO

8.If you are going to be photographing a series or you will be going on a trip you wish to record, a log will provide you with a natural framework for story telling. A log can also record your original intentions on making the exposure. Field notes can be invaluable in guiding later image processing.

9.The wide-angle, spreading out the field of vision, is the best lens to use in cramped quarters when you have no possiblity of moving away from your subject in order to include all details in the frame. If you want dramatic perspective, a fish-eye lens will encompass 180 degrees of the subject or a super-wide angle will encompass 90 degrees.

10.Twin cameras bottom to top, one with regular film, the other a still video will help when working with models when the model is in constant motion.

During each break in the session, the model and photographer can review the still video on a TV monitor and note changes that need to be made. Because the twin cameras are simultaneously triggered, everything on the disk will be almost an exact duplicate of what is on the film. Video still backs also prove an excellent training aid for assistants in photography schools. It will be possible to take a couple of disks, spend a few hours photographing, and then study the results before reusing the disks the next day. This is especially helpful when trying to learn complex areas of photography

TELEPHOTO

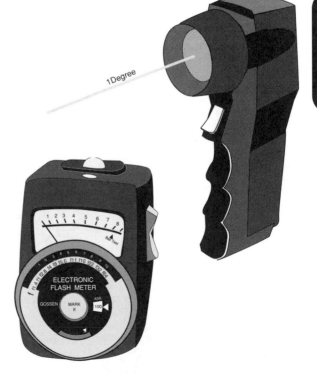

1Degree

ELECTRONIC FLASH METER

GOSSEN MARK II ASA 100

The spot and flash light meters are are the best way to keep light under control

DEPTH OF FIELD

Out of focus

Out of focus

In focus

Depth of field, an optical phenomenon created by the camera lens, portrays the area betwen the foreground and background in sharp focus. In controling depth of field the smaller the f/stop the larger the area in sharp focus. The f/stop is of primary concern rather than shutter speed. As you change the f/stop settings, you also alter exposure.

Large f/stop results in a narrow or short depth of field.

If f/22 lets in............1unit of light

Then f/16 lets in.............2 units oflight

Then f/11 lets in4 units of light

Then f/5.6 lets in16 units of light

Then f/4 lets in32 units of light

f/2.8

7 8 10 12 15

Short
Depth
of field

Foreground
Depth of field Background
Distance to center point

Distance to center of FOCUS

Foreground

Background

FEET 7 8 9 10 15 20 30 40 50 80 100

Long
Depth
of field

As you change F-stop settings you alter exposure

As the f/stop gets smaller the shutter must stay open longer to match the loss of light to the exposure of the image.

Narrow depth of field

Short

f/22

f/8

f/4

Long

Distance to center point

Long depth of field

f/16

3 7 8 10 12 15 20

The Shutter

46

EXPOSURE

Exposure depends greatly on the photographer's accuracy in determining the amount of available light and his understanding of variables such as harsh, direct light, bright sunlight, open shade,

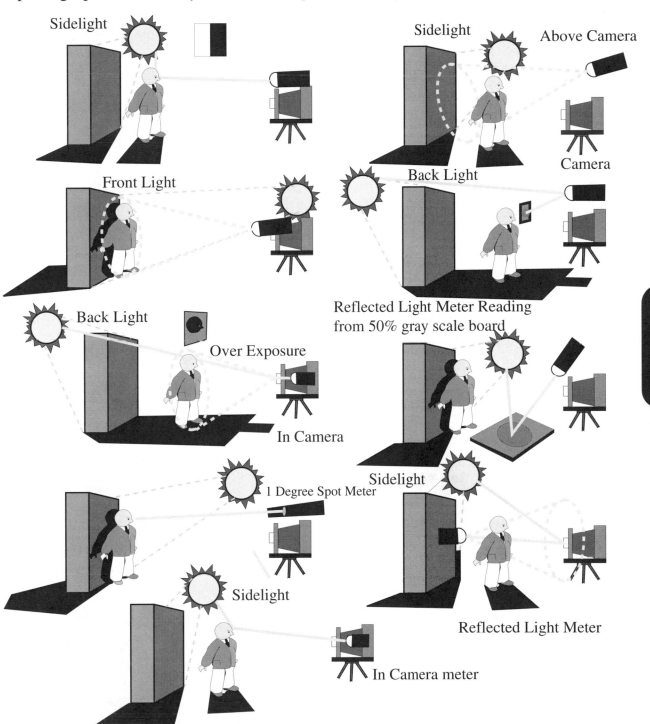

Sun angles and optimal light meter angles for best results in reading available light

late afternoon sun or the vagaries of indoor light. At times it can be difficult to get an accurate light meter reading with a camera which has a built-in light meter due to the fact that it reads the light being reflected off the subject rather than the available direct light. By holding your hand in front of the lens and taking a reading off the palm, you can get a better idea of available light.

CONTRAST

To produce rich luminous prints which depict the character of the subject with maximum effectiveness the photographer must achieve a proper balance between three different kinds of contrast. Contrast in the subject, contrast in the negative and the contrast of the printing.

SUBJECT CONTRAST

"Contrast" is the popular word for what is more correctly called the <u>brightness range</u> of the subject. A subject with high contrast will have a long brightness range. This means that the <u>difference</u> in brightness between the brightest part of the

subject and the darkest part of the subject is great. A subject with low contrast, sometimes called a "flat" subject, has a short brightness range. This means that the <u>difference</u> between the brightest and darkest parts of the subject is comparatively slight.

The brightness range of a given subject is determined by the interplay of three factors:
1. Intensity of the illumination
2. Direction of the illumination
3. Nature of the subject.

Intense illumination alone will not produce a long brightness range. Imagine that you are looking at the beach with the sun coming directly behind you. The subject is very bright but it has a short brightness range because there is nothing dark in the scene. If you now turn so that the sun comes from the side you can see the shadows cast by objects in the scene and the brightness range is greatly increased. If there are dark rocks in the scene along with bright sand and water the brightness range will be increased still more and this points to the third factor

LOW NORMAL HIGH

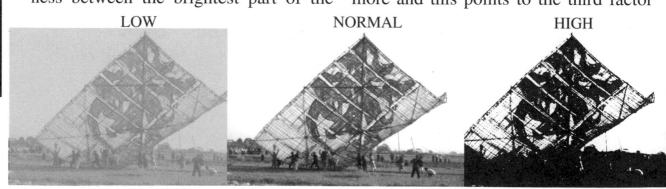

mentioned above. If the same scene is viewed on a cloudy day, the brightness range is greatly reduced. The intensity of the illumination is much less and it has lost its directional quality. On an overcast day the light comes from all parts of the sky so there are no shadows.

NEGATIVE CONTRAST

Contrast in a negative is indicated by the difference between the most transparent and the most opaque parts of the negative. The correct techncal term is the "density scale" of the negative. An over-exposed negative may be very dense in all its parts and still not be of high contrast. On the other hand, an underexposed negative may be fairly thin (transparent) in all its parts and still be of rather high contrast. It is the degree of difference between the light and dark parts of the negative or print that indicates contrast. The contrast in a negative is determined, for the most part, by the brightness range of the subject, the exposure, and the amount of development which the negative receives. In a print it is the amount of ink on the paper.

COMPOSITION

Composition is the arrangement of elements within the picture so that the result is pleasing to the eye. Generally, good composition provides a unity to the picture so that the parts look like they belong together.

The key to good composition is seeing what the camera sees. The human eye and mind "edits" what we see so that what does not interest us, we do not see. The camera sees all. We must "edit" the scene for the camera by selecting the subject, its position, the background we shoot it against, and the lighting under which the subject is photographed.

There are certain forms that beneficial to composition. Lines which converge to a point add depth to the picture, therefore, telephone poles, fences, buildings may be used to add depth to a photograph that is otherwise only wide and tall.

Besides adding dimensionality, composition can add feeling to a photograph. Strong vertical lines tend to add a feeling of strength and alertness, while horizontal lines are more relaxing and soothing.

A curved line, river, road or walkway add a feeling of gracefulness and restfulness. Groups of three tend to add stability. Unification of parts of a photograph may be accomplished with lines, arms, a person's gaze, or simply position. The key to good photography is to unify the elements of a photograph without making the picture stiff, posed, or formal. A major problem in all photography is the elimination of distracting elements. Anything that does not add to the photograpph should be eliminated .

Imagine the area shown in the viewfinder divided into thirds, positioning each man in a third of the frame, thus producing a more dynamic picture.

Rectangular composition refers to the arrangement of forms within the film area. Objects within the rectangle of the photograph are arranged either by placement of the objects or of the photographer or of both.

Usually the first decision a photogra-

pher must make is whether the picture is to be taken in a horizontal or vertical format.

You should experiment holding the camera both ways to see how the selected part of the scene fits into camera's rectangle of exposure. In general, horizontal compositions suggest repose or side ways movement, depending upon the subject matter. The vertical format is most appropriate for the depiction of height, strength, and magnitude.

KEEP IT SIMPLE!

The more objects you include,the greater

your chances are of creating a compositional hodgepodge and technical challenge in making a good exposure,especially in sorting out which objects will be in focus (depth of field).

When there are many elements within the scene, they can be "simplified", rendered as a single impression if they can be related in some way. Individual grapes can be a bunch and three individual men wearing the same uniform can be pilots. Rhythm or pattern can also unify dispar-

ate elements in a photograph. Two subjects in parallel— dolphins, race cars or marching soldiers — impart a feeling of unity. The subjects seem to belong together. Likewise, a wind-blown walker and a flapping flag, if their movements are seen as parallel, can impart this same feeling. I usually try to align near and far subjects in parallel and, whenever possible, align subjects in parallel with foregrounds or backgrounds.

Compositional balance refers to the weighting of different components of the picture in relation to each other, including objects, tonal masses, total contrast, and movement as opposed to the lack of movement. This does not mean that dark must be balanced equally by light. To the contrary, a quiet scene characterized by a great deal of gray or highlights can be balanced by the judicious placement of a single dense or dark object.

Movement within the rectangular area should be inner-oriented. A moving object should not be going off the very edge of the photograph. It looks better coming into the pictorial area from the edge, although it should not be at the very edge. Within the scene, a subject may approach from the background.

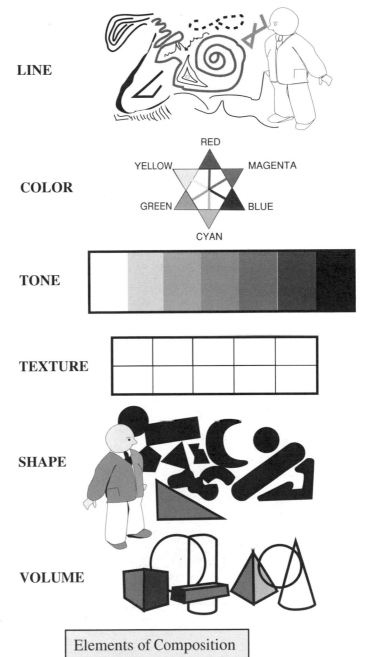

LINE

COLOR

RED
YELLOW — MAGENTA
GREEN — BLUE
CYAN

TONE

TEXTURE

SHAPE

VOLUME

Elements of Composition

51

USE NATURAL FRAMES

Framing adds interest to scenes by accenting subjects and creating the illusion of depth in the two dimensional images. For example, try getting as low as possible and shooting through treebranches or leaves. The subject will be close to center while the frame fills the intersection of thirds. Also, the details of the near frame, in contrast to the details of the far subject give the impression of depth.

BREAKING THE RULES

The rules of photo composition are guidelines only, a bit like the rules of grammar to a good writer. There are people who will defend the rules to the death and photographers who follow the rules will usually make better photographs. Yet, like the writer, a photographer should be facile, know these rules so well that they are intuitive, but he should always make the rules work for him rather than the other way around. Real creativity comes when the rules are knowingly broken to create a particular effect.

PORTRAITS

The portrait photo is more than a passport shot. It reaches inside the subject and finds elusive qualities like personality and character. For effect it can utilize make-up, costuming, special lighting and posing. Ideally, the subject should have photogenic qualities, which include high cheek bones, hollow cheeks, small features, and a clearly drawn chin and jaw line. However, not many people are so endowed, which puts a premium on the photographer's art. With make-up you can complement the contours of natural features, making small eyes a little larger, extending the corners of the lips or building up their apparent thickness if they appear too thin. A photographor can accentuate a person's best features and underplay negative features.

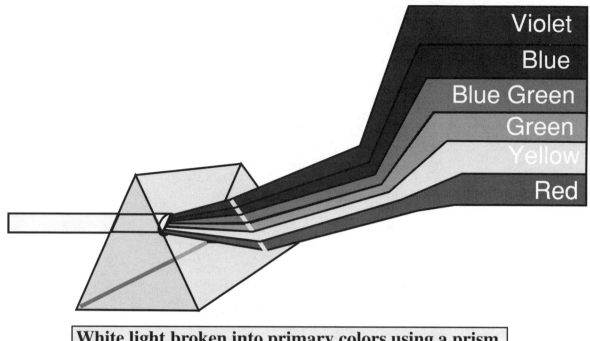

White light broken into primary colors using a prism

Violet
Blue
Blue Green
Green
Yellow
Red

LIGHT

The camera utilizes light energy. Light, generated by the sun, is an energy that travels through space in electro-magnetic waves at 186,000 miles per second. When that light strikes a raindrop, creating a prism effect, it is broken up into a spectrum of colors in a dazzling, transparent rainbow.

There are many different wave lengths of light which make up the different colors of light in the rainbow. This spectrum covers vibrations ranging from short gamma and cosmic rays, through X-rays and ultraviolet radiation, to visible light and the long infrared radar, television, and radio waves. The ultraviolet or infrared cannot be seen by the naked eye but can be seen or recorded by film.

REFLECTION

Everything you see, except from direct light sources like the sun or a lightbulb, is illuminated by reflected light which is light striking a surface and bouncing back toward your eye. When light strikes a smooth surface, such as a mirror, still water, or highly polished metal, it has a definite direction. Rough and textured surfaces such as frosted glass or a heavily made-up face will tend to absorb more light and any reflected light will scatter off in all directions.

REFRACTION

Light's behavior is reasonably predictable in that it always travels in a straight line until it encounters anything with a

different density than air, whereupon it will <u>refract</u> or bend. Just as light bends when it strikes water, it also bends when it goes through glass, losing some of its intensity as a small amount is reflected away. At the same time that you have a refraction of light, you also have a greater or lesser degree of reflection depending upon the surfaces—smooth or rough.

ABSORPTION

Any particles in the air or underwater, visible or microscopic, will absorb some of the available light. Black absorbs light and white reflects light.

CLEAR UNFILTERED CONDITIONS

Smoke, dust particles, smog, steam, anything which floats in the air will diffuse light and reduce the illumination on your subject. Enviorments with clear air such as high altitude mountains or near the

LIGHT THROUGH PARTICLES & AIR

EARTH

ATMOSPHERE

Light being absorbed in the atmosphere; the longer the distance, the less light reaching the subject.

Light reflecting and absorbing on glass

ocean, have an abundance of unfiltered light. Your subjects will be a more intense color, there will be more reflections, and sunlight will be brighter— all conditions conducive to overexposure of film, particularly if you are using slide film, or a digital camera which has the least tolerance for overexposure or underexposure.

The solution is to keep a constant vigilance over the environmental conditions. Many amateur photographers produce washed-out photographs taken near the glare of snow or water. If using slide film, a precautionary measure would be to set the camera's aperture an f-stop or two lower than actual lighting conditions require or speed up the shutter speed to account for bright conditions. If you have the time, you may "bracket" by taking a shot at the apparent normal exposure. Follow with two more shots, one at the f-stop higher than normal exposure and one at the f-stop lower than normal exposure.

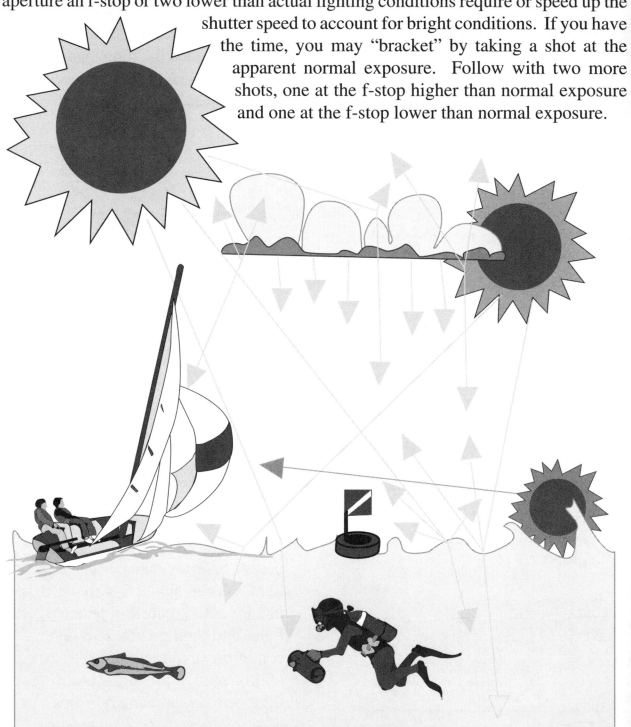

Light Being Diffused By Reflection And Absorption off Water Clouds

DIRECTIONAL LIGHT

Directional light, the most harsh, comes directly from the sun, through clear, unfiltered air or is reflected off water, snow, clouds, or white objects such as buildings or boats. Photographs shot in bright, directional light will have more brilliance and contrast. This type of light emphasizes the surfaces and planes of your subject.

NON-DIRECTIONAL LIGHT

Light becomes less directional as it penetrates an atmosphere containing dust, smog, and other minutiae. These particles steal away the light. Your subjects will appear rounder and softer in non-directional or soft light. If you want these effects when taking a portrait, place the person in the shadow of a white curtain or sail where the light is more filtered rather than direct. Most portaits are best done in non-directional light as features appear softened.

LIGHT AND COLOR
HOW YOU INTERPRET IT

You, the photographer, can use equipment, filters, lighting and selecting the appropriate time of day to achieve marvelous creative images if you understand how we really see light. Again, when white light strikes suspended particles of water, such as raindrops, it breaks up into the individual primary colors of red, blue and green creating a prism or rainbow effect. These primary colors are always present in projected light, either from a lightbulb or the sun or TV screen but are not always visible.

WHAT THE EYE SEES

The radiation that the human eye responds to as opposed to the full spectrum that can be photographed with a camera, falls into a tiny portion of the electromagnetic spectrum, between ultraviolet and infrared. The brain is not too fussy about what it perceives as white light and is actually quite willing to accept a garden variety of wavelengths in the visible spectrum as white light. If you photograph white house in the early morn- or late afternoon, using color transparency film, you would be shocked at the redness of the light which your eye perceived as white. Your brain remem-

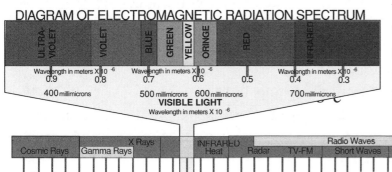

Electromagnetic spectrum

DIAGRAM OF ELECTROMAGNETIC RADIATION SPECTRUM

bers the way something should look and then automatically compensates for environmental changes in color. You know through experience that the house is white but the film will honestly record it changing from red to blue to red, throughout the day, as the color temperature changes.

One of the great advantages of using color negative film, such as Kodacolor, is that it not only records a broader spectrum of light (greater latitude), but also allows you to remove unwanted color through filtration. You can restore white back to white. A film of narrow latitude, such as Ecktachrome, cannot be color corrected after exposure unless it is subjected to being digitized and recolorized in a computer photo processing program.

KELVIN SCALE MEASURES COLOR TEMPERATURE

In order to take photographs with good color, it is necessary to know the color temperature of the illumination present and to match film and filters to that temperature. Refer to the temperature chart of common light sources and illumination.

Color temperature reading is measured on the Kelvin scale, commonly used by physicists and serves as a standard comparative measure of the wavelengths present in the light we see. The temperature of the light source, in addition to its composition or makeup, determines what colors of light are emitted. Light or low temperature, such as that of a candle burning at 1,900K., has more red wavelengths. Skylight, from 1,100K. to 1,400K., has a maximum of blue wavelengths. Unless color film is chosen to match the light present when the exposure is made, the photograph will have a cast of either too much red or blue. Imbalancing light colors are found particularly early and late in the day when light is reddish (low temperature). The digital camera excells in low light conditions.

CHECKING TEMPERATURE

Most photo flash and floodlights are marked with their color temperature. For unusual lighting situations, you may use a color temperature meter, which can help you determine when filters are necessary to achieve color balance

FLUORESCENT LIGHTING

Some lighting situations, such as those with fluorescent lights, are near impossible to gauge. These lights give off concentrations of one or a few colors so that they present to the camera's eye a

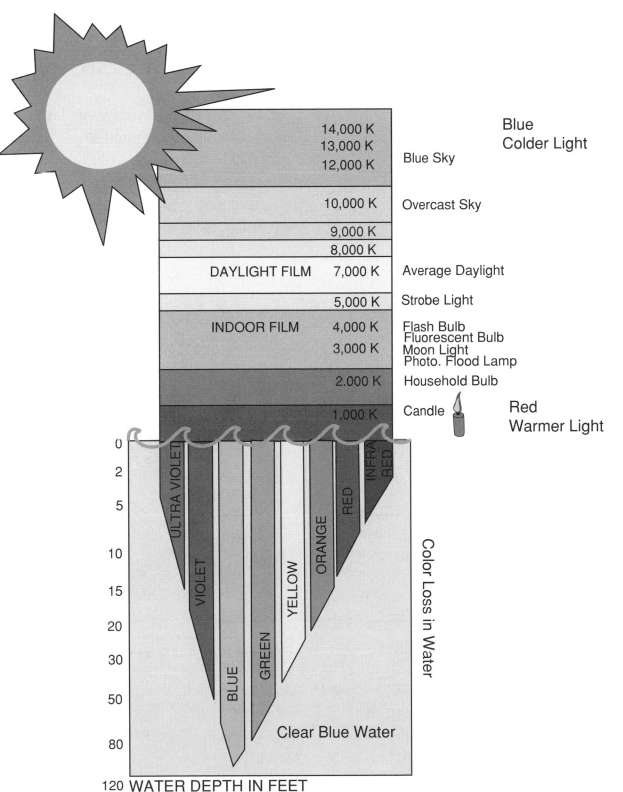

14,000 K
13,000 K
12,000 K — Blue Sky

Blue
Colder Light

10,000 K — Overcast Sky

9,000 K
8,000 K

DAYLIGHT FILM 7,000 K — Average Daylight

5,000 K — Strobe Light

INDOOR FILM 4,000 K — Flash Bulb
Fluorescent Bulb
3,000 K — Moon Light
Photo. Flood Lamp

2,000 K — Household Bulb

1,000 K — Candle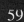

Red
Warmer Light

0
2
5
10
15
20
30
50
80
120 WATER DEPTH IN FEET

ULTRA VIOLET
VIOLET
BLUE
GREEN
YELLOW
ORANGE
RED
INFRA RED

Color Loss in Water

Clear Blue Water

KELVIN SCALE MEASURES COLOR TEMPERATURE

discontinuous spectrum heavy in blues and greens. In a frustrating attempt to photograph decorative lighting panels hung over fluorescent lights several years ago, we ended up with blueish prints, in spite of the use of a 40 CC magenta filter on the camera lens. To the eye, the panels looked white but the camera recorded the erratic wavelengths of light which refused to be tamed by filters. Fortunately, correcting for this kind of color imbalance is easy with a computer based image processor.

ARTIFICIAL LIGHT

The electronic strobe, virtually a flash-bulb that can be used many times over, comes with varying power outputs. The more expensive units have faster recycling times, which are also dependent upon how much power has been drained from the battery during use. There is a certain limit to the number of flashes per battery or charge.

The color balance of an electronic flash is equivalent to daylight. However, as the distance between you and your subject increases, the color balance falls off. The brilliance of colors weakens when you get beyond seven feet from your subject.

All cameras, particularly single-lens reflex cameras, must be switched to X-synchronization when you are planning on using electronic flash. Check your owner's manual for the recommended shutter speed.

MANMADE SUNSHINE
IN LOW LIGHT

The use of flash and strobes and all artificial lighting is best limited to extreme low light conditions when your photographs are in danger of being underexposed. Available light will always give better results. Artificial light can flood the subject

Strobe Light

Tiger Eye

Umbrella, camera, and strobe

unflatteringly if the photographer does not understand its potential effects.

Your goal should be to keep the lighting as natural as possible. Listed below are methods that make the use of artificial lighting more natural by diffusion of light.

STEPS TOWARD EFFECTIVE USE OF ARTIFICIAL LIGHT

1. Direct strobe or flash at a white surface such as a wall or curtain rather than at the subject.

2. Direct the stobe or flash through a piece of translucent plastic hand held across or attached to the strobe unit. Some flash units have a clip-on piece for this purpose. This method is best for portraits as it directs more of the light to the subject than Method 1.

3. The least desirable location for a strobe or flash is on top of the camera as it generalizes the light and is likely to give pink eyes to your subjects when color film is used. By shooting at different angles, with the strobe or flash unit strategically placed, you can create desirable shadows and keep the lighting close to your subject, thereby assuring more intensity.

4. You can stretch a piece of nylon stocking over a strobe unit (do not place over flash bulb) to diffuse the light and tone down harshness.

5. The inverse square law: The intensity of light changes inversely with the square of the distance between light sourcc and subject. At two feet, each square foot of subject area receives only 1/4th the light that a single square foot receives at one foot.

CALCULATING EXPOSURE WHEN USING STROBE LIGHTING

When you are using strobe lighting you cannot determine correct exposure by taking a light meter reading since the electronic flash of light is 1/1000th of a sec-

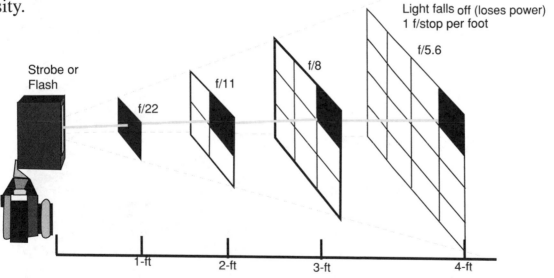

Light falls off (loses power) 1 f/stop per foot

f/5.6

f/8

f/11

f/22

Strobe or Flash

1-ft 2-ft 3-ft 4-ft

As artificial light (strobe) falls off, F-stop must adjust 1 F-stop per foot

ond or faster. You can calculate exposure by using the exposure guide/calculator that comes with your particular strobe unit. The distance from the strobe light to the subject is the most critical aspect of exposure when using artificial light. Or you can determine correct exposure by taking a light meter reading using a strobe light meter.

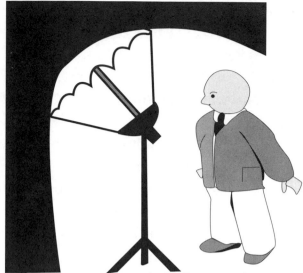

Example: f/4 f/stop opening
Film 100 ASA
SUBJECT SIX FEET FROM CAMERA
SHUTTER SPEED XOR 1/30 OF SECOND

EXPOSURE LATITUDE TABLE

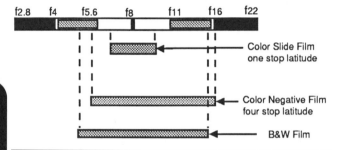

The exposure latitude for color negative film and black and white film has a wider latitude to expoure than slide film

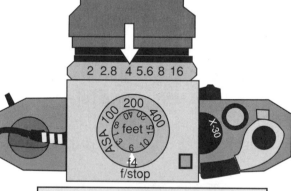

Strobe calculation on the camera

TESTING FOR PROPER EXPOSURE

Your strobe's guide/calculator may not be adequate to inform you about use of artificial lighting. In place of a light meter develop your own scale for your own strobe unit in conjunction with its calculator exposure guide. The test given below will allow you to determine the f-stop settings for certain distances, extremely important since the f-stop and distance from light to subject are what controls the ultimate exposure.

Camera shot on white out table

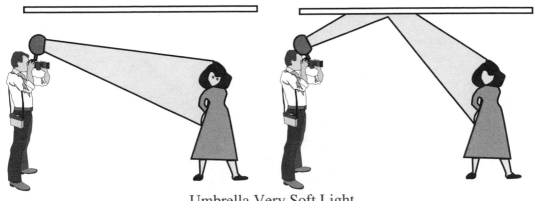

Umbrella Very Soft Light

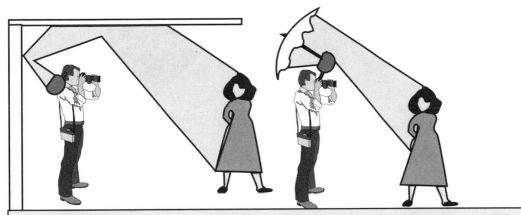

Diagram shows how to bounce flash to light subject from side and soften light

63

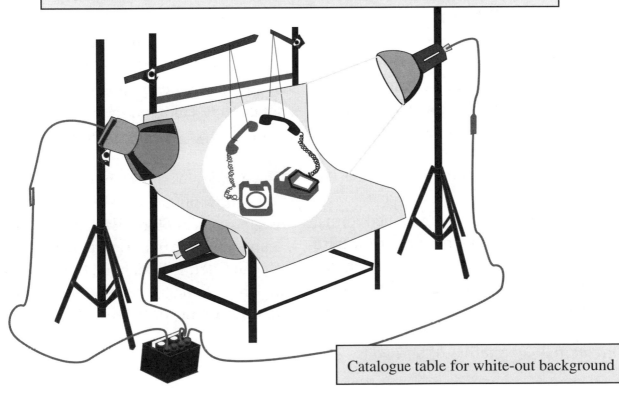

Catalogue table for white-out background

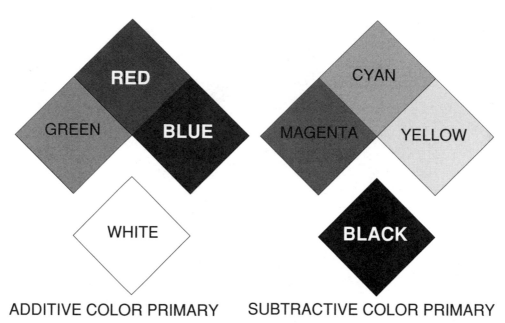

PRIMARY COLORS

RED

GREEN BLUE

WHITE

ADDITIVE COLOR PRIMARY

Additive primary colors combine to produce
WHITE light.

SECONDARY COLORS

CYAN

MAGENTA YELLOW

BLACK

SUBTRACTIVE COLOR PRIMARY

Subtractive primary colors combine to produce
BLACK light.

CONTROLLING LIGHT WITH FILTERS

With filtration you are attempting to recreate the balance of the color in the direct light present when the picture was taken. White light consists of equal parts of red, green, and blue, (RGB) those colors known in photography as the additive primaries.

Two of these primaries combined form a color which is complementary to the third primary. For example, red light plus green light makes yellow light, which is the complement to blue light. Any two of these additive colors can be mixed to create the subtractive or secondary colors: cyan, magenta and yellow. The interaction of the additive primary colors in photographic light sources and the subtractive colors in the filters form the controls necessary in color photography.

Three diagrams show why cyan, magenta, and yellow pigments in filters are known as subtractive colors. Each one blocks or "subtracts" one of the additive primaries. A cyan filter, for example, blocks the red in white light. The amount it blocks depends on the density of the filter.

FILTER COLORS

A magenta filter is made up of equal parts of red and blue; a yellow filter is made of equal parts of red and green; and a cyan filter is made up of equal parts of blue and green. If you add a magenta filter to the filter pack, you will be subtracting its complementary primary color, green, from the white light. Magenta itself has no green. If you add any one secondary color, you automatically weaken its complementary primary color, thereby strengthening the other two remaining primary colors, which in the above case will be blue and red. If there is too much blue light passing through the lens onto the screen and you want to reduce it, place a yellow filter into the pack and the blue will be weakened. Listed below are the possible filter combinations. I recommend thinking of all filters in terms of magenta, yellow, and cyan. If you were to use the red, green, or blue filters, you would find that they may not correspond exactly to their subtractive colors. The color balance will not necessarily be the same.

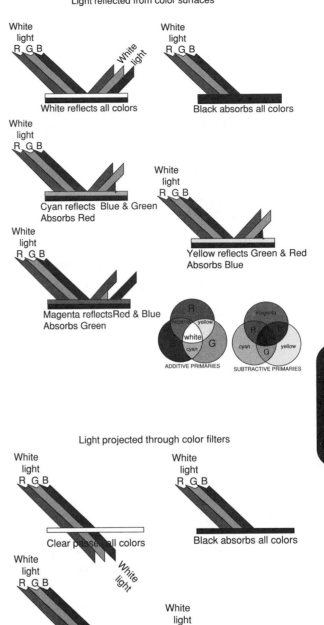

Light reflected from color surfaces

White reflects all colors

Black absorbs all colors

Cyan reflects Blue & Green
Absorbs Red

Yellow reflects Green & Red
Absorbs Blue

Magenta reflects Red & Blue
Absorbs Green

ADDITIVE PRIMARIES

SUBTRACTIVE PRIMARIES

Light projected through color filters

Clear passes all colors

Black absorbs all colors

Cyan
stops Red & passes Green Blue

Yellow passes Green & Red

Magenta
Passes Red & Blue
Absorbs Green

ADDITIVE PRIMARIES

SUBTRACTIVE PRIMARIES

65

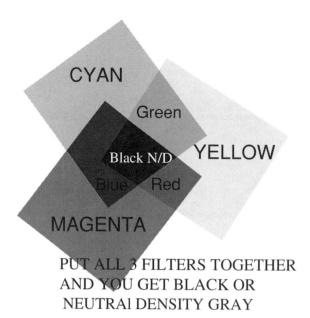

CYAN

Green

Black N/D YELLOW

Blue Red

MAGENTA

PUT ALL 3 FILTERS TOGETHER
AND YOU GET BLACK OR
NEUTRAl DENSITY GRAY

PHOTOSHOP COLOR BALANCE

Filter Combinations

A RED FILTER (absorbs blue and green)
or is equivalent to

a YELLOW FILTER (absorbs blue)

a MAGENTA FILTER (absorbs green)
a GREEN FILTER (absorbs blue and red)
a YELLOW FILTER (absorbs blue)

a CYAN FILTER (absorbs red)
a BLUE FILTER (absorbs green and red)
a MAGENTA FILTER (absorbs green)

a CYAN FILTER (absorbs red)

For an experiment, stack the magenta, yellow, and cyan filters together holding them over a sheet of white paper. Move the bottom filter away. What color is left? Pull out the next filter separately. This simple exercise will familiarize you with what happens in the enlarger. Since an enlarger bulb provides low temperature light, no higher than 3,300K., it is high in red and yellow. Therefore, most of the time the filter pack is balanced with magenta and yellow. Cyan is rarely used because it contributes a blueish cast .

In color photography, the use of filters is necessary to obtain optimum color balance from each negative, but it is important to remember that the more filters you use, the greater the density. When light is projected through several filters, definition is weakened by the scattering of light so you will be reducing brightness and detail on your print.

66

REFLECTED LIGHT PRINT VIEWING

Your viewing light source will greatly influence the appearance of colors. Fluorescent lighting is the least desirable source to use when viewing prints unless those particular prints will always be shown in that environment. It is best to critique a print using incandescent light. When a color print is "finished" but does not look natural, it is said to have a color cast. This appearance may be due to too much yellow, blue, red, or an incorrect color balance. It can have too much of any one of the three additive or subtractive primary or secondary colors. Think of it as being an over-exposure or under-exposure of one or more of the paper emulsion layers. It will be helpful if you learn to recognize color casts at a glance.

Viewing prints using Kodak viewing filters to check proper color balance

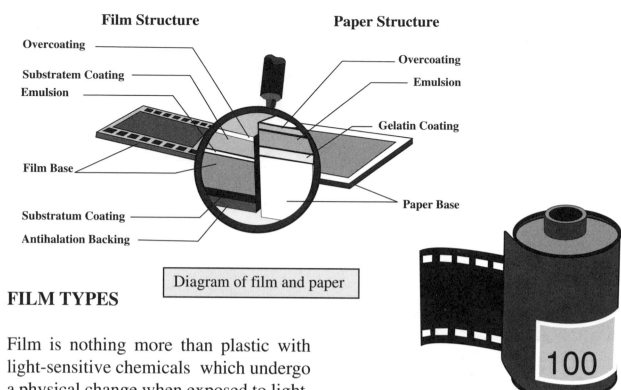

Film Structure

- Overcoating
- Substratem Coating
- Emulsion
- Film Base
- Substratum Coating
- Antihalation Backing

Paper Structure

- Overcoating
- Emulsion
- Gelatin Coating
- Paper Base

Diagram of film and paper

FILM TYPES

Film is nothing more than plastic with light-sensitive chemicals which undergo a physical change when exposed to light. There is no all-purpose film as each film has a different sensitivity to light or ASA. Films with an ASA of over 100 are called fast films (very sensitive to light); films with an ASA of under 30 are considered slow. If there is not much light you will need a fast film to take advantage of all available light. If natural light is low and your light meter indicates that you cannot take a picture with your ASA 400 film, you can increase your ASA to 600 or 800, thereby changing the development time. Be sure to notify the processors of the new ASA. The resulting photographs will be more grainy. As an alternative to the above, I keep a few rolls of Tri-X black and white film to be used in extremely low or limited light conditions. This film also needs special development. To be certain of how a film performs under all conditions, choose one type of film and use it extensively. You will observe the effects of light when you shoot indoors, resulting in softer images as opposed to outdoors, resulting in harsher images even though you may be using the same film type. By selecting various ASA films with regard to the available light in your shooting environment, you can reduce your use of flash and strobe, giving a more natural quality to your photos besides reducing the use of extra equipment.

FILM SELECTION

The selection of film is one of the most important factors in taking a good photograph because it determines what the final result will be. Keep the shooting environment in mind. A film that is very sensitive to light such as 400 ASA is recommended for indoor shooting but is unsatisfactory when shooting in bright sunlight.

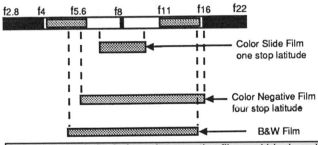

EXPOSURE LATITUDE TABLE

The exposure latitude for color negative film and black and white film has a wider latitude to expoure than slide film

TRANSPARENCIES

Secondly, in making your film choice, determine whether your end result will be transparencies (35mm slides), prints, color, or black and white. The case to be made for color transparencies is that you have a finished product after development of the film and, by using a simple viewer, you can choose the shots to be made into prints or negatives. The results are also compact and easy to store. Any color transparency film is quite sensitive to exposure due to its narrow latitude, so light meter readings must be noted carefully. Other color films are more forgiving.

COLOR

Color transparencies are less expensive because they can be used to make black and white prints, color prints, and still be shown as slides. The color negative can not be used to create all of these different results.

FILM CARE

Film should be kept out of heat and sun. If you want to render your film useless, put the loaded camera or film box in the sunny window or your car's dashboard. When keeping film for long periods store it where it will be cool and free of moisture, such as in a freezer. Before use, let the film warm up for 24 hours. You can keep film in a styrofoam ice chest with silica gel to keep it dry when traveling. Or you may use the plastic food pouches that can be heat-sealed with an inexpensive unit purchased in hardware and department stores.

EXPIRATION OF FILM

Film suffers deterioration with age, although, if you keep film cool and dry, you may assume it is still good after the expiration date on the film box. When purchasing film, this expiration date should always be noted because the manufac-

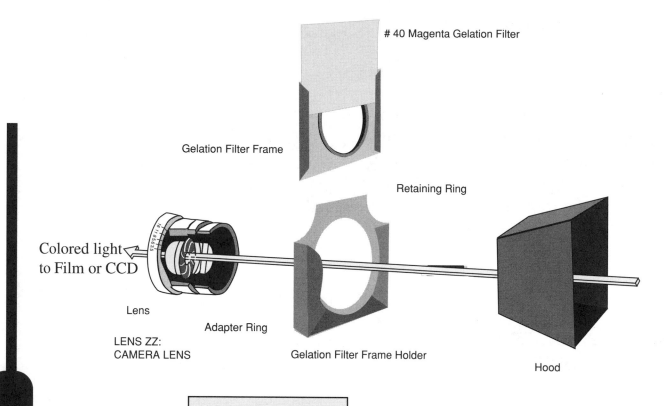

40 Magenta Gelation Filter

Gelation Filter Frame

Retaining Ring

Colored light
to Film or CCD

Lens

LENS ZZ:
CAMERA LENS

Adapter Ring

Gelation Filter Frame Holder

Hood

Gelation filter frame

turer will not stand behind the film after that date.

FILTERS

All light is naturally filtered as it travels through the atmosphere, encountering particles of dust, moisture, smog, and other minute obstacles. This penetrating light weakens in intensity, changes color many times over and, ultimately, as it reaches great depth in bodies of water, only blue light remains. All the other colors of the light spectrum have been absorbed. Artificial filters are used to control not only the character but also the color of light reaching the film. As the photogra-

pher encounters naturally filtered light, he often wants to restore a missing color or shade. For instance underwater, red light is filtered out at ten to fifteen feet. A color filter can be used to restore human skin to its natural pinkish color. Without the use of this filter underwater, skin would appear bluish.

POLARIZING FILTERS

Just as normal wave lengths of light change color, they also break up into many planes as they strike minute particles of dust, moisture, and smog. Light, reduced to vibrations on one plane, by artificial or optical means is

polarized. A polarizing filter may be regarded as an optical picket fence. As light passes through the "pickets", all but one direction of vibration is eliminated.The filter removes objectionable reflections when you are photographing near water, through a window, or trying to make a sky appear a deeper blue so that the white clouds look more dramatic.

HOW TO USE

While looking through the filter, rotate until the unwanted reflections are eliminated and then, not changing the filter's position, place it over the camera's lens. With a single-lens reflex camera, the filter can be adjusted while on the camera. Obviously, polarizing filters eliminate a considerable portion of the light waves since they pass only those vibrating in one direction; thus, when a polarizing filter is used over a lens, exposure must be increased to compensate for loss of light. In a single-lens reflex camera with a built-in light

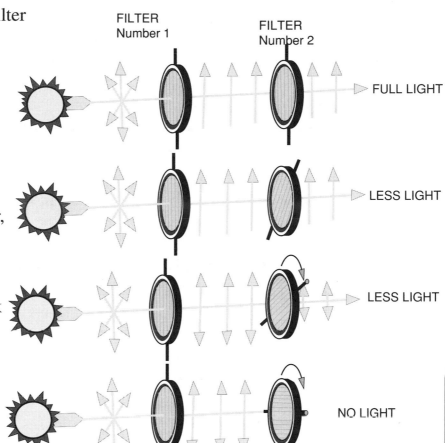

FILTER Number 1

FILTER Number 2

FULL LIGHT

LESS LIGHT

LESS LIGHT

NO LIGHT

POLARIZED LIGHT BY USING POLARIZING FILTERS

LIGHT BEING POLARIZED BY REFLECTION

30 degrees TO 35 degrees

30 degrees TC 35 degrees

NONMETALLIC SURFACE

When using filters to polarize natural light coming from all directions, you need to use two polarizing filters. By adjusting the filters at different angles you can control light reflections

meter there is automatic compensation.

ULTRAVIOLET FILTERS

For long-distance shots and overcast days, the skylight filter is used to remove part of the blue of light; however, the filter is barely noticeable as to the amount of correction. It is used most extensively as a lens protector because it is less expensive to replace than a camera lens that has been scratched or hit repeatedly. Many photographers keep this filter semi-permanently on their cameras.

An ultra-violet filter removes those light rays, giving deeper penetration and the illusion that you can see more clearly and deeply into haze. This filter is also used as protection for camera lenses.

SPECIAL EFFECTS FILTERS

There are a number of special effects filters which work for black and white or color, each one used to create an unusual effect such as multiple images, diffusion of images or vari-colors.

CLOSE UP PHOTOGRAPHY

Close-up photography is used to capture details which would be lost with standard, minimum focusing. An insect, an exotic stamp, a tightly machined industrial part are all subjects calling for close-up shots. Most camera lenses focus down to approximately two feet. To get closer, as with macro photography, you may require one of the specialized lenses or attachments discussed below.

CLOSE-UP LENSES

Close-up lenses (diopters) are magnifying lenses which can be easily attached to the front of the regular camera lens, allowing focusing at a much closer distance than normal. By the addition of a close-up lens the camera-to-subject distance can be reduced to a few inches. Close-up lenses are relatively inexpensive, light and can be used on all cameras, making them one of the most versatile of the types of equipment used for macro photography.

These lenses come in different sizes and refractive strengths. The size of the lens must be matched to the size of the filter ring on the camera lens. A 52mm close-up lens will fit a 52mm camera lens. The higher the number of the lens, the greater the power.

For instance, a #4 will allow you to effectively get closer to your subject than a #1. It is possible to stack as many as three lenses or diopters together to shoot at still closer distances. When stacking close-up lenses, always mount the stronger lens nearest the camera.

CLOSE UP - LENS (Diopters)

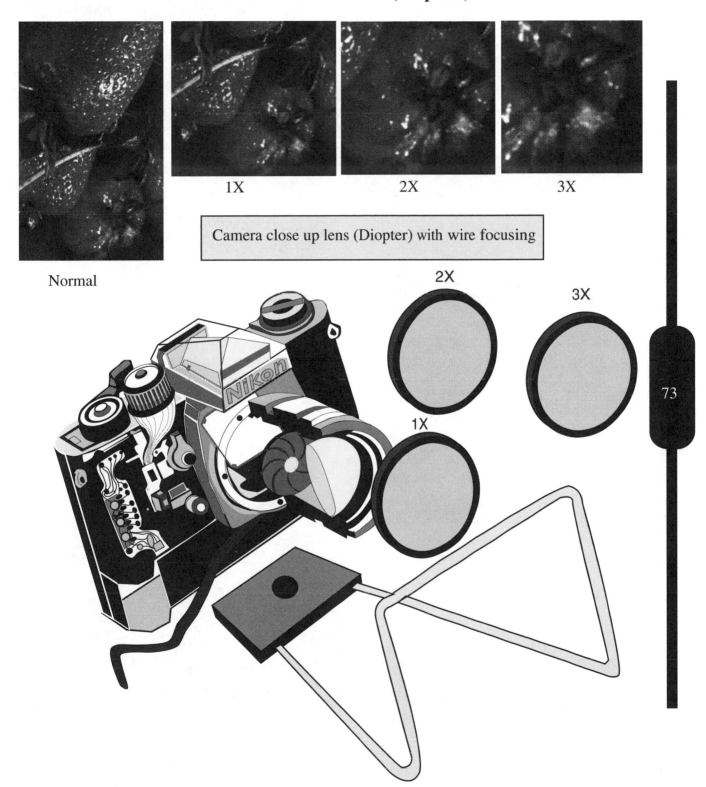

1X

2X

3X

Normal

Camera close up lens (Diopter) with wire focusing

2X

3X

1X

73

74

N.A.S.A.digital camera photos

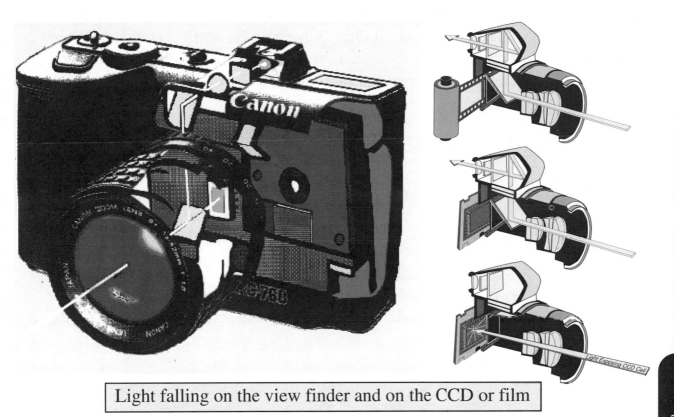

Light falling on the view finder and on the CCD or film

CHAPTER V, DIGITAL CAMERAS

Still video cameras look like oversized 35mm cameras, but instead of recording images on film, they use a two-inch video floppy disk that fits into the back of the camera. Where the film would ordinarily be, there is a charge-coupled device (CCD) that senses color and light and converts images to a video signal using an analog format based on television's NTSC standard. The view finder is a tiny screen that shows what the CCD is seeing and the shutter button is a contact switch that tells the internal disk drive to record.

Still video offers the 35mm camera freedom to capture images of any object from any angle you choose with one major enhancement - because the images are recorded electronically, they can be stored, transmitted and edited directly. Applications like desktop publishing, multimedia, and image databases are all enhanced by the flexibility and convenience of this technology. News photographers can snap pictures electronically and file them via telephone without having to process film. People with computers are discovering these cameras

offer more than acceptable results for low-resolution printing, screen presentations, and multimedia presentations. Captured images can be used for high-resolution production at small sizes.

CCD CHIP-HOW IT WORKS

The CCD chip is the equivalent of a piece of film with the ability to electronically record what the lens of the camera has seen. These small photosensitive chips have positive and negative poles to which a single charge is delivered when the diode is struck by light. Thousands of light sensitive diodes are arrayed on a single CCD chip. Similar to the devices found in video camcorders, still video camera CCD's capture an image in hundreds of thousands of pixels. A typical 660 line picture will contain 400,000 pixels that measure the intensity and color of the

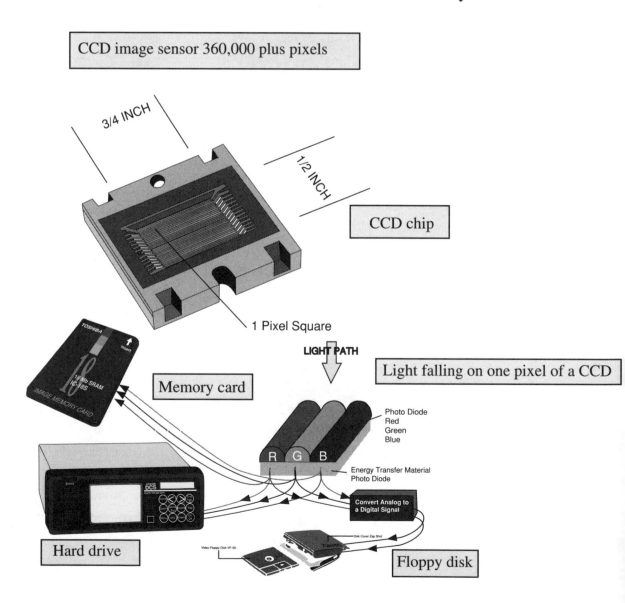

CCD image sensor 360,000 plus pixels

3/4 INCH

1/2 INCH

CCD chip

1 Pixel Square

LIGHT PATH

Light falling on one pixel of a CCD

Memory card

Photo Diode
Red
Green
Blue

R G B

Energy Transfer Material
Photo Diode

Convert Analog to
a Digital Signal

Hard drive

Floppy disk

CCD Structure

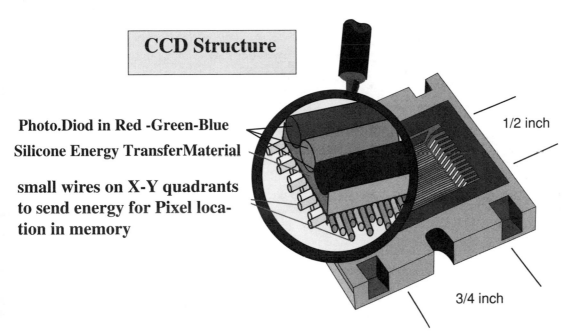

Photo.Diod in Red -Green-Blue

Silicone Energy TransferMaterial

small wires on X-Y quadrants to send energy for Pixel location in memory

1/2 inch

3/4 inch

Film Structure

Paper Structure

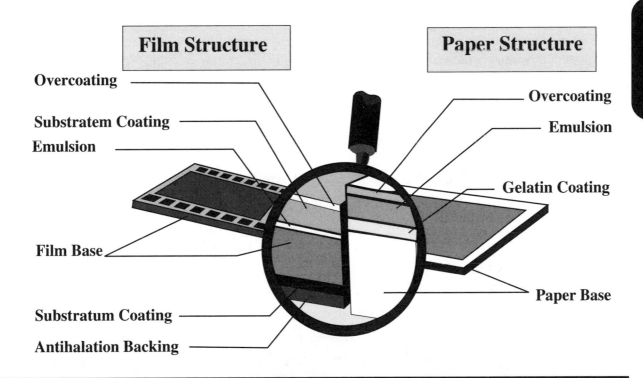

Overcoating

Substratem Coating

Emulsion

Film Base

Substratum Coating

Antihalation Backing

Overcoating

Emulsion

Gelatin Coating

Paper Base

Enviornmental problems; traditional film is cheaper at first, but the cost of film (and film processing) adds up quickly. There is an environmental factor to consider as well. Film and processing is very toxic creating up to a gallon of chemical sludge for each 24-exposure roll.

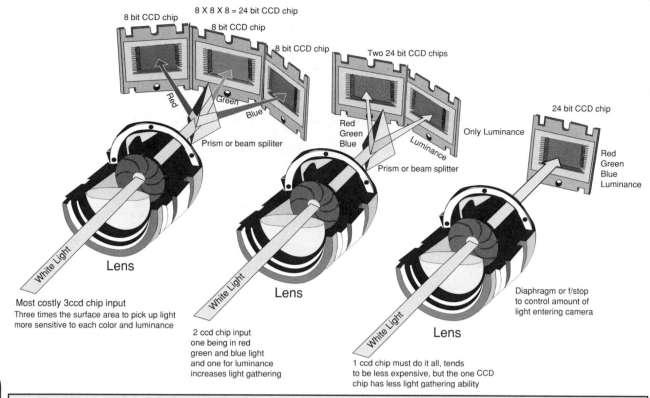

8 X 8 X 8 = 24 bit CCD chip

8 bit CCD chip

8 bit CCD chip

8 bit CCD chip

Red

Green

Blue

Prism or beam spilter

Most costly 3ccd chip input
Three times the surface area to pick up light
more sensitive to each color and luminance

White Light

Lens

Two 24 bit CCD chips

Red
Green
Blue

Luminance

Only Luminance

Prism or beam splitter

White Light

Lens

2 ccd chip input
one being in red
green and blue light
and one for luminance
increases light gathering

24 bit CCD chip

Red
Green
Blue
Luminance

Diaphragm or f/stop
to control amount of
light entering camera

White Light

Lens

1 ccd chip must do it all, tends
to be less expensive, but the one CCD
chip has less light gathering ability

A superior method for recording color to CCD circuits is to split the incoming light with a prism so that each primary color of red, green, and blue falls on a separate CCD. As this method requires a more elaborate array of CCD circuits, cameras like this will be more expensive.
One Sony electronic still camera uses somewhat of a compromise between the two methods. The ProMavica 5000 uses a two CCD solution; one CCD registers only luminance, and the other has a red/ green/blue filter to measure the color.

image. Diodes sensitive to red, green, and blue light create a combined signal to provide the actual lines of the image. The images are then stored as analog information, in a format based on television's NTSC format. SV camera "pictures" are stored on a standard two inch video floppy magnetic disk using the concept of frames and fields. A single image is drawn in two passes of an electron gun. First, the odd horizontal lines of the frame are drawn, then the even lines. The two passes are known as the "field" and "frame."

A single floppy disk can hold 25 frame pictures, each made up of an even and an odd field. But by storing images as only one field (called a hem image), a disk can hold 50 pictures. The horizontal resolution is halved because one field, or half the horizontal lines, are removed. When displaying the pictures, the "missing" lines are created either by duplicating each line, or by interpolation (averaging between two lines to create a middle line). Interpolation provides a better looking image with a visible stair step effect, but the

resolution of the images is still the same. While professional units will store frame and field images, the consumer units, such as Canon's Xapshot and Sony's Mavica, store one field image. The limits to still video are in its resolution on the CCD sensorchip. The mid-market units tend to have around 750 pixels on the horizontal axis and around 500 on the vertical, giving a range of about 400,000 to half a million pixels for a single image. By contrast, there are between ten and twenty million grains in a 35mm frame, depending on film type. The difference can be dramatic.

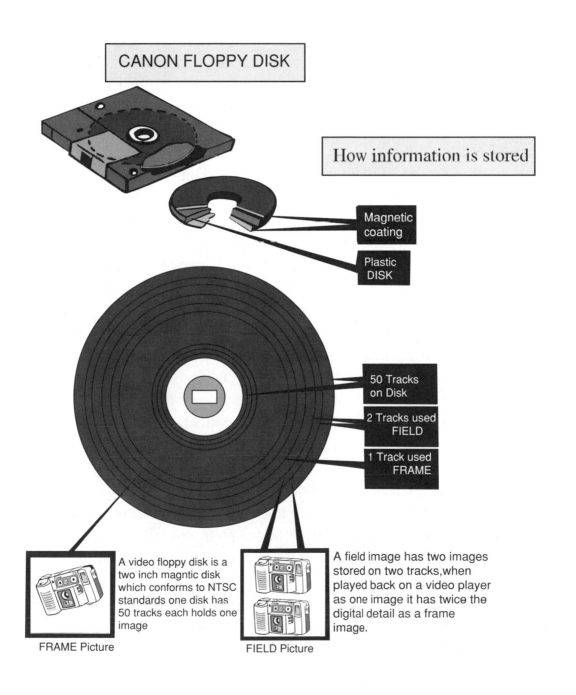

CANON FLOPPY DISK

How information is stored

Magnetic coating

Plastic DISK

50 Tracks on Disk

2 Tracks used FIELD

1 Track used FRAME

A video floppy disk is a two inch magntic disk which conforms to NTSC standards one disk has 50 tracks each holds one image

FRAME Picture

A field image has two images stored on two tracks,when played back on a video player as one image it has twice the digital detail as a frame image.

FIELD Picture

ADVANTAGES AND DISADVANTAGES OF DIGITAL CAMERAS

Digital cameras and CCD's offers a number of advantages over film. The images are recorded quickly and easily and can be displayed on a television monitor, or immediately digitized using a frame grabber. The disks can be erased for reuse, or stored for several years, though they are not an archival medium. (Like other magnetic media, the length of time these disks will last is dependent upon a number of variables such as use and exposure to magnetic fields).

On the down side, the SV camera design includes a number of compromises. While the CCDs used to capture the image have the same approximate resolution as the final image (about 640x480), each pixel is only sensitive to one color, so the information of several pixels must be combined and averaged to calculate the actual image. The second compromise is in recording the images onto the floppy disk which store the image in an analog format. More like audio or video tapes than disks, still video disks store very little data when compared to the same sized digital disks used in laptop computers. And because the disks are so small they have to compress (in other words, discard) some of the color resolution. The effect of this is visible in high contrast situations and can appear as ghosting at color boundaries. Another limitation is the recording process itself. Because it's an analog format just like magnetic audio tape, the recording process can introduce noise, which is most visible when the picture's signal is at the limits of the recording medium. This would be most visible in recording pure whites.

HISTORY OF ELECTRONIC PHOTO

Electronic photography was pioneered by Sony in 1981 when they introduced the first Mavica. Now, virtually every major camera and video power is involved in still video, including: Sony, Canon, Kodak, Minolta, Nikon, Panasonic, Casio, Konica, Olympus, Fuji, Hitachi and Polaroid. These companies watched nervously as Beta and VHS divided the video world in the early part of the decade and determined to set up a standard format before the rush began in earnest. This was created by something called the Electronic Still Camera Standardization Committee, which agreed on a 2 inch disk format and all the concomitant electronic nuances. Photojournalists, particularly news photographers, were the first to embrace the new technology. Using film transmitters and the telephone, a news shooter could file captioned photographs with the newspaper's photo editor in minutes. Without having to rush back to a lab to process film, a photographer could stay with a breaking story longer and still make deadline. The editor, sitting at an electronic photo desk, could quickly screen the shooter's work using his transmitted index and pick the shot best suited for the story. And publishers loved

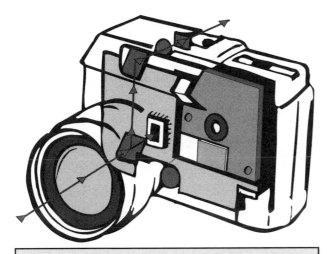

The original CCD still Sony camera

the new technology. Not only was it fast, it was cheap. Silver based photographic materials are expensive.

HOW TV CAMERAS WORK

A TV camera works like a TV set, only in reverse. Instead of making light, it senses light. The camera lens focuses the image of a scene onto a light sensitive pick-up tube or CCD chip in the camera. This tube is shaped like a miniature TV picture tube and works in a similar way. The inside surface of the tube is sprayed with electrons which stick to the place where the dense image is projected. Wherever light strikes the tube, the electrons get "bumped off"; thus the light and dark parts of a scene create "bare and full" places on the pick-up tube's surface. Inside the camera tube, an electron gun zigzags in the same pattern as the TV's electron gun did, only this gun knocks off the remaining electrons as it scans back and forth. As they are

shot off, the electrons are collected, counted, and turned into electric vibrations which are video signals.

These signals go to your TV set and tell its electron gun to "shoot, don't shoot." Thus the light and dark parts of the original scene become "shoot, don't shoot" commands for the TV's electron gun, which creates a light and dark image on your TV screen. SYNC circuits in the camera send a signal (which becomes part of the video signal) that starts the camera tube's electron gun at the top of the picture and sweeps it back and forth. When the TV set receives the signal, it uses the SYNC signal to start the TV tube's electron gun at the top of its picture at the same moment

and makes it zigzag back and forth coinciding with the camera's electron gun. Thus the zigging and zagging of both are synchronized and the TV set can create a picture similar to what the camera saw.

LENS

The optical system of the analog video system is the same as the optical system of a conventional silver halide still camera. The difference usually is that the sensors used to capture the electronic image are much smaller than the conventional 35 mm film so that a lens used on an interchangeable lens still video camera has actually four times the magnification of the same lens used with 35 mm film. As an example, a 50 mm lens used with an electronic sensor 1/4 the size would be the equivalent of a 200 mm lens used with a 35 mm camera. This means that the development of wide-angle lenses is a greater challenge for the still video camera designer while long focal lenses for sports use or law enforcement surveillance are already available and at lower prices than equal focal length lenses for 35 run cameras.

AVAILABLE CAMERAS

Most mid-range cameras come with two lens positions, one generally labeled "wide,"which approximates a 50mm. lens, and the other called "tight" which comes in around 75 or 80 mm. Some cameras have trouble focusing on very near subjects, but others include a macro option

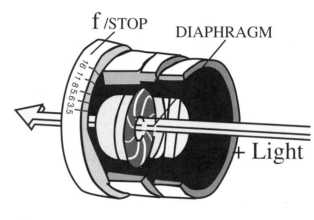

Lens

FOCAL LENGTH AND ANGLE OF COVERAGE OF LENSES
The CCD chip is about half the area of a 35mm film so 50mm lens is about like 125mm on Pixel camera

	Fisheye	Wide Angle	Normal	Medium Telephoto	Long Telephoto

35 Lens in mm	8mm	16mm	28mm	35mm	50mm	85mm	135mm	250mm	500mm	1000mm
Degree of coverage	180°	90°	75°	63°	43°	29°	18°	10°	5°	2°

50 MM 60 MM 85 MM 105 MM 200 MM 500MM 1000 MM 2000 MM

Focal length and angle of coverage for 35mm camera lens
and using the same 35mm lens on digital CCD camera.

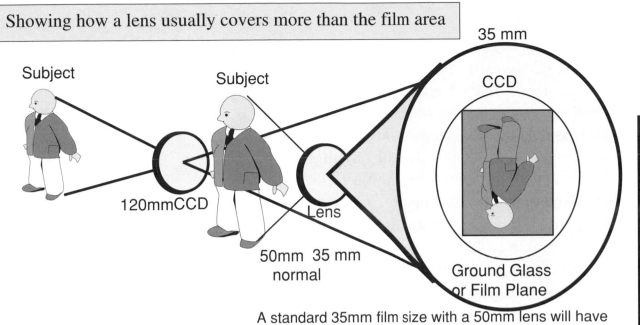

Showing how a lens usually covers more than the film area

Subject

Subject

35 mm

CCD

120mmCCD

Lens

50mm 35 mm
normal

Ground Glass
or Film Plane

A standard 35mm film size with a 50mm lens will have
a coverage like 120mm lens on CCD half its size

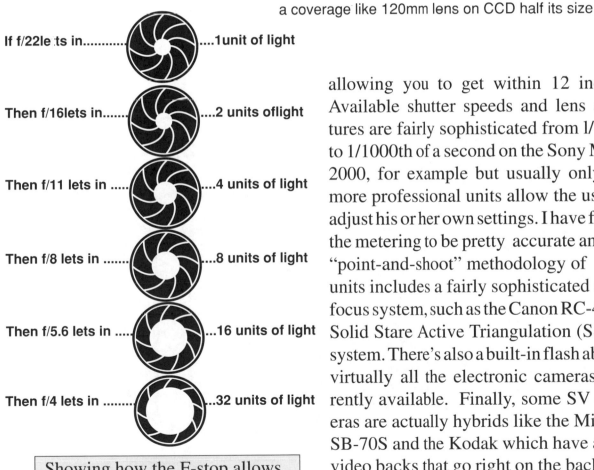

If f/22le ts in............1unit of light

Then f/16lets in.......2 units oflight

Then f/11 lets in4 units of light

Then f/8 lets in8 units of light

Then f/5.6 lets in16 units of light

Then f/4 lets in32 units of light

Showing how the F-stop allows
in different amounts of light

allowing you to get within 12 inches.
Available shutter speeds and lens aper-
tures are fairly sophisticated from l/ 15th
to 1/1000th of a second on the Sony MVC
2000, for example but usually only the
more professional units allow the user to
adjust his or her own settings. I have found
the metering to be pretty accurate and the
"point-and-shoot" methodology of most
units includes a fairly sophisticated auto-
focus system, such as the Canon RC-470's
Solid Stare Active Triangulation (SSAT)
system. There's also a built-in flash aboard
virtually all the electronic cameras cur-
rently available. Finally, some SV cam-
eras are actually hybrids like the Minolta
SB-70S and the Kodak which have a still
video backs that go right on the back of a
regular 35mm. camera body.

CANON-RC470

The RC470 is a semi-professional camera that has a built-in flash and a two-position fixed wide/telephoto lens. In contrast to the low-resolution consumer units such as the Canon Xapshot which will output a video signal to a television monitor, the RC470 requires a second unit to send the image to a television monitor or computer. Its fast-frame advance feature can shoot up to 20 images a second. This is ideal for sports photography when the perfect shot depends on the right millisecond. And of course, with no processing time, the shot doesn't have to come from the first three innings of a night game just to make the morning edition's deadline— now the winning run crossing the plate can make it into print.

Clearly the RC-470 is not quite the equal of the 35mm slide we put it next to, especially in terms of color quality and overall resolution. SV images may not work as a full-bleed magazine cover, but for smaller sizes and less crucial color rendering these images do just fine, especially if you import them into an image editing program where they can be re-worked.

The RC-470 is simple to use, can record in frame or field mode, and offers single shot as well as continuous and high-continuous settings.

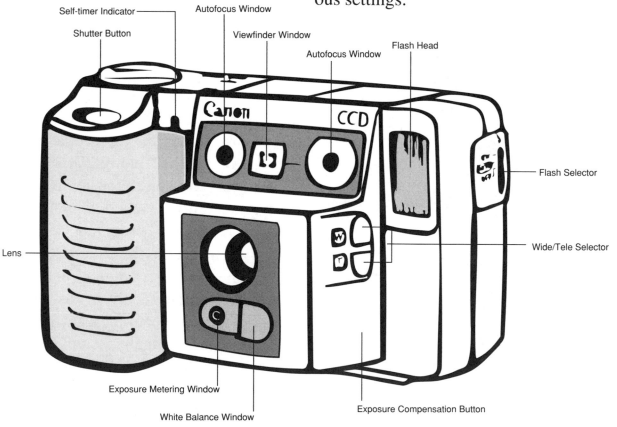

Canon RC470 digital camera

RC-250

Canon also has an entry level camera called the RC-250 that uses a computer board (computer eyes) in place of the disk drive/digitizer unit. XAPSHOT is a complete solution for the entry-level user. The XAPSHOT Still Video Computer Imaging Kit offers the convenience of Still Video technolology at an affordable price. It bundles a XAPSHOT camera with all of its necessary accessories and a Computer Eyes video digitizer board with software. The XAPSHOT SV camera records 50 images (300-line video fields) on a reusable 2-inch floppy disk. Its point- and-shoot operation, built-in flash, and automatic features allow for quick and easy "electronic photography" of virtually any subject. Images can be played back directly from the camera to any standard NTSC TV monitor. When used with the Computer Imaging Kit, the same single video cable connects the XAPSHOT to the digitizer for computer input. The bundled software controls the image capture, image adjustment, and save functions of the digitizer. Once the image is saved in the computer environment, it can easily be exported to various applications. Images can be incorporated into desktop publishing, used to enhance a database, or added as visuals to multimedia presentations. The RC-250 XAPSHOT Still Video Computer Imaging Kit is ideal for personal use and many business applications. The kit is available in different computer versions: 8-bit or 24-bit graphics display - Captures and displays up to 24-bit (16.7 million colors) 640 x 480. It also supports 32-bit QuickDraw and saves in PICT and TIFF file formats.

Canon XAPSHOT and telephoto lens

TOSHIBA

Toshiba also has a digital still camera, the MC200. The Toshiba camera uses an Image Memory Card to store 6 to 12 images.Toshiba claims its camera has a much better signal-to-noise ratio than other still-video cameras. Most picture graininess, the company asserts, is caused by the bead and circuitry used to record the image. Their CCD has an effective resolution of 756-x-486 pixels and a shutter speed from 1130 to 11500 of a second. Because it has no disks and no motor, the camera uses very little power and weighs only a little over two pounds. The memory cards used to store images can hold 6 images in high resolution and 12 in standard mode. Each card contains 2 megabytes of static read-only memory, which needs very little power, and a replaceable

battery that will maintain images for about four months. To extend the life of the cards to a year or more, Toshiba has a caddy that can store and power several cards at a time. Still, you'll eventually need to transfer your images to a computer or erase them. The camera also requires a player to output the images for on-screen viewing. Of the three models available, one is an interlace box for Toshiba lap tops. An advantage to this option is that the images remain compressed at only 180K, and can be sent over a telephone line via the laptop. At $8,000 for camera, flash, and battery charger, the Toshiba MC200 system is for the professional photographer.

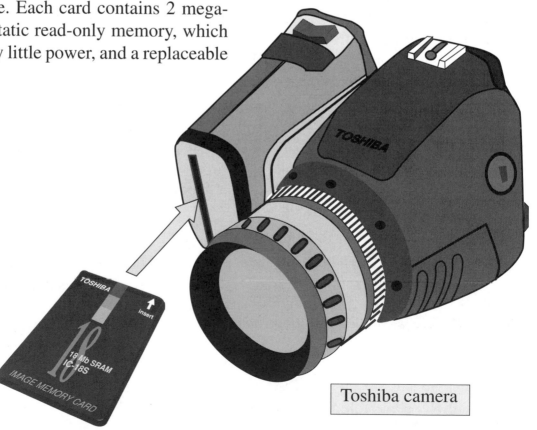

Toshiba camera

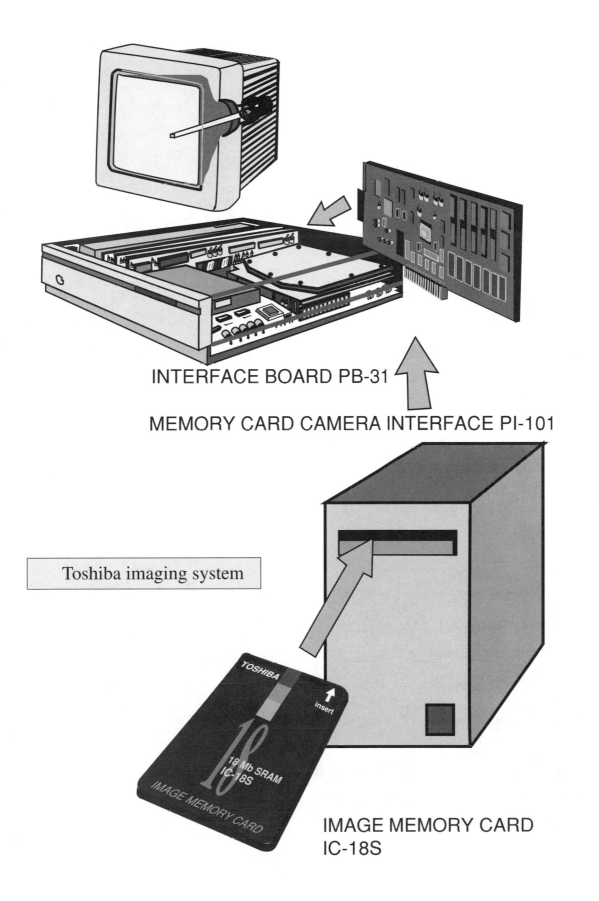

INTERFACE BOARD PB-31

MEMORY CARD CAMERA INTERFACE PI-101

Toshiba imaging system

IMAGE MEMORY CARD
IC-18S

TOSHIBA

insert

18 Mb SRAM
IC-18S

IMAGE MEMORY CARD

KODAK

Kodak also has a prototype digital camera. A shoulder pack contains a hard drive that stores 7 to10 images, and has a 3x4 inch screen for previewing the images. The 1.3 million- pixel imaging array provides a 1,280 x1,024-resolution image. It has an equivalent film speed of 1,000-1,600 ASA for black-and-white and 400 for color. Images can be downloaded to a computer, or sent by phone to a remote site.

KODAK AND NIKON

The DM3 and DC3 Systems require only an external modem and the accessory keyboard to transmit images. These systems include all the features of the DM3/B and DC3/B Systems, plus: image compression Stores 400-600 compressed images.

The Nikon F3 camera operates essentially the same as when film is in the camera once the Kodak still video back is installed. Only a special interchangeable focusing screen is needed. Because the image sensor of the F3 is approximately half the size of a 35 mm frame, the effective focal lengths are doubled making a 300 mm lens the equivlent of a 600 mm lens . An infrared filter is built into the sensor. In addition to photojournalism, the professional digital camera system will have application for police surveillance, security, disaster assessment, scientific and medical imaging, industrial photography, and other market applications. Kodak's DCS doesn't resemble a film camera; it is a film camera, a Nikon F3 and a megapixel chip (that is, a CCD of 1.3 million pixels) in its place. It writes to a on-board Winchester drive. Each

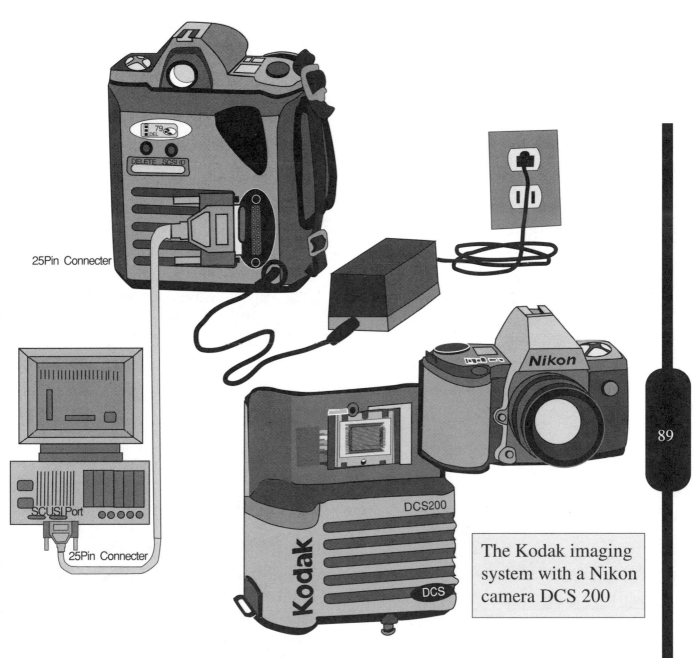

25Pin Connecter

SCUSI Port

25Pin Connecter

DCS200

Kodak

DCS

The Kodak imaging system with a Nikon camera DCS 200

image can be captioned. It is more like an extension of the computer when the computer decides to go on a shoot. It converts the images that come through the lens into 24-bit digital data at a resolution of 1024 by 1280 pixels—about the resolution necessary for a 4-by-5-inch magazine quality print.

Kodak has a more portable version of its Digital Camera System (DCS) linked to Nikon 35mm SLRs. The new DCS 200 digital camera contains a 1.54 million pixel sensor where film would normally be in the Nikon 8008 camera body. There is no external pack as with the Nikon F4 arrangement, just the DCS module

attached to the camera bottom, resembling a large motorized film advance.

The CCD array was devised by Kodak to provide high resolution in both black and white and color model chosen. Autofocusing, exposure control, auto flash and a full complement of Nikon lenses. Kodak's DCS 200 system can be used with Apple Macintosh or IBM and compatible computers with a SCSI port. Kodak's M5 megapixel CCD sensor produces a 1012x1524 array, or a total of 1.54 million pixels. Its image capture rate is one image every 2.5 seconds; image file size, 24 bit color, equals 4.5m.b.. You have a black and white ISO range of 100-400 to work with; or ISO 50-200 in color.

NIKON

Nikon has been selling a professional still-video system for years. The system, which only takes black-and-white images, consists of a camera, two lenses, and a portable transmitter. The transmitter has a 4-inch black-and-white monitor for previewing images. Photographers can choose images and transmit them over a phone line to any wire service photo receive equipment. For Gary Fong, director of photography for the *San Francisco Chronicle,* the Nikon system has proven invaluable. "This technology allows us to stay out in the field longer," says Fong,

"and allows us to push the deadline later." There are drawbacks, however, that prevent the *Chronicle* staff from using the system more widely. Resolution can be a problem, and the camera can be difficult to focus, which causes even more loss of detail. "You have to watch the lighting situation. Like video, it needs to have flat (diffused) light in order to perform at its best. Contrast lighting and back-lighting are difficult." The quality of the San Francisco Bay Area's cellular phone system also causes problems, introducing some ghosting that *Chronicle* staff haven't been able to remove, necessitating use of the local telephone network instead.

Nikon digital black and white camera

SONY DIGITAL CAMERA

Sony's electronic camera offerings include the ProMavica line of fixed-lens color still video cameras the 2000, 5000, and 7000. Each of these models use 380,000-cell CCDs. The ProMavica 2000 is a single CCD camera. The 5000 uses two CCD's. One to measure luminance and another to measure color.

The 7000 is the only hand-held camera mentioned here to offer a three CCD array one CCD for each primary color. It records images in a fully-interlaced frame

CANON RC-570 STILL VIDEO CAMERA

You can capture and store any image, playback to a computer as a pocket-sized slide projector with remote control, perform time-lapse studies, record from other video devices, function as a camera, record existing 35mm slides or negatives, or transfer to use in documents and communications. The Canon RC-570 camera's high resolution frame recording of 450 horizontal lines results in clear on-screen images and sharper copies from printers. It is

It is connected to a PC or Mac with a video digitizer.

A 3X power zoom lens lets you frame your shots inside the camera to get exactly what you want. The 3X lens zooms from the 35mm camera to the equivalent of a 43mm wide angle setting, up to 130mm telephoto. An optional wide angle converter is also avalable. For 35mm slides and film negatives, the 35mm film adapter lets you copy them directly onto a 2- inch video floppy disk.

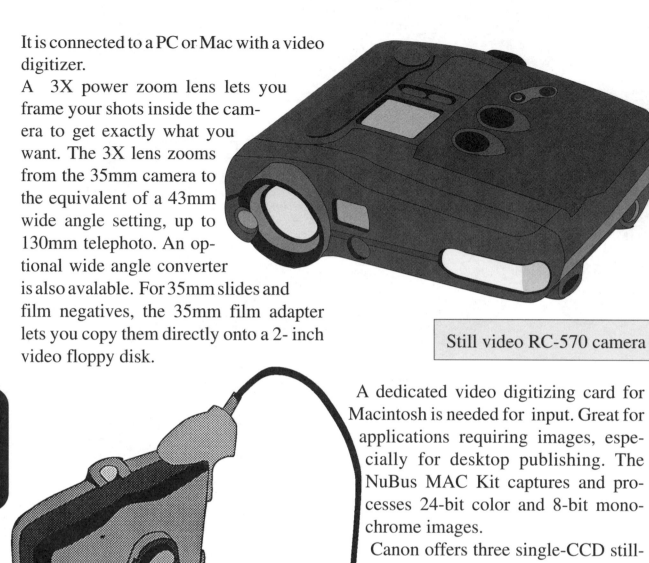

Still video RC-570 camera

A dedicated video digitizing card for Macintosh is needed for input. Great for applications requiring images, especially for desktop publishing. The NuBus MAC Kit captures and processes 24-bit color and 8-bit monochrome images.

Canon offers three single-CCD still-video cameras; the RC-250, RC-360, and RC-570. They are hand-held, fixed-lens cameras which can record up to 50 color images on a removable two-inch video floppy. All three models provide video out, which lets you show images directly from the camera on your television or VCR.

Slide attachment

the still video cameras

MODEL	FEATURES	REQUIRED PERIPHERALS	RESOLUTION
RC 250 Canon	Fixed focus, exposure, white balance, flash, macro-shooting, Hi-band, records 50 fields per disk	Xapshot Computer Imaging kit converts images for PC/ Macintosh	300 video lines (640x480 in captured files)
RC-470 Canon	Auto features; focus, exposure, white balance, flash, two-position lens, Hi-band, frame (25/per) or field (50/per) images.	Need still video player or video floppy disk drive	400 video lines
RC- 570 Canon	StrobeAttachment, SlideCopier, Auto features; focus, exposure, white balance, flash, two-position lens, Hi-band, frame (25/per) or field (50/per) images.	Need still video player or video floppy disk drive	410 video lines
QV-1000C Nikon	High-resolution images via monochrome CCD; sensitivity equivalent to ISO film speeds of 400,800, or 1600; CCD sensor function shoots 20 images per second	Analog transmitter included; need capture board (prices vary)	562 lines of horizontal resolution
Dycam Model 1 Dycam, Inc.	32images, 256 grey levels, Mac or PC compatible, standard file formats	None	376 x 240 pixels
Fotoman Logitech	32 images stored on internal RAM chip, FotoTouch software, PC compatible	Windows 3.0 of higher	376 x 240 pixels
MC200 Toshiba	Stores to memory card, standard mode, 12 frames, high-quality mode, 6 frames, 4 shots per second	Memory Card Camera Interface unit,Memory CardandPlayer, board	400,000 pixels
ProMavica- MVC 2000 Sony	Single-chip, Hi-band, point and shoot autofocus, 12--73mm, F/1.4 zoom lens with macro.	Need still video recorder/player.	400 lines of horizontal resolution
ProMavica- MVC 5000 Sony	Two-chip, single-lens reflex, Hi-band, manual aperture and shutter override. Optional field/frame and audio record.	Need still video recorder/player. Strobe compatible, Nikon-compatible lenses,	500 lines of horizontal resolution
ProMavica- MVC 7000 Sony	Three-chip, single-lens reflex, Hi-band, manual aperture and shutter override. Optional field/frame and audio record.	Need still video recorder/player. Strobe compatible, Nikon-compatible lenses,	700 lines of horizontal resolution
Sound Mavica MVC-A10 Sony	Built in macro lens, records up to 10 seconds audio per track, up to 50 images without sound, 25 images with sound.	Need drive or player/recorder, and capture board (prices vary)	340 lines of horizontal resolution
Consumer Mavica MVC- C1 Sony	Up to 50 pictures per disk, continous shooting of 4 or 9 pictures per second, autoexposure, autoshutter, and autoflash.	Need drive or player / recorder and capture board	300 lines
PRO DCS Kodak / DCS-200 Kodak	High speed image capture, Photoshop driver; monochrome or color.	Nikon-compatible lenses, Nikon-compatible flash unit	1,328 x 1,024 pixels

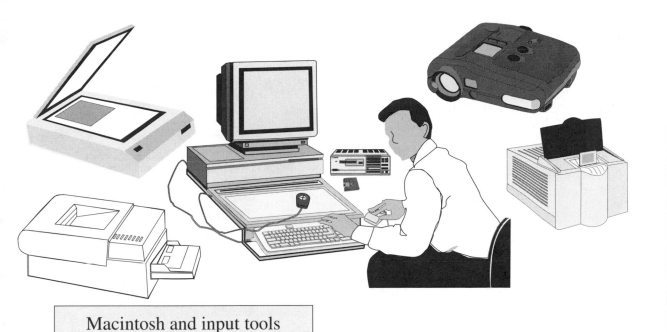

CHAPTER VI, THE MAC AND SCANNING TOOLS

The greatest advantage to still video is that once an image is captured it can be fed immediately into a video player, or in less than 20 seconds, into a computer using a video digitizer board. This plus is a considerable time savings for desktop publishers. Digital cameras use a CCD to capture an image. Rather than store the image in an analog format, they immediately digitize the image and save it as digital information, thus reducing the chance for noise or signal degradation. On the down side, saving an image in a digital format requires much more bandwidth (or information) than it does to record the same image as analog information . Advances in compression technology have helped lessen the problem but

one of the stumbling blocks of using digital cameras is the limited number of storable images. Macintosh black and white version, Mac 512 Enhanced, MacPlus, SE, SE/30, Classic do not have true gray scale. The resolution goes up with 8-bit per pixel depth, making it difficult to use for imaging. The larger video images processed on the Macintosh can suffer from a limit to the size at which they can be printed without losing resolution. This is because a digitized video image has a fixed amount of data which is relatively small when compared to a scanned image. The pixels can be "stretched" only so far before they become visible. In general, video images can be printed at sizes up to about 5 x 7 inches before this occurs. Clear, larger images are possible through a process called re-sampling. Some graphics editing packages (for example Adobe PhotoShop) now offers this feature, the

use of which allows you to print images at virtually any size. Whereas re-sizing an image merely uses the existing pixels to fill a larger area of the page, re-sampling produces a new image, with more data than before, to provide sufficient resolution for the larger area. The original pixels may be spread more thinly, but a process of interpolation produces new pixels to fill in the spaces. Re-sampling effectively converts a video image into a scanned one, thus giving you much greater flexibility in deciding on a final size. Newspapers in particular would find this feature helpful for front-page scoops.

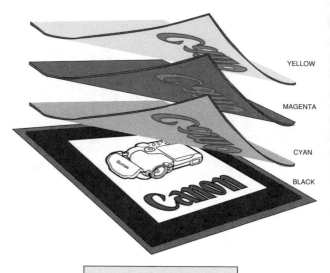

Four color separation

GETTING COLOR INTO PRINT

Manipulation of color imagery is already with us and its only a matter of time before Macintosh users will be able to match the sophistication of professional electronic photo retouching at a fraction of the cost. Full-color still video images are already finding their way into print in catalogs, newsletters, corporate presentations and lots of data bases. There are quite a few software packages that can do color editing, four color separation and pagination. Using the tools is simple enough, but the functions involved in color processing are more involved than with monochrome processing. For this reason, I recommend that you work closely with your local print bureau which has the necessary knowl-edge to give you good results on paper. Service bureau people are the experts in working with high end color worksta-tions, know how to work with images for such problems as the dot gain in the output device, the quirks of a particular printing press, different kinds of paper stock, and even ink impurities. Color printing is still a complex field, and that isn't likely to change in the very near future.

The advantages of using video and the image grabber for color capture are that you can do much of the pre-press work on your own machine and that you can do it with a minimum of investment. Video images, even in 24-bit color, do not con-sume massive amounts of disk space, and therefore processing is quicker and more easily manageable. Standard 8-bit dis-plays are adequate for editing while the software will retain the full 24-bit data.

The steps described below are what I consider to be the most practical and

Disk Loaded / Interval Indicator

Frame Indicator

Wireless Control Indicator

Reverse Button

Forward Button

Eject Button

Disk Slot

Power Indicator

Power Button

Erase Standby Button

I.D. Button

High-Band Indicator

Erase Indicator

Still video disk player

Track# Display / Consecutive Erase Button

Screen Speed Selector / Single Erase Button

straightforward ones involved in taking color images from video and presenting them to your print shop for final output. Capture your images with the image grabber color adaptor using automatic exposure and multi grab for best results.

Save your color images as 24-bit TIFF or PICT files, even if you are using an 8-bit display system. Use the scale image option to set an initial scale of between 120 and 180 cells per inch.

Use a color graphics package, such as Photoshop, ColorStudio or Digital Darkroom, to sharpen the images and to do general pixel editing.

If necessary, resize and resample the image for the final make-up but don't do the separations until you have been advised by the print shop.

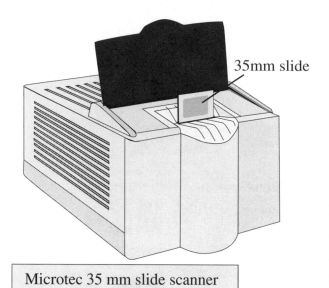

35mm slide

Microtec 35 mm slide scanner

SLIDE SCANNERS

Color on the Mac has grown from a high-end curiosity to an important element of desktop publishing, multimedia, and presentations. The first crucial step in this process is to capture the image.

Slide scanners, which scan 35mm photographic transparencies, are an excellent image capture method for publication work. As source material for scanned images, transparencies have two main advantages over prints. First they are inherently capable of a much wider range of brightness, contrast, and color saturation than are reflective materials such as color prints. Second, slides are easier to handle, store, and transport than prints are. Taken together, these two factors have made slide scanners the device of choice for those brave souls who perform desktop color separations.

SLIDE SCANNERS AND STILL VIDEO CAMERAS

Still video images are not as sharp as those digitized by a slide scanner. The slide scanner images have almost double the resolution than those images of a still video camera. However, for people who require only screen-resolution images or images for low-resolution printing such as newsletters, the still video system offers important benefits. Operational cost is lower—the high price of developing slides and printing film is replaced by reusable disks. Slide scanner performance and resolution are directly related to the optical resolution of the scanner. The Barneyscan and Nikon can both produce professional color scans for images up to 8 x 10 inches that is required for producing full-page quality color images. The sheer size of high-resolution files taxes the Mac to its limits. A 150-megabyte file is not unusual for a full-page image. Personally, I have used the Nikon L-S, the Barneyscan, and Microtec for successful desktop publishing.

BARNEYSCAN

Barneyscan can only digitize 35mm, but with an increasing number of professional photo libraries standardizing on 35mm slides, this may be more strength than limitation. The machine itself is the brainchild of Howard Barney, the Ameri-

can physicist and joint inventor of what became the Matrix film recorder. He envisioned the need for high quality color archiving that retained genuine photographic color density and range. Using fairly simple proprietary technology, coupled with the precision necessary for high-resolution scanning, he came up with a desktop box with a considerably smaller footprint than a Macintosh II. At the time, archiving was its only predicted use and the software written to drive it still shows a bias towards the adjustment of color balance and resolution for simple digital storage. The machine has already found a home in scientific data capture and mu-

seum archiving and its move into color reproduction has been almost an afterthought.

SOFTWARE

Once scanned, the image is saved, either in Barneyscan's native format, if you're moving the file into Barneyscan XP for manipulation, or as a PICT or TIFF file (including IBM TIFF) for export to a page make-up or color separation program. The machine's origins in picture storage are most evident in its bundled software: two packages, Barneyscan Mac and Barneyscan XP. The fist of these pro-

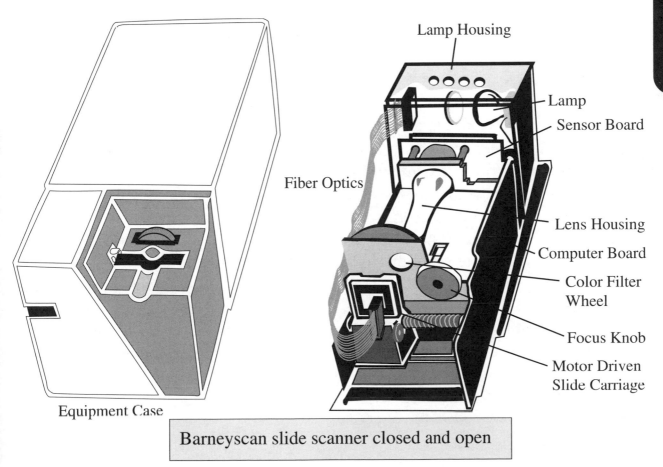

Lamp Housing

Lamp

Sensor Board

Fiber Optics

Lens Housing

Computer Board

Color Filter Wheel

Focus Knob

Motor Driven Slide Carriage

Equipment Case

Barneyscan slide scanner closed and open

grams simply drives the scanner, allowing some predetermined alteration to, sharpness, brightness,andthe saving of scans in a number of formats for subsequent manipulation. It's at this early stage of the process where the skills of the conventional scanner operator would still save time. A quick, experienced eyeball assessment of the slide can avoid a lot of rescanning.

Barneyscan XP is the more exciting of the two packages shipped with the machine, offering an extensive range of image manipulation features, all executed in virtual memory and all very quickly picked up. The program has a toolbox much like many of the color paint programs around at the moment and every bit as sophisticated.

CALIBRATION

Next, you need to calibrate the scanner. Scanners use a linear CCD (charge-coupled device) array to record the light that passes through the transparency. The calibration process establishes values for absolute black and absolute white and compensates for minute variations in the lighting and in the response of each element in the CCD array. Barneyscan recommends recalibrating its scanner weekly or each time you move it. The process, which takes about 15 minutes, uses a special calibration slide (supplied) and, once started, requires 110 user interven-

tion. The focus command presents an on screen numeric display that changes as you adjust the focus wheel on the scanner. The image is in focus when the highest number is displayed. I found this more difficult to use than the auto-focus of the other scanners and it didn't really seem to increase sharpness.

The Nikon scanner is self-calibrating and is ready when connected to the board. Using absolute values for black and white, it automatically performs a routine called pre-scan sensitometry during the first scan of each session and uses it to match the range of tonal values in the slide being scanned. Normally, this needs to be done only once, but if a slide is very different in tonal values from others scanned in the same session, you can choose prescan sensitometry from a menu. Prescan sensitometry takes about ten seconds, depending on the contents of the slide.

STORAGE

A single scan can occupy up to 16 megabytes. Two scans can easily fill up a 40 megabyte hard drive. How images are dealt with, stored, and moved is a challenge. Those of us involved in trying to make desktop reproduction a reality are already dabbling in mass storage technologies that were a fantasy a few years ago.

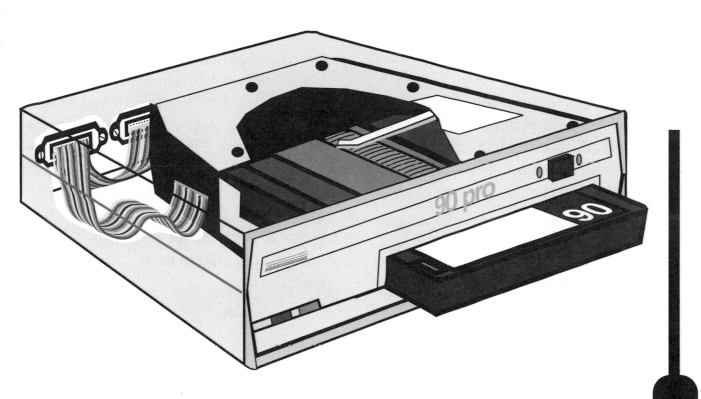

Hard disk drive with 90 MB. removable disk Bernoulli and SyQuest

MEMORY

It's important to remember that scanned images are devourers of computer memory. A typical 24 bit image can take 80 MB of file space, and very often can't be directly imported into a page. You need to have enough free memory to be able to place the document into a page makeup program so start with as low resolution as possible. Just before final printing, the high res copy complete with cropping and resizing, can be substituted for the working copy. These demands on hardware storage and RAM are important considerations when you decide to buy and operateyour own scanners.

CONNECTING NUBUS CARDS TO SCANNERS

Scanners require a Mac II with a vacant NuBus slot and at least 4 megabytes of RAM. A 24-bit video card, although not required for scanning, is almost essential for doing any manipulation of color im-ages. The scanner's software produces an 8 bit dithered image for display on an 8 bit color monitor. Any adjustment to the color can quickly turn these dithered images into garbage. Adjust dithered images at your own risk! The Barneyscan is the easiest of the scanners to set up since it uses a proprietary NuBus board that requires no configuring. After you cable the board to the scanner and place the program in the system folder, the scanner is ready.

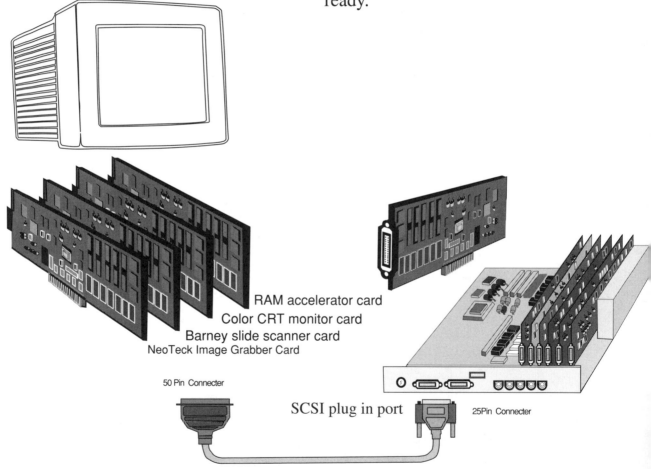

RAM accelerator card
Color CRT monitor card
Barney slide scanner card
NeoTeck Image Grabber Card

50 Pin Connecter

SCSI plug in port

25Pin Connecter

RAM cards and SCSI plug in ports

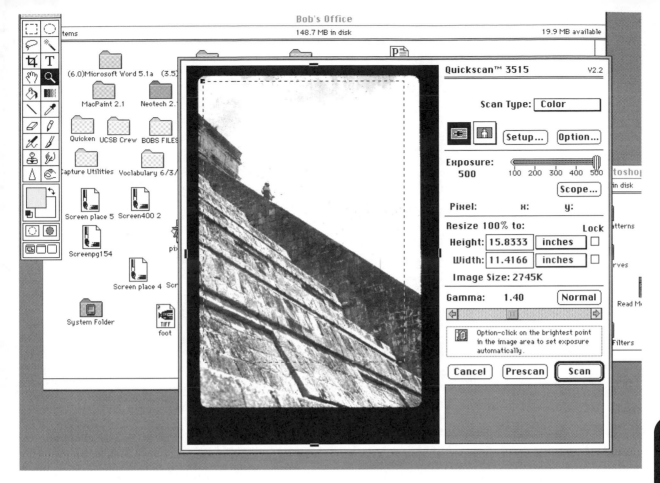

PREVIEWING THE SCAN

All scanners allow you to perform a quick low-resolution preview scan. Use this as a basis for adjusting exposure controls, cropping the image, and doing gamma correction. You can adjust the midtone levels in an image without changing the highlights and shadows. You can also use automatic exposure and gamma settings on each scanner. The Barneyscan software does a fast preview scan, taking about 35 seconds to produce a gray-scale preview image with 256 shades of gray. Prescan in the gray scale. Color prescanning takes up too much memory. Use the preview scan to sct exposure, gamma-correction levels, and image cropping and scaling for the final scan. The effects of your adjustments are displayed in the preview image.

Resolution equals the maximum resolution of the scanner (6,144 x 4,096 pixels) The scanner automatically chooses the default setting it wants, resulting in a 768 x 512 pixel image. If you want a higher resolution, you'll have to overcome the scanner's choice.

SCANNING SLIDES

Once you have the correct exposure settings, cropping frame, and scaling factors set to your satisfaction, the next step is to perform a full-resolution scan and save it to disk. The Barneyscan treats scanning and saving to disk as two separate opera-

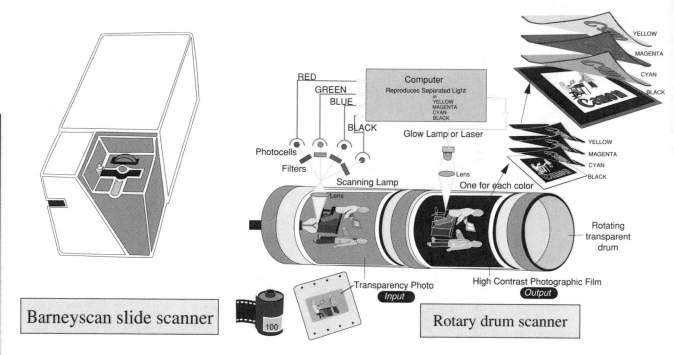

Labels within the figure:

RED
GREEN
BLUE
BLACK

Computer
Reproduces Seperated Light
in
YELLOW
MAGENTA
CYAN
BLACK

Photocells
Filters
Scanning Lamp
Lens

Glow Lamp or Laser
Lens
One for each color

YELLOW
MAGENTA
CYAN
BLACK

YELLOW
MAGENTA
CYAN
BLACK

Rotating
transparent
drum

Transparency Photo
Input

High Contrast Photographic Film
Output

100

Barneyscan slide scanner

Rotary drum scanner

tions, but it still has the fastest scanning speed of the slide scanners. The scanner treats scanning to disk as a single operation. It also has a somewhat unusual file-handling system. When you choose "scan to disk", the program asks you to name a folder that will contain the image files. In addition to saving the final image file, the software saves the red, green, and blue channels of the image as separate TIFF files, so a scan requires well over twice as much disk space as the actual image. To use the maximum 6,144 x 4,096 pixel resolution of the scanner, you need 45 megabytes free on your hard disk.

TYPES OF SCANNERS

There are many types of scanners. Flatbed scanners use many diodes that are arranged into one big plate onto which the whole image is either placed or projected depending on the scanner configuration. Each diode handles one pixel of scanned information. The array scanner uses fewer diodes than the flatbed, needing repeated scans of the overall image until enough information is gathered to reproduce it. Eikonix, Array Technologies, Agfa Compugraphic, Scitex, and Truvel all make scanners that use this CCD array approach. Scanners for prepress color come in two major varieties: photodynod and charge-coupled device. Both measure the brightness of each particle of an image then turn that measurement into a voltage but each works in a different way. The PMT scanner uses photosensitive chips called dynodes through which a high current is passed. The photons release energy. Dynodes are arranged in groups. The small number of electrons released is multiplied

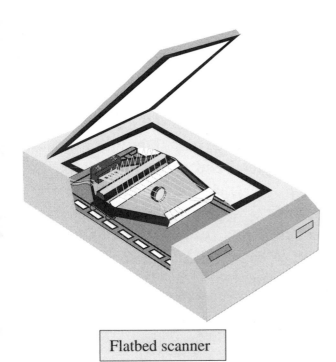

Flatbed scanner

Column scanner

from dynode to dynode, allowing the scanner to measure the amount of light in that particular spot on the image. This analog electronic output is then digitized and used to make separations. A CCD scanner uses diodes to sense light. These small photosensitive chips have positive and negative poles to which a single charge is delivered when the diode is struck by light. Thousands of diodes are set into arrays on a plate onto which the image is either laid or projected. But diodes are not as sensitive to light as are dynodes, and thus have trouble with information at the extreme ends of their measuring scale. This information is needed to discern the highlights and the dark areas(contrast) of a photograph.Scanners also differ in how they capture images. Drum scanners use a removable drum that rotates in front of a image sensor. The art or photo is placed

on the drum. If it's a transparency, a clear drum is used. If it is reflective art, the drum is opaque. A flatbed scanner looks like a copier with a flat plate of glass upon which the image is set. The scanner uses no lens or focusing device, but scans directly onto the CCD array. Some flatbeds provide an attachment that allows you to scan transparencies, but illumination can be unpredictable. Most slide scanners only shoot one size: 35 mm. However, the column scanner which is similar to a copy stand with a camera, will scan both flat copy and three-dimensional objects. The image is projected onto a CCD through a lens mounted on a column Scanners also turn images into particles and then arrange them into a bit-mapped image. The smaller the dots, the finer the image, which is why one of the most important indicators of a

scanner's capability is its resolution. First of all, let's make a distinction between what the scanner takes in and what it finally produces. A scanner that has a CCD array of 4000 by 6144 pixels may not be able to reproduce the image with that resolution. The pixel number indicates how many pixels are available to be spread over the entire image. The larger the image being scanned, the less resolution available. Make sure to find out the output resolution in DPI, not the scanning resolution in pixels. There's one firm rule: once you scan an image at a given DPI, you can't go back and get any more resolution. You're stuck with the original limits. You can fool with it at the editing level by using interpolation, but you can't actually increase it. Secondly, remember that this image will wind up getting converted into a 4-color line screen. This may be fairly coarse, like the 90-LPI screen in newspaper work, more moderate like the 120 LPI screen in most magazines, or very fine like a fancy catalog with a 150 LPI screen. How much scanning resolution do you need for a given line screen? A rule of thumb is to require twice the density of the screen . You need 2 DPI for every LPI. If you're printing with a 15O LPI screen, you really only need to scan at around 2 10 DPI. You probably get a little leeway by going up to 300 DPI, or two times the LPI resolution, but any more than that is overkill and won't add more detail to the final line screen. What happens when the image is enlarged? If the size is doubled, you'll need twice the DPI. Turning a 35mm slide into a full magazine page could involve an eight-fold increase in size. To maintain your 150 LPI screen, you now need to scan around 1680 DPI. Once you try and stretch that 35 mm slide into a double-page spread and get into the 3400 DPI area, you may be exceeding a CCD scanner's capabilities. You have no choice but to go to a scanner with higher resolution. A rotary slide scanner has higher resolution.

DYNAMIC RANGE AND GRAY SCALE

As there's a difference between what a scanner sees in an image and what it finally puts out, there's also a difference in how it reads each of those dots in the bit map and how many contrast shades between dark and light are read in each RGB pass. The number of bits in the processor taking down the readings determines how many units are in the scale. If it's 8-bit, there are 256 graduations. If it's 12-bit, there are 4,096. Of course, that's 8 bits per color, so a 3-color 8-bit scanner is said to have 24- bit color. And with 256 shades on three different color filters, that's 16.7 million available colors. Not bad. Remember that not every system advertised as 12-bit uses all those bits for carrying image data; sometimes a couple of bits are shaved off for processing and only 10 bits are actually being used.

Do you need 256 or more shades even though most people can't discern more than 60 shades of gray with the naked eye? Yes, to cope with the fringes of the gray scale. The problem of most CCD scanners is that they don't have a broad dynamic range. Hence you will have difficulty scanning in an entire gray scale. Using a density range from 0 to 10 PMT scanners can read about 7 while most CCD's will be lucky to have a range of not much more than 5. Range can also be extended and manipulated using the scanner's software. By altering the map of how input is converted, more graduations can be added. With Photoshop, you can alter the density curve and refigure the color balance for a more defined gray scale. Re-mapping can also help get rid of digital "noise" in dark areas, represented by a smattering of unwelcome white dots. Other software manipulation is required when the image changes size. Spaces between the scan lines may develop and the software has to decide the color to use to fill in the lines. The better the software the more accurate the color and gray scale of the filled in lines. When you decide to increase the image size, the spaces between the scan lines will widen and then resampling will occur. Information from the two closest scan lines (top and bottom) will create a third scan line in the middle. Often, resampling weakens the image. Do not assume that resampling is a substitute for rescanning the original image. The law is when in doubt, rescan.

COLOR SCANNING AND RGB

Scanners measure color levels by shining colored or filtered light on the image and measuring the reflection (or, in the case of transparencies, the amount of color passing through the surface) of red, green blue (RGB). All scanners start in RGB, but high-res scanners immediately convert this information to cyan-magenta- yellow-black (CMYK). Currently, desktop publishing equipment requires that the information stay in RGB, which is why the drum color scanners can't input directly to a desktop system. Conversion back to RGB and conventional formats like TIFF must be done. CCD scanners sample RGB levels in two ways: either in one pass or one pass per color at a time. More inexpensive scanners, such as the Sharp may lose a good deal of quality in opting for a three-in-one pass arrangement, although there's a payback in speed. Some three- in- one pass units also have trouble keeping exactly the same light levels throughout the scan, especially when fluorescent lighting is used instead of preferred halogen lamps. As the fluorescents heat up, they get brighter and unevenness develops. As one solution, scanner manufacturers add optical feedback circuits to keep the lamp intensity constant throughout the scan. More expensive CCD scanners can handle all three colors in one pass with less difficulty.

RESOLUTION IN SCANNING

Inside a scanner, light is reflected from or projected through the photograph to be scanned. The reflected or projected light is directed to the scanner's light sensitive diodes (CCD's). Each of these measures the amount of light striking it and generates an intensity value between O and 256 for each of the three additive primary colors: red, green, and blue. The scanner then combines these RGB samples to produce the 24-bit full-color image (8 bits per primary color).

High end scanners generally have greater sensitivity and they will read two almost identical colors as different. A scanner with a lower dynamic range records the two similar colors as the same .

Most "desktop" scanners use CCD's; the density of these determines the scanner's resolution. Each CCD records color information and outputs one 24-bit color value, which comprises a single pixel in the resulting digital image.

Motion during a scan can also create image lines. This can occur if the movement of the drum or bed holding the original artwork is not smooth and continuous. In such a case, the image will have a seam or line through it. Desktop scanners do not automatically seek an image's white and black points so they generally shorten the image's dynamic range. Most high end scanners automatically and accurately determine white and black points and spread out the range of tones to be scanned, recording them more accurately.

It's important to know, before you scan, what resolution to use to get as much information as you need but not much extra.

Macintosh display screen resolution is 72 DPI. That means that if the original was a scan of a 35mm slide at 2000 DPI, theimage would occupy about 26 x 38 inches on screen. In practical terms, almost no image quality is gained beyond a 2:1 ratio of information to the (LPI) halftone resolution. The difference between 1:1 and 2:1 can be significant for reproduction of photo images.

How to find the sharpest area on your flat bed scanner and test for scan quality:

1. You will need a 8 X 10, 18% neutral gray card and an eleven step graywedge. The gray card is a perfect gray surface with very little variation in the value of the gray across the entire surface. A graywedge is a series of neutral gray squares printed on a standard surface similar to the gray card but smaller. The shade of each square ranges from 0% to 100% black.

2. To test for variation in color across your scanner, place the 18% gray card on to the scanning surface and make a high resolution (300 DPI) scan of the entire gray card.

3. Open the file in Adobe Photoshop and see if the image varies in color shift from the neutral of the original. In the worst case you may notice that it may be darker in one corner and lighter in the other. Locate the area that gives you the most accurate neutral gray and use it for your most critical color scans. You must calibrate your monitor correctly before attempting this test.

4 .To test for dynamic range place the gray wedge on the scanner and scan it at high resolution (300 DPI). Scanning the gray wedge exhibits what you will be getting when you make the actual scan.

5. Open the file in Adobe Photoshop and examine the number of grays that the scanner can resolve. Some darker grays can be recovered with the levels control in Adobe Photoshop. In less expensive scanners, there will be less recognition of the gray scale. You will tend to lose the extreme ends of the scale.

6. The best results can be achieved by scanning at as high a resolution as is possible. This technique will retain the greatest number of gray shades. Always reduce from a larger size to a smaller size to maintain maximum resolution.

7. Before you place your glossy photographs or art onto the surface of the desktop scanner, spray them with a light coating of dull matt spray to eliminate the surface glare that can be picked up by the average flatbed scanner.

8. Scanning prescreened photos and eliminating moire on a flatbed scanner require the following steps:

a. Newspaper images, when scanned, can cause moire problems and take a long time to convert to grayscale. One solution is to scan the screened photograph at a 45° angle to the surface of the scanner. Then open the angled image in Adobe Photoshop and rotate it back to horizontal position.

b. Lay plastic or glass on top of flatbed scanner to lift photograph about 1/16 of an inch which will serve to soften the halftone dots on the prescreened halftone.

c. Rotate photograph from the 45 degree angle to eliminate the moire

d. Using the median filter in combination with the unsharp mask filter in Photoshop might also be needed to soften the sharpness of the dots.

IRRITATION OF PIXEL STAIR STEPPING

There will be times when you have to contend with the harsh pixel stair stepping found in the paint program. First resize your image as large as possible on your given system. In general you can make it at least twice its starting size.

Next resize it back down to the size you want it to be. Resizing the image will add a soft edge to the jagged stair stepping and

is known in computer speak as anti-aliasing. The only way to increase the size of an image without reducing its resolution is through resampling. Every time an image is resampled, data is either lost or artificially created. In either case, you are throwing away some of the image's resolution. You might also use the blur filter to soften the jaggies found in some of the more difficult areas of your image. You should periodically run a hard disk optimizer after working on several Adobe Photoshop projects. Running the optimizer cleans up a fragmented disk and makes Adobe Photoshop run faster and reduces the risk of disk crashes.

TAMRON FOTOVIX

Film video processor will do slides or negatives; needs a video board to bring image into a computer.

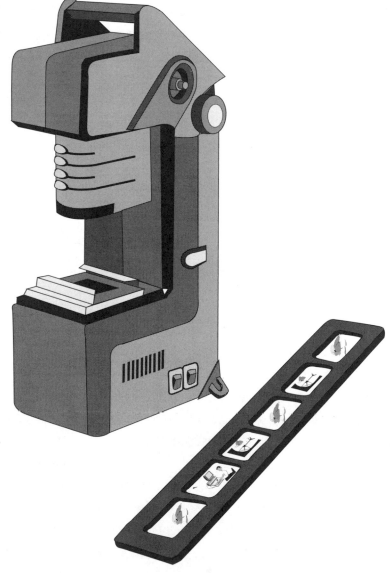

TAMRON FOTOVIX

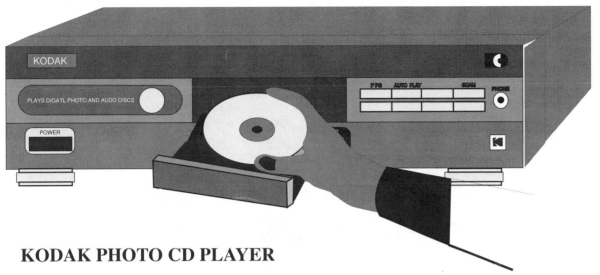

KODAK PHOTO CD PLAYER

Photo CD imaging is currently limited to 35mm originals but market demand will probably quickly drive the technology to larger film formats. Kodak has a process by which your digital images from 35 mm film slides and negatives can be transferred to a CD. The quality level of the images that can be scanned onto a photo CD are far higher than those images from other scanning techiques available to photographers.

Kodak photo CDs will provide a natural gateway to desktop publishing. The resolution level of the images will not be adequate for large size prints.

The CD's of photographs also enable the average photographer to do more with his images. They can be sent on wire services, the images are permanently catalogued and available to desktop publishers, and the photographers have a natural archive of their work.

Art directors and editors can view the images on disk players .

A Photo CD looks like a standard audio CD, but instead of music, it holds about 100 digitally recorded 24-bit color images.The number of images that will fit on a disk will vary slightly, depending on the grain of the photograph being scanned. For instance, a fine-grained photograph will require more information to be stored. Each image is recorded at five different resolutions: 128 x 142, 256 x 384, 512 x 776. To bring the images into your computer, you'll need a fully configured CD-ROM drive. The ability of being able to put your photogaphs onto a CD disk eliminates lab printing thereby making the viewing of our images much more immediate. Also you can easily send out the almost indestructible CD's for viewing by editors and prospective publishers.

The still video of stock photographs may also enable the average studio owner to do more with images. Currently, we are limited to full stock agencies, and extensive promotions, or else we ignore our photos in favor of "doing something with them one day." When art directors and editors have disk players, it will be possible to record stock images onto disks and inexpensively send them out a CD catalog of the work.

112

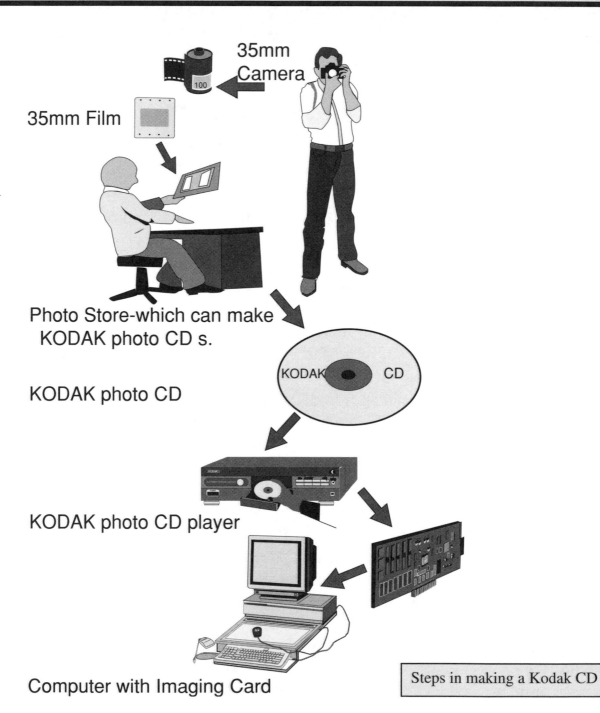

35mm Camera

35mm Film

Photo Store-which can make KODAK photo CD s.

KODAK photo CD

KODAK photo CD player

Computer with Imaging Card

Steps in making a Kodak CD

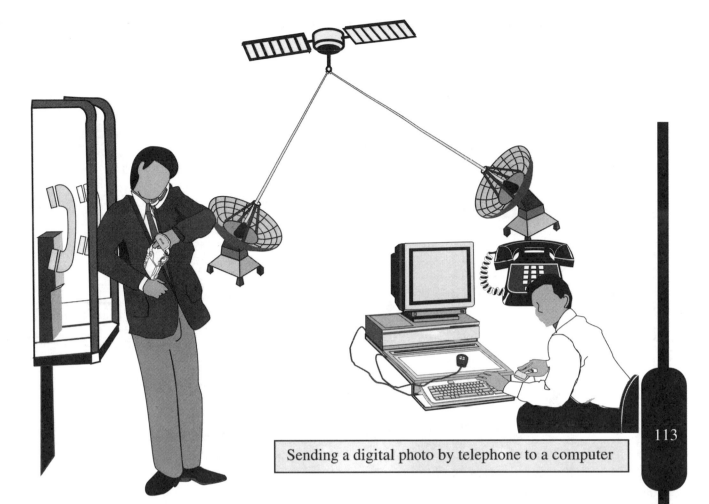

Sending a digital photo by telephone to a computer

MAC AND MODEM

Your Macintosh can communicate with another Mac using a modem or any personal computer with appropriate communications software, an IBM or mainframe computer. A computer modem basic job is to send information to and receive information from another computer. A terminal has a keyboard to enter information and a display screen to see what you're receiving and sending. As a terminal, your Macintosh can transfer information to other computers as well as gain access to the data bases, applications, and the storage capacity of large computers.

Each computer that you want to communicate with must have its own data communications software. A larger computer such as a mainframe usually has sophisticated data communications software to manage the flow of information. For the Macintosh to communicate with another computer, both must transmit data according to the same rules, called communications parameters. After space shuttle landings, NASA applies this technology to send immediate images of any problems to the command center.

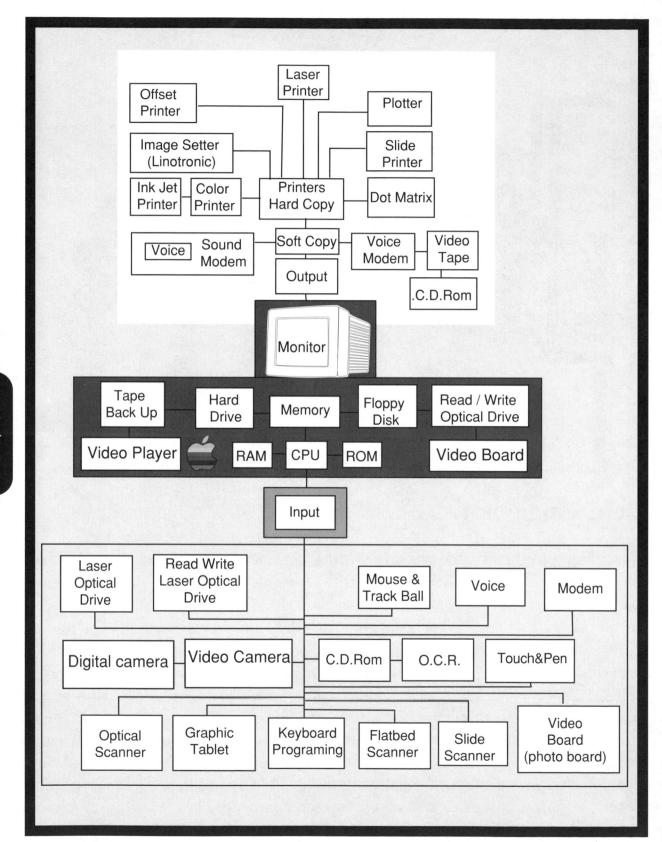

114

CHAPTER VII, THE TOOLS OF THE TRADE

First you must invest in a computer. Advocates say Apple's Macintosh is the supreme computer because it is "user friendly". This means that someone un-schooled in computers can sit down and, without prodding or instruction, begin "computing". As a writer, my wife Jacqueline was a staunch member of the pencil and typewriter school. Finally a few years ago I convinced her, masochist that I am, that she should begin her new book on the Mac. After 2 months during which time she was able to produce the manuscript for a 160 page book, I was barely able to get my Macintosh back. When she started calling it her computer I knew I had opened a Pandora's box.

I prefer the out-of-the-box basic Macintosh without software enhancement. The on-screen pixel design, a feature of the basic

The C.P.U. Mac II.

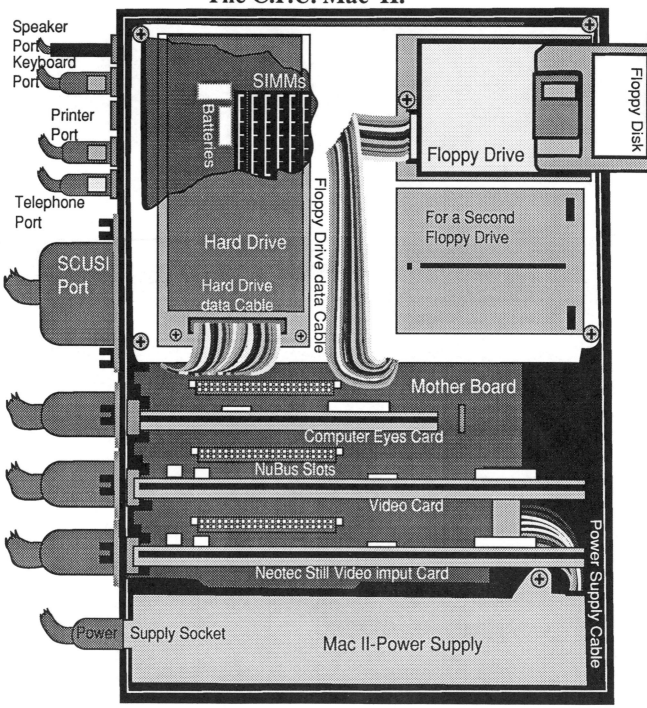

Macintosh, works well with photographs and needs a minimum of software enchancement. Each program, whether simple MacWrite or Photoshop, interact with the operator using the same pull-down menu. Every Mac program that I I use is designed to operate with the same pixel design. You can buy other computers cheaper and enhance them with plug-in boards which deliver the same pixel format but there is no guarantee that your image processing software will always work as expected.

THE KEYBOARD

Someone from the old typewriter school of writers, such as my wife, will always have a soft spot for the Mac's keyboard. It is detached from the computer itself so it can even be used on your lap and the keys are equal to the standard keyboard of a typewriter. In fact, the Mac's keys are so suave, your typing speed increases greatly. Each key is a switch coupled with electronic circuitry to encode data, that is record whether it is on, pressed, or off. A computer keyboard needs more keys than

Apple computer keyboard

the typewriter; these extra keys are found surrounding the keyboard area. In addition to a numeric keypad, you will find (1) function keys, (2) special keys labeled Ctrl (Control), Enter, or Return, and (3) four cursor movement keys to move the cursor up, down, left, and right.

Function keys are sometimes referred to as soft keys because their meanings change with the application you are using. They provide the ability to condense a complicated series of keystrokes into the press of a single key. Software may define the function keys to perform special commands such as boldface, underline, or delete a sentence or a paragraph. Sometimes function keys are user defined to allow you to enter a series of keystrokes that can then be assigned to a function key. For instance, logging on to an on-line information service, such as CompuServe, requires that you enter a user code and a password. By programming your user code and password to a function key, every time you log on, all you have to do is press a single key in lieu of repeatedly entering a long sequence.

CONTROL KEYS

The Control key is always used in conjunction with one or two other keys to give instructions to a program. For example, when using a word program, pressing the S key and control causes a save to a floppy or hard drive. If you hold down the Control key while pressing the V key, the draw program would interpret and give an instruction to paste a photo or a character.

Direction keys from keyboard

The Alt key is used in the same manner. The specific instructions that are implemented through the use of control keys are defined by individual programs. As with function keys, each application program will use the control keys differently. They are often used on keyboards without function keys. Control keys in conjunction

with other keys enable you to perform complex operations with a minimal number of keystrokes.

THE MOUSE

The mouse is a pointing device that combines traditional cursor movements—accomplished by pressing cursor movement keys—with the means to select an object on the display screen. For example, when confronted with choices on a menu, you point to the selection of your choice by positioning the cursor with the mouse; then you press a button on the mouse to select your choice.

The original mouse was about the size of a baseball, moved on large wheels, and had three control buttons. Its appearance led to its name. The cord looked like a tail, the three buttons looked like two eyes and a nose, and the wheels elevating the body looked like feet. Today's mice are smaller and more elegantly designed, but the name remains the same.

Mice are now offered as a standard feature of the Mac and IBM Personal System/2, and as an optional feature for many other brands of computers. Many software packages incorporate optional mouse interfaces.

Mice are available in mechanical and optical versions. On the underside of the mechanical mouse is a ball that is similar to the trackball device . As the mouse rolls up, down, left, and right across the flat surface, a signal is sent to the computer that drives the cursor up, down, left, and right, corresponding to the motion of the mouse.

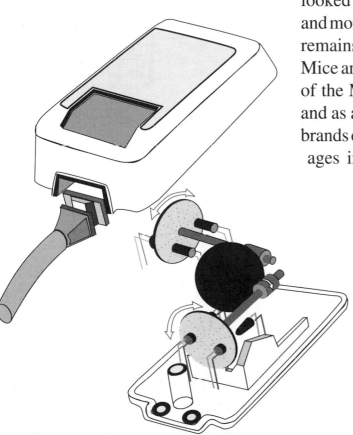

Internal view of a mouse

TOUCH TECHNOLOGY

The most natural of all pointing devices is your finger. Pointing with a finger is used in two important pointing methods: touch screens and touch pads. Touch screens are

LIGHT PENS

A light pen also utilizes the principle of touching the screen, but it does so with a hand-held pen that contains a light sensi-

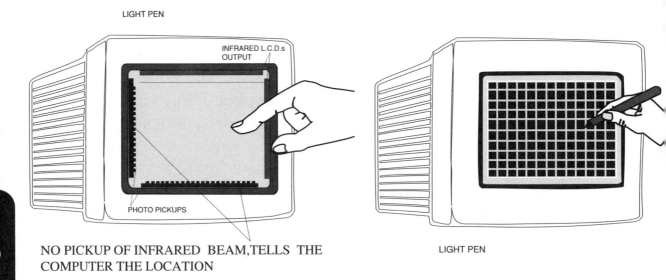

LIGHT PEN

INFRARED L.C.D.s OUTPUT

PHOTO PICKUPS

NO PICKUP OF INFRARED BEAM,TELLS THE COMPUTER THE LOCATION

LIGHT PEN

Infrared monitor

Light pen monitor

easy to use, especially in situations where you need information quickly. But touch technology is limited because it offers poorer resolution than that achieved by a mouse or other pointing devices. Fingers are simply too large for great accuracy, so a stylus often has to be used to accomplish detailed work. Also, touch-screen systems are produced in limited quantities; thus they are expensive to install on an existing computer screen.

tive tip. This is the device used by football commentators when they "draw" out a play on your television. It can pinpoint a spot on the screen with much greater accuracy than the human finger and it can be used to draw on the screen. Consequently, it is used in such intricate applications as computer-aided design where accurate drawing on the screen may be required.

Drawing tablet

DIGITIZED DRAWING TABLETS

Electronic drawing is also possible on a sensitized surface such as a graphics tablet. As the pen contacts the surface, a difference in electrical charge is detected and the drawn image is stored in the computer. This technique is actually a form of digitizing. The tablet contains a grid of sensor wires, and as the pen moves over the grid, it makes contact with specific points on the grid. In this way, continuous movement of the pen is translated into digital signals.

DIRECT-SOURCE INPUT

Time-consuming and error-prone transcribing can be bypassed by entering data directly from their source. This saves time by eliminating the step of pressing register keys. Another advantage is that it is usually a more accurate way of entering data. Sensors can record changes in temperature, weight, pressure, light, and odor—all of which may be useful as input to a computer. It is even possible to record the human voice as input. Voice-input systems can be trained to respond to a set of

simple spoken commands, such as "good" or "defective." You train them by recording the commands with your voice. The system can then match these stored voice patterns with spoken commands.

WHAT IS MEMORY?

Computer memory is generally classified by the nature of the accessibility of the information and is divided into two major categories: random-access memory (RAM) and read-only memory (ROM).

READ ONLY MEMORY

Plugged into the mother board of every computer is one or more computer chips that have been loaded with the basic input/output system (BIOS), the set of instructions that control how the computer functions. Like the neural instructions to our beating hearts, the computer cannot function without these BIOS instructions so they are loaded into Read Only memory where they are relatively safe and will reliably activate every time the computer is turned on.

In the Macintosh the ROM chips also hold the instructions that create the computers characteristic pull-down menus, windows and dialog boxes plus the diagnostic routines that check the health of the components and peripherals each time the computer is turned on.

RANDOM ACCESS MEMORY

Random-access memory (RAM) is a type of memory that can be read from or written to. It should be called read/write random access memory. Most RAM is actually dynamic random-access memory or DRAM; dynamic because it is constantly being refreshed with electrical pulses. A video display screen loses its image if it is not constantly refreshed. Because most RAM is dynamic, it is said to be volatile, that is, it loses its contents when the electric power is shut off. Virtual memory, a recent innovation, is a software sleight-of-hand that allows the computer to use unused hard disk space as if it were RAM memory chips. Virtual memory works by keeping the most active application and document segments in physical memory. Less-used segments of open applications

122

The basic operating premise is a set of on/off electrical switches which can be turned on and off in combinations to accomplish a given result (PROGRAMMING)

Groups of bits put together to create a byte can represent a graphic symbol like the (A) below. These graphic symbols represent text (visual symbol) on the monitor(CRT).

Memory is how many on/off switches you have available to make a program.

Each switch can be programmed to send two bits of information: ON or OFF.

On

Off

Off

2 switches= 4 bits

Off | On

| 1 | =BYTE=A language text

| 1 | 0 | 0 | 0 | 1 | 0 | 1 | 0 | =8

A	B	C	D	E
F	G	H	I	J
K	L	M	N	O
P	Q	R	S	T
U	V	W	X	Y
Z				

Monitor

Keyboard

4 switches= 16 bits

Off | Off | Off | On

8 switches= 64 bits or 1 byte

Off | On | Off | On | Off | On | Off | On

A This combination of switches could represent an A-Helvetica 12 pt., in black. B would be represented by a different combination of switches.

16 switches= 296 bits

Off | Off | Off | On | Off | On | Off | On | Off | On | Off | On | Off | Off | Off | On

123

Example of binary language which consists of combinations of 0 or 1 or On/Off

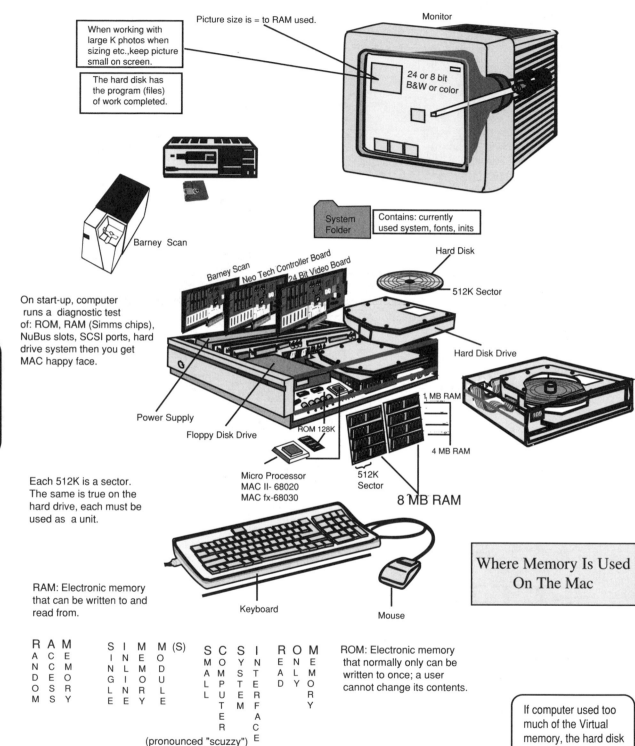

When working with large K photos when sizing etc.,keep picture small on screen.

Picture size is = to RAM used.

Monitor

The hard disk has the program (files) of work completed.

24 or 8 bit B&W or color

Barney Scan

System Folder

Contains: currently used system, fonts, inits

Hard Disk

Barney Scan Neo Tech Controller Board 24 Bit Video Board

512K Sector

On start-up, computer runs a diagnostic test of: ROM, RAM (Simms chips), NuBus slots, SCSI ports, hard drive system then you get MAC happy face.

Hard Disk Drive

Power Supply

1 MB RAM

Floppy Disk Drive

ROM 128K

4 MB RAM

Micro Processor
MAC II- 68020
MAC fx-68030

512K Sector

Each 512K is a sector. The same is true on the hard drive, each must be used as a unit.

8 MB RAM

Where Memory Is Used
On The Mac

RAM: Electronic memory that can be written to and read from.

Keyboard

Mouse

R A M
A C E
N C M
D E O
O S R
M S Y

S I M M (S)
I N E O
N L M D
G I O U
L N R L
E E Y E

S C S I
M O Y N
A M S T
L P T E
L U E R
 T M F
 E A
 R C
 E

R O M
E N E
A L M
D Y O
 R
 Y

ROM: Electronic memory that normally only can be written to once; a user cannot change its contents.

(pronounced "scuzzy")

If computer used too much of the Virtual memory, the hard disk will crash.

HARD DRIVE

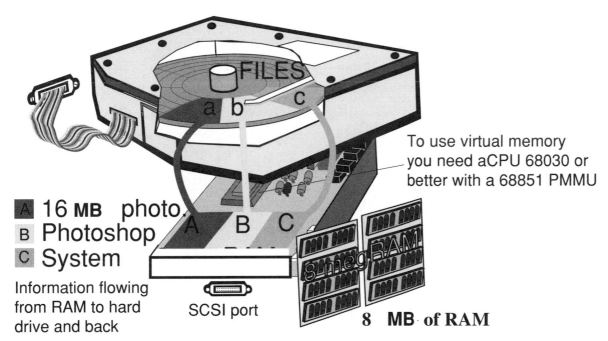

FILES

a b c

To use virtual memory
you need aCPU 68030 or
better with a 68851 PMMU

A 16 **MB** photo.
B Photoshop
C System

A B C

8 meg RAM

Information flowing
from RAM to hard
drive and back

SCSI port

8 **MB** of RAM

With virtual memory you can open a larger application than will fit in RAM at one time. The system keeps the most frequently used parts open in RAM and the least used in a reserved part of the hard drive, returning it to RAM as needed to complete the task.

Transfer of information using the hard drive as RAM memory when large amounts of memory are required to process a photograph

PERIPHERAL

and documents are kept in a special file on the hard disk. When an application needs a segment not currently in physical memory, the system software automatically swaps the least-used segment in physical memory with the needed segment on disk.

The dictionary says the word peripheral means "located on the outermost part of a region." Things are different in the computer world. Peripherals—such as color monitors, color printers, color scanners may be right in the center of things, but they are still peripheral to the Central Processing Unit (CPU).

125

FLOPPY DISK DRIVE

Floppy disks are thin circles of Mylar that have been coated with a film of magnetized substance. They are enclosed in a protective jacket with access openings for the drive spindle and the read/write head,. Floppy disks are the most popular storage medium for personal computers as well as for still video systems. The disks are available in several standard sizes: 2-1/4 by 2-3/4, 3-1/2, 5-1/4 and 8 inch.

The storage capacity of a floppy disk depends on the disk's density. The density of a disk is measured in two ways. First, the track density or number of tracks on the disk, is measured in tracks per inch. Second, the bit or linear density is the number of bits per inch per track. Early floppy disks had a track density of 48 tracks per inch and a linear density of 2800 bits per inch and came to be known as single-density disks. Through technological improvements, the linear density of floppy disks was doubled and therefore the capacity of the disk was doubled. These floppys came to be known as double-density disks.

Data is stored on a disk in sectors, which are segments of a circle, and tracks, which are circles of different radiuses on the disk. If you examine a floppy disk, you will find a small timing hole next to the spindle hole in the center of the disk. A beam of light shines through the timing hole while the disk is rotating and, on every revolution, the light beam marks the beginning of the disk so that electronic circuits can mark the relation of the read/write head to the sectors. Even though floppy disks come in standard sizes and densities, different operating systems will format disks differently. For example, the IBM PC cannot read the data stored on a Macintosh floppy disk, and vice versa. A 400K floppy will hold approximately 200 pages of text, an 800K floppy 400 pages.

FLOPPY DISK

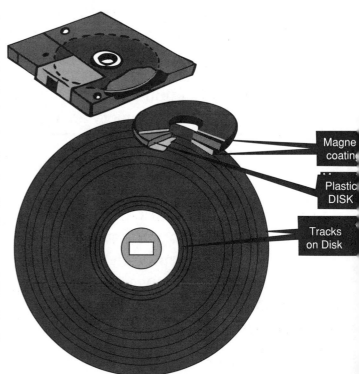

Magne coatin

Plastic DISK

Tracks on Disk

126

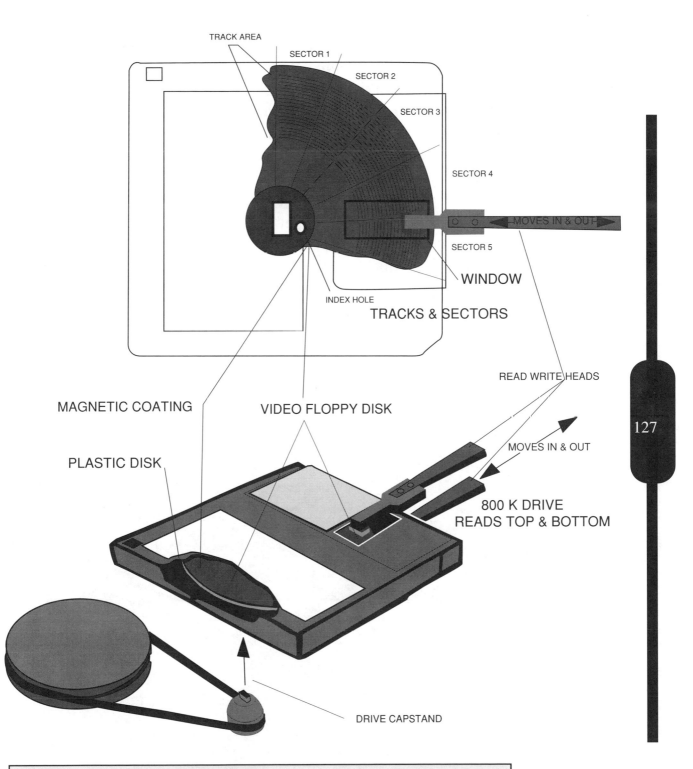

TRACK AREA

SECTOR 1

SECTOR 2

SECTOR 3

SECTOR 4

MOVES IN & OUT

SECTOR 5

WINDOW

INDEX HOLE

TRACKS & SECTORS

READ WRITE HEADS

127

MAGNETIC COATING

VIDEO FLOPPY DISK

MOVES IN & OUT

PLASTIC DISK

800 K DRIVE
READS TOP & BOTTOM

DRIVE CAPSTAND

Getting information and storing information on a floppy disk

HARD DISKS

Hard disks store data on rigid aluminum or ceramic platters coated with a magnetic oxide material. To a personal computer user, the capacity advantages of hard disks over floppy disks offer potential access to hundreds of programs without the nuisance of swapping floppy disks. In addition, the maximum size of files is much greater on hard disks and hard disks operate about 20 times faster than floppy disks, giving them a significant performance advantage. Because hard disks are rigid,

groups of disks can be stacked on the same spindle. Such an assembly requires multiple read/write heads for each surface; these are attached to access arms that move the heads to the desired track. As with floppy disks, the number of tracks and the density vary from disk to disk. When multiple disks are stacked, the term cylinder is used to refer to the imaginary surface formed by all the tracks directly above and below one another. Accessing data on a disk requires the mechanical movement of the access arm and the time it takes for the desired data to rotate under

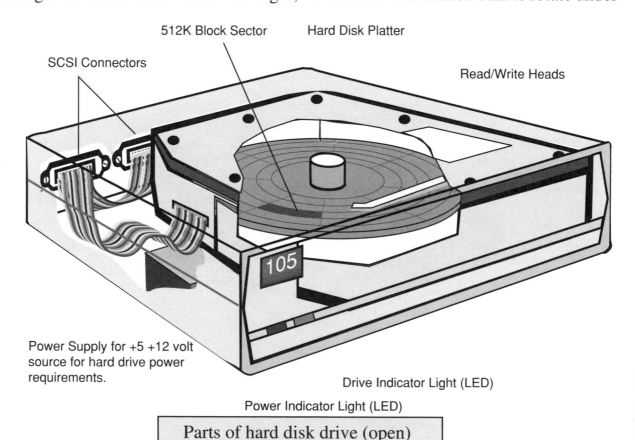

512K Block Sector

Hard Disk Platter

SCSI Connectors

Read/Write Heads

105

Power Supply for +5 +12 volt source for hard drive power requirements.

Drive Indicator Light (LED)

Power Indicator Light (LED)

Parts of hard disk drive (open)

the read/write head. The advantage of the cylinder approach is that data on several tracks can be accessed with one movement of the access arm. If you know a little bit about hard disk technology, caring for your hard disk properly will make sense. All disks have a magnetic recording surface. Data is stored on the disk as magnetic fields created by the movement of the read-write heads across the surface. When floppy disks operate, the read-write head skims the disk. Friction causes the disk to wear out and lose its ability to record magnetic fields without error. That's why floppy disks periodically fail and it's important to make frequent copies. Hard disks have smaller rotating heads. This allows greater precision of movement so data can be recorded more densely. With a hard disk, wear is not a problem because the disk head rides a hair's breadth above the disk surface However a stray piece of dust or a smoke particle can bump the head, causing the head to touch the disk, and ruin a part of the disk. This is the ominous "head crash". Fortunately hard drives are tightly sealed in airtight chambers to keep contamination out.

There is never enough memory. No one knows this better than the person using a computer to process color images. The memory requirements are daunting. But there are solutions such as external hard drives which can be cabled to the computer as easily as a printer or a scanner.

OPTICAL STORAGE

The optical disk, however, may be able to pick up where the high-density magnetic disk leaves off. An optical disk is a disk on which data is encoded for retrieval by a laser. Optical disks offer information densities far beyond the range of current magnetic mass-storage devices. Similar devices have been on the market for several years in the form of laser video disks and audio compact disks (CDs) for consumer use. These laser video disks are analog, that is, the disk contains one spiral track,

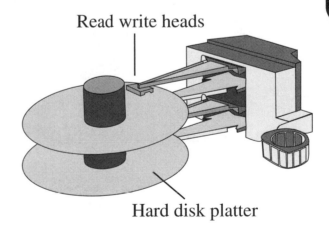

Read write heads

Hard disk platter

Hard disks and heads

like the track on a phonograph record. Optical disks for computer applications are digital and store their information on concentric tracks like their magnetic cousins.

COLOR MONITORS

Over the past couple of years, probably the most important development in the color monitor field has been the improvement in 24-bit color monitors. Technically, the difference between the 24-bit monitor and its 8-bit cousin is that the circuitry in the 8-bit monitor limits the number of colors that can be shown on the monitor at any one time to 256. The 24-bit monitor can display as many as 16.7 million colors at any given time. This may seem like a lot of excess color, given that a 1024 x 768 monitor can only display a maximum of just over 786 thousand col-

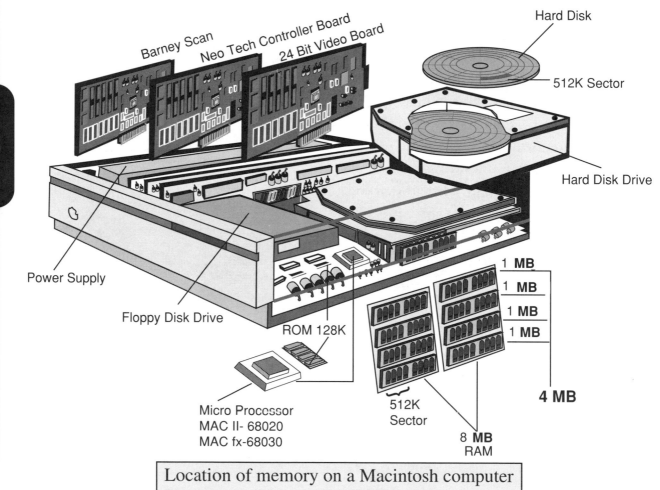

Barney Scan

Neo Tech Controller Board

24 Bit Video Board

Hard Disk

512K Sector

Hard Disk Drive

Power Supply

Floppy Disk Drive

ROM 128K

Micro Processor
MAC II- 68020
MAC fx-68030

1 **MB**
1 **MB**
1 **MB**
1 **MB**

4 MB

512K
Sector

8 **MB**
RAM

Location of memory on a Macintosh computer

ors at one time. Less than 5 percent of the total available. However, the more colors available, the greater the color possibilities and the more vivid the colors should appear. Do you need a 24-bit color monitor? You do if you're in the photography-graphic design field and doing work regularly requiring monitors. Compare the displays. Brighter is better. Contrast can be determined by putting half-white, half-black art on different monitors to judge which have the clearest separation between black and white. Keep in mind that storing all the extra 24-bit colors means

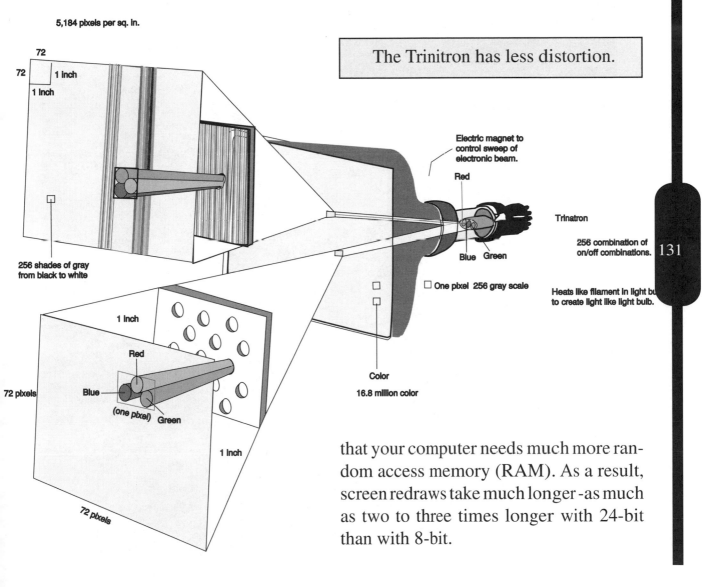

5,184 pixels per sq. in.

72
72
1 inch
1 inch

The Trinitron has less distortion.

Electric magnet to
control sweep of
electronic beam.

Red

256 shades of gray
from black to white

Trinatron

256 combination of
on/off combinations.

Blue Green

One pixel 256 gray scale

Heats like filament in light bulb
to create light like light bulb.

1 inch

Red

72 pixels

Blue

(one pixel) Green

1 inch

72 pixels

Color

16.8 million color

that your computer needs much more random access memory (RAM). As a result, screen redraws take much longer -as much as two to three times longer with 24-bit than with 8-bit.

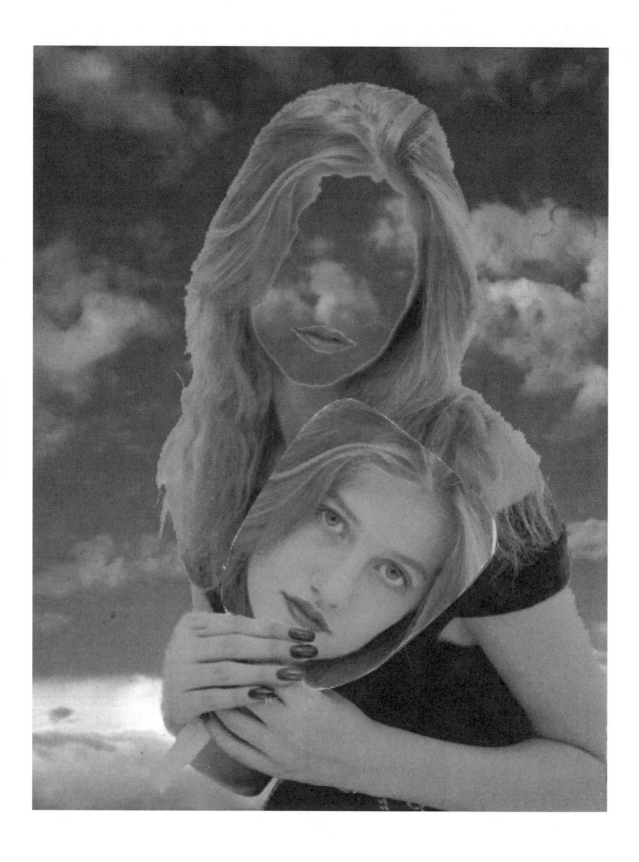

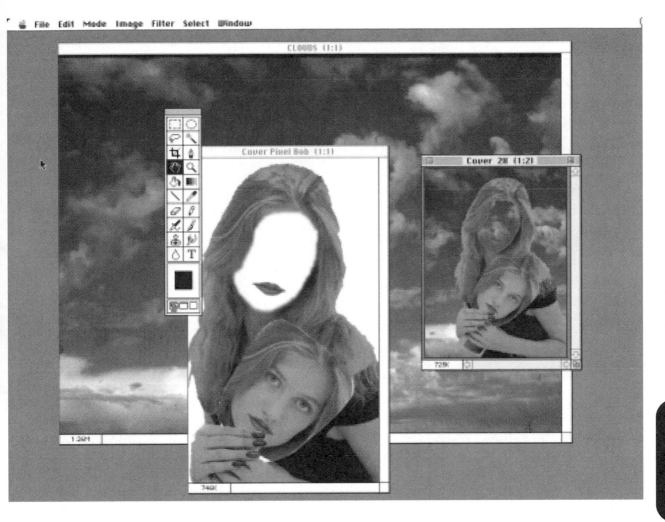

CHAPTER VIII, PIXEL EDITING

One of the popular notions held about computer imaging consists of the transformations made possible through the fingertip magic of pixel processing. It's almost all true. You can take away wrinkles and shadows and make the plain more beautiful by the manipulation of pixels. Any electronic camera or electronic importing device (slide scanner or flatbed scanner) creates an image on the computer through the CCD chip, digitzed through the eye of the device. It changes light to electrical impulses that the com-

puter understands which then go through a cable to the SCSI port committing it to memory. The software controls how much information is retained of the image in the computer's memory as a digital file, then displays it on the screen. It is selective as to the amount of energy stored as photographic images. Pixel imaging, one of the most exciting of the new desktop applications, consists of this electronic importation of a photograph into the computer, followed by its modification, enhancement, and eventual output. Once the

photo is scanned in and then stored on a disk or hard drive, the electronic image can be adjusted a number of ways.

When you work on a photograph you need a great deal of memory and a clear hard drive. If you have ample memory you can work quickly. Working on a finished photograph may require 15 to 20 MB of memory to hold and be able to manipulate the image. Open hard drive space is imperative. Keep space on hard drive so the image can access memory as needed.

PHOTOSHOP

Photoshop, a Macintosh program, can change one pixel into millions of colors or grab a group of pixels and exchange them or remove them, giving you control of every dot in the photograph. This is when the fingertip magic transpires. Once you have manipulated the pixels to conform to your specifications, the program makes a print of the new image which is now a reproduction of the original photograph. Photoshop's strongest point is its virtual memory which allows you to utilize unused hard disk space for large images. For systems which do not have enough memory to load an entire photograph and the pixel editing program at the same time, virtual memory is a great advantage. Some computers are limited to 2 to 4 megabytes of memory which is not enough to work on larger

photos. Only a portion of the image needs to be viewed on screen while editing takes place. Even though you are manipulating a small visible portion, the rest of the total image is stored in RAM. One square inch of high resolution image takes up about 250 K of disk space and several times that much to manipulate it in RAM. Simultaneously the entire image is actually being altered although it is not visible on the screen. The virtual memory in Photoshop works better than that in Apple System and later programs. If there is sufficient memory, a composite of images can be open at the same time but with only one image at active status. The images or several parts of the same image are windowed on the screen. Any modifications can be made to a specific selected area or to the entire image. It's a very simple process to control brightness and contrast. The person at the controls still has to take an active role in choosing the optimal amount of information displayed and stored. The photographer needs to know the amount of resolution needed to make the final printed image so that an excessive amount of memory is not used up in working and storing the image.

In a final print you may need 2400 DPI (Dots Per Inch) but you must understand the final product and choose the least amount of resolution (with a reserve) so that an excessive amount of memory is not used up unnecessarily. If you use up

Multiple windows open, two different enlargements for retouching

too much memory while the image is being worked on, it will slow down processing the print. Students often scan images at higher resolution (300 to 600 DPI), assuming that the final print will be a better quality. The maximum resolution needed to work on an image is 72 DPI which when printed on a laserwriter will be 300 DPI. It is best to use as low a DPI as possible. The print will still come off with a high resolution. Video

images, like photographs, are considered analog images. These images have a continuously changing range of brightness values going from solid black to solid white with an almost infinite number of shades of gray. The digitized image is actually a discrete gray scale approximation of the original analog image. Photoshop uses 256 brightness levels to recreate a digitized image in

black and white or color which is then multiplied 256 RGB to 16 million colors; therefore color photo retouching must deal with a complex set of variables and millions of colors and not just a mere 256 tones. When we view color, we have three elements to view: hue (type of color), saturation (purity of color), and brightness (the intensity).

In an image which contains 16 million colors, the human eye can easily detect changes in these elements. To achieve the same perception of continuous tone as with a monchrome image, many more colors are necessary to make it believable.

Programs have multiple types of select lassos and you can precisely set the tolerance by telling them how many gray or color values above and below the specific point to include. You can also set an absolute threshold above or below the value which lets you isolate a particular value or range in an image. With full color 24 bit editors, the operator can have the option to protect completely or not protect. It gives you the ability to control amounts of pixels from one image to the other and the exact area that they will fit into. This type of variable protection is a powerful tool for achieving or enhancing realism or for producing special effects on a photo.

Generally speaking, any 24-bit color paint program can be used to do a substantial amount of high quality editing. Some photo editing programs excel at

image editing chores that are counterparts of conventional photographic and retouching techniques such as darkening and lightening, altering color balance and selective colorizing. They also make it relatively easy to select, manipulate, and add parts.

Most color image editors offer a way to protect or mask parts of the image from editing. The mask can be the shape of a selection, built up of multiple selections, or just drawn. The program can isolate and select the parts of an image you might want to mask. All the selection and image tools work hand in hand with the masking features.

IMAGE CONTROLS

Photoshop has image controls allowing you to work with "paint brushes" and filters such as sharpen and blur. If you have a picture with a relatively light sky and a foreground made up of darker shades, you can duplicate clouds in the sky using image controls without affecting the mountains that form the horizon.

PASTE CONTROLS

The paste controls work using a similar principle but include features useful in cut and paste work. You can speciify that pastes replace only the sky shades. You could then forget about painting clouds and simply drop in a dramatic sunset behind your mountains.

Smudge tool

Pen tool

THE STAMP TOOL

This is one of the most useful tools for retouching. The stamp permits you to pick up a small section of an image and paint with it. Photographs rarely contain smooth tones and without the stamp or the use of a similar tool, touched up areas can look unnatural. With the stamp you can actually move unblemished areas of a face to disguise a dark spot or shadow. For instance, you can click on an eye and then click a second time for the new position of the second eye in another location. As long as you hold down the mouse button you'llreproduce the eye in the second location. The original eye will also remain.

The auto select feature, which searches for the edges of pixels with similar values, allows you to select objects in a picture without manually lassoing them

137

IMAGE GRAPHING

A good program holds the original image in RAM and stores copies in buffers in order to give you levels of undo. But the buffers use up memory.

Graph data provided for an image that you are working on can show the distribution of values in an image. This type of histogram can be very useful when you are trying to identify image problems.

Image curve for changing color and contrast

138

Color types

TYPES OF COLOR

When you see color, we have three elements to view: hue (the type of color), saturation (purity of that color), and brightness (the intensity). In an image which contains 16 million colors, the human eye can easily detect changes in these elements. To achieve the same perception of continuous tone, as with a monochrome image, many more colors are necessary to make it believable.

THE RGB

The RGB system has various brightnesses of red, green, and blue light which combine to form the colors of the spectrum.

THE HSL

The HSL system; color is defined by its hue (depending upon the wavelengths of light present), saturation (purity of light depends on the number of different wavelenghts present), and lightness (brightness which is dependent upon the amplitude of light waves).

139

THE PMS

In the PMS system or Pantone Matching System a standard is provided for the reproduction of colors with a system of premixed inks. Printed color swatches are assigned identification numbers. Pantone colors are specified as spot colors and don't play a big role in editing the continuous-tone photos reproduced in scanned imagery but this system of color identification is widely used by the commercial printing and publishing industry.

THE CMYK

The CMYK (Cyan-Magenta-Yellow-Black) is a subtractive color system in which the colors of the visible spectrum are mixed by overlaying various densities of cyan, magenta, yellow, and black inks usually in very fine patterns of extremely small dots. These patterns are called halftone screens. The system is called subtractive because the printed inks absorb or subtract certain wavelengths of the white light that hits them, reflecting the color that remains. If you are seeing red, all light except the red is being absorbed. Black ink is added or substituted to sharpen the dark colors.

The art of manipulating photographic images can be traced back to the early days of photography. There is little to indicate a "photographic reality" ever existed.

Not long after photography was invented, photographers learned they could perfect the new found photographic images by such techniques as retouching, hand coloring, and combination printing of negatives. Of course, not everyone was pleased with this type of trickery. By 1856, a series of angry letters appeared in the Journal of the London Photographic Society, complaining about the manipulation of photographs. In particular, the protesters wanted retouched photographs banned from all society exhibitions. The campaign was to no avail. Much later, a photography historian wrote, "...retouching had reached such proportions, it seems, that it became difficult to find photographs which had not been embellished by hand." As early as 1859, the now-familiar technique of double exposure was described in detail by English photographer Henry Peach Robinson in a booklet with the revealing title On Printing Photographic Pictures from Several Negatives. The popularity of photographic manipulation continued from John Heartfield in the 1920s to the artistic multi-image creations of Jerry Uelsmann today. And now, there is a new tool, the computer.

If nearly every kind of image manipulation can be done in the darkroom, why bother using computers? There are two reasons. First, changes in a digitized picture made by computer are reversible, which makes experimenting with different transformations much easier. Second, not only can the computer mimic with programs everything skilled professional lab workers do in the darkroom with light and chemicals, it can also produce images that are nearly impossible to create any other way.

During the Renaissance, the goal of a painting was to accurately reproduce the lighting and depth of a scene. Once accomplished, goals shifted to such interests as telling a story, capturing a mood.

Perhaps photography ought to head in a similar direction. We must look closely at what must be communicated and find ways to do it. What's beyond photo realism, then, isn't more visually accurate images that can be rendered in less time but tools to help others communicate messages graphically.

Electronic imaging brings photography into the realm of illustration because it doesn't "let" reality get in the way. We are all subject to the limitations of time and space, but photographers now have more freedom to create because of the advent of electronic imaging.

CHAPTER IX, PAGE LAYOUT

The desktop publishing revolution may rival the importance of Gutenberg's invention of movable type almost 500 years ago. The final products of a desktop system are camera-ready or plate ready documents that can then be printed or reproduced. More than a few people believe it all began the day Paul Brainerd lost his job as an executive with a company that manufactured publishing systems for newspapers and magazines. That was 1984. He had an idea. So he gathered a group of engineers around him, used his life savings as a stake, and started Aldus Corporation, naming the company for a 15th century Venetian printer. Within several months they produced the PageMaker program, the first software publishing link between the Macintosh and the LaserWriter printer. PageMaker was the first program to easily integrate text and graphics, eliminating paste-up by putting the composition process on screen. Traditionally, publishing involves a number of specialists. A graphics designer designs the publication, a typesetter sets the type, a camera operator creates halftone screens of photographs, and pasteup artists put it all together. Now, desktop publishing enables us to set type, create images, and do the work of the paste-up artist electronically. Electronic layout is so fast and easy, it's possible to experiment with different designs until we achieve the effect we like, thus reducing the need for an outside designer.

INTERACTION WITH A COMPUTER

This concept of interaction between a person and a computer is called user interface as opposed to computer interface, mean-

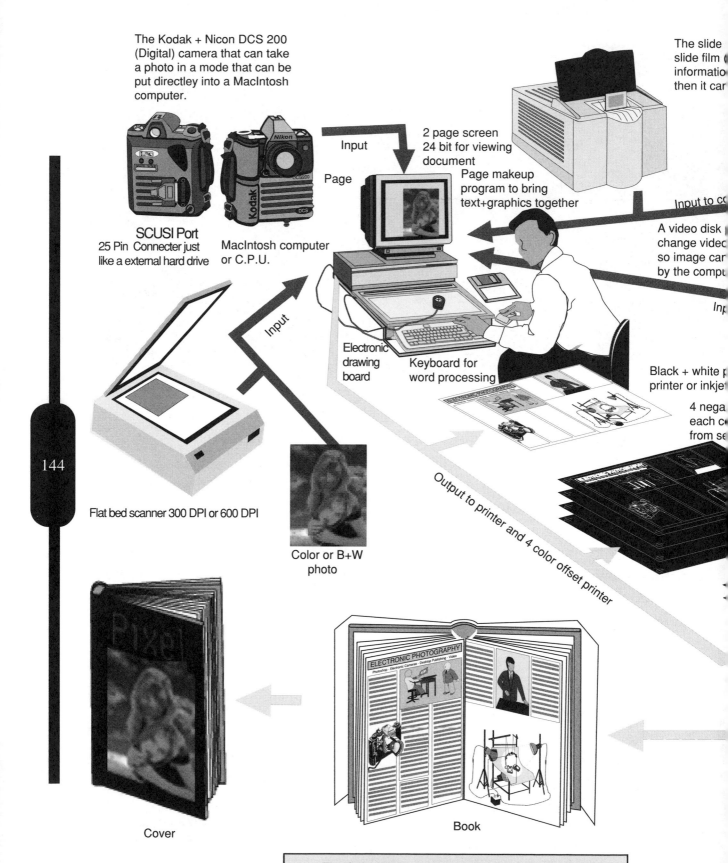

The Kodak + Nicon DCS 200 (Digital) camera that can take a photo in a mode that can be put directley into a MacIntosh computer.

The slide
slide film
informatio
then it car

Input

Page

2 page screen
24 bit for viewing
document

Page makeup
program to bring
text+graphics together

Input to c

A video disk
change video
so image car
by the comp

Inp

SCUSI Port
25 Pin Connecter just
like a external hard drive

MacIntosh computer
or C.P.U.

Electronic
drawing
board

Keyboard for
word processing

Black + white p
printer or inkjet

4 nega
each c
from se

Input

Flat bed scanner 300 DPI or 600 DPI

Output to printer and 4 color offset printer

Color or B+W
photo

144

Cover

Book

Desktop page make up from photo to book

zes a 35mm
ositive) into
by the computer,
to the document.

35mm slide

Image

(Analog)

The video disk camera
will take an image and
store it on a video disk.

INPUT

Desktop publishing is possible because you can bring text, illustrations and photographs (color or black and white) into a page makeup program, place all elements onto an electronic page then view it on a C.R.T., move elements around, change their size and placement on a page that can be changed.

Video disk will hold
up to 50 images.
(Photos)

ed

er

er

4 sheets of plastic overlayed
to make a 4 color proof.

am.

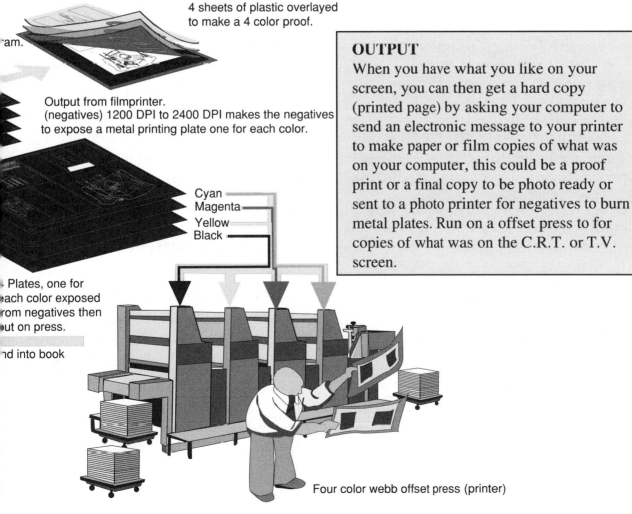

Output from filmprinter.
(negatives) 1200 DPI to 2400 DPI makes the negatives
to expose a metal printing plate one for each color.

OUTPUT

When you have what you like on your screen, you can then get a hard copy (printed page) by asking your computer to send an electronic message to your printer to make paper or film copies of what was on your computer, this could be a proof print or a final copy to be photo ready or sent to a photo printer for negatives to burn metal plates. Run on a offset press to for copies of what was on the C.R.T. or T.V. screen.

Cyan
Magenta
Yellow
Black

Plates, one for
each color exposed
rom negatives then
ut on press.

nd into book

Four color webb offset press (printer)

145

ing computer to computer. If you want to interact with a computer the best way to do it is via the Mac's desktop design. You move the mouse around so that the cursor points to the Apple logo in the upper-left corner of the screen. Hold down the mouse button. The pull-down menu will appear. This is the desk accessory menu and from this list you can choose the function you want the computer to perform (within reason and those functions that appear on the list!!!). If you are starting a new project you OPEN a new file and give it a title. Now you can begin typing a newsletter or a novel. As you will learn, there are many functions and one application menu may have several command menus for each program.

SOFTWARE THAT FITS THE JOB

By changing software, the purpose of the computer can be directed to fit different jobs whether it be typing manuscripts, spreadsheets, digitizing drawings and photographs, or working with page layouts. The incomparable Pagemaker allows you to do a one-page theatre announcement, a newsletter, or a 200-page book.

PAINT PROGRAMS

These programs allow users to "paint" a picture on-screen using icons which look like paintbrushes, spray cans, and even pencils. Paint programs are pixel-oriented.

They allow the user to have control over the image down to the individual picture element (pixel) or dot.

DRAW PROGRAMS

These programs are like paint programs in that they give the user complete freedom in creating images on-screen. However, these programs are object-oriented, not pixel-oriented, which means that users create the images by combining various building blocks such as circles, rectangles, angles and lines.

ILLUSTRATION PROGRAMS

These programs, primarily used on Apple Macintosh systems, specialize in the creation of curves and high-quality line art. They allow the user to import a scanned image, trace the image using special curves and lines, and add color and shading gradations. Adobe Illustrator and Aldus Free-Hand are examples.

PHOTO RETOUCHING PROGRAM

These programs, again primarily used on the Macintosh, enable photographers and image processors to do more on the computer than can be accomplished in a traditional darkroom. You can manipulate contrast, sharpen or soften, flip, crop, retouch, and completely alter any image that can be digitized Photo Shop, ImageStudio

146

and Digital Darkroom are retouching programs which also allow you to change colors or patterns and remap gray levels.

DESKTOP PUBLISHING PROGRAM

These programs allow users to manipulate and integrate the text and graphics parts of a document, typically in WSIWYG - what you see is what you get on screen. Aldus PageMaker, Letraset's Ready, Set, Go, and QuarkXPress are well known examples.

DESKTOP PRESENTATION

These programs automate the production of all of the elements associated with formal presentations including text charts, diagrams/slides, speaker's notes, and audience handouts.
There is a rapidly emerging body of software programs that integrate digital sound, video, graphics, animation and text. The general phenomena is called multi-media. Computers and CDROM's (Compact Disks loaded with Read Only Memory)in their new partnerhsip are producing exciting educational packages, film composites, and video games that truly rival those seen in arcades.

MAKE A COPY FOR BACK-UP

First load the page make-up disk and make a set of copies in case of mishap: earthquake, fire, electric failure, or the children decide to disconnect your life support while you gct a cup of coffcc.

CREATING MASTER PAGE

You create your first page by creating a master page that wil not actually be printed. Every page hereafter will be created in the image of the master page and it will be dictated to every left and right pages as to layout. This master page can be overruled on any given page but will be there when you start another new page throughout the entire document. You can make changes if you want to add or delete something.

PLACING TEXT AND GRAPHICS

Next step, choose from the menu, the "place" file for entering material previously made-up using the MacWrite, MacPaint, or other discs . You will place documents into the preformed page (page-make-up) which you have already designed. You may also "paste" text and graphics onto the page from the "clipboard" or "scrapbook". If you are well-organized, you will have originally used disks that have been made up for ultimately placing into the page layout.

147

Place the disk into the disk drive while in "place" and a dialogue box will appear with a list of documents that can be set-up. These could be in any of the programs that will work with PageMaker. Depending on which program you are using at the moment, a symbol for MacWrite, MacPaint, or MacDraw will appear on the monitor's screen. You then move the symbol (by controlling the mouse) into column grids and the text will flow to the end of the column. You can then place the text in the next column or in a column on another page. This word wrap will continue to function for up to 100 pages. If your text is lengthy, you must start a new word wrap every 100 pages. Once all the text and graphics are placed to your satisfaction, what you see is what you get.

Page- 400% enlargemnt

DISPLAYING

Displaying is a function of the menu. PageMaker has several display possibilities. You can view the page at its actual size of either 50%, 70%, or 200% enlargement.. There is also the option of viewing the lefthand or righthand page together, allowing you to see how the actual page will appear as a pair.

File -Place

Page- 400% enlargemnt

SAVING YOUR MATERIAL

You do not wait until your document or text is completed before you save because if the power goes off you will lose all of your material. Everyone has had at least one tragic occurrence with material disappearing before your eyes because a save wasn't made. First you have to make a file by going to the File menu and pulling down to Save As which will give you a dialogue box asking you to title your document. Type a title into the box, go to Save, and your new title will appear in the menu bar. After every few paragraphs, it is very wise to go to File menu and pull down to Save.

ADOBE ILLUSTRATOR

The above drawing programs are based on the screen-oriented bit-mapped system or the object-oriented system which is a series of anchor points connected by curved or straight lines. Serious computer artists rely on using both systems. The advantage of the bit-mapped programs are that you are very free to create as an artist, building a form pixel by pixel. Pixels are the dots that make up the screen. The advantage is that what you see on the screen is what the picture will look like. The disadvantage is that you cannot expand or contract the picture without loss of quality. If you expand too greatly, the stairstepping necessary becomes obvious

and detracts from the illustration. The result is similar to an overenlarged photograph. Available screen-oriented programs are: MacPaint, FullPaint, and Cricket Draw which all use a combination of the screen-oriented and object-oriented systems printing in PostScript.

In the object-oriented system, illustrations are stored as a description rather than a painting so there is no loss of resolution when the graphics are enlarged or reduced as in the screen-oriented systems. The graphics images can be transferred into PageMaker and Ready, Set, Go 4 which are page makeup programs for combining text and graphics.

The advantage to the object-oriented program is that the illustration is linked together with anchor points. The number of pixels between the anchor points is determined by mathematical formula. Objects or illustrations can be made larger or smaller without loss of quality because as the anchor points are moved either closer or further away, pixels are added or taken away. The illustration will be the same quality whether the size of a postage stamp or ten feet square.

The project can be worked on in many different layers. It's like drawing on top of several sheets of plastic while you are able to see through five or six layers. The illustration can be viewed as a separate entity or you can deal with one layer at a a time beore returning it to its position in the stack. For color printing, each layer

Windows - Toolbox

can be printed by the laser writer separately.

These programs lend themselves well to measurements on screen such as for architectural drawings since you can manipulate your graphics. You can enlarge one small part of a drawing to facilitate working on a detail

PREPARING ILLUSTRATIONS AND PHOTOS

The MacDraw program, as opposed to the MacPaint program, is the best to use in conjuction with the laser writer for drawing and illustrating because of its fill edge option, meaning that it produces lines with clean edges not needing touch-up. Photoshop is a digitizing system which can bring a printed photograph into a Page Maker or QuarkXPress program to be used in a document. With this system, you can also digitize a drawing, illustration, or any prepared flat art work into a document that can be used for placing into final form on the PageMaker. Documents must be saved in PICT format on a disk for illustrations. As you need illustrations, you pull

them off the reserved disk and onto the PageMaker where you can resize and reshape them. This is especially handy for cropping pictures and reforming borders. Photo shop must be used in conjuction with a scanner or video camera in order to digitize a photograph or art work, meaning to break up the image into pixels (black dots) that register on the computer screen. Once you have the image on the screen, you can reduce it, elongate it, rotate it, and actually clean up a rough drawing. This image can be saved as a file to be placed in a later document.

WINDOW ON 8 and 1/2 BY 11 SCREEN

You are working on a 8 and 1/2 by 11 page but you can only view 1/3 of it through the window (computer screen). If you wish to view the whole 8 and 1/2 by 11 inch document in its entirety, although greatly reduced due to the necessity of compressing it into the display area, you must double click on the hand displayed in the menu bar or you can go to the Goodies menu and pull down to Show Page.

If you want to view a particular section of your page, you merely have to move the window to that part of the page you want to see by moving the cursor into the dotted rectangle to the desired area.

Digital photograph, by student Mike Smith

LASSO AND SELECTION RECTANGLE

You have to use the lasso or selection rectangle to activate an area that you want to change. Allows you to draw a dotted rectangle or circle around an area you wish to manipulate. You do this by holding down the mouse and drawing a blinking, dotted line around the picture or area you have selected. Some of the operations that rely on this procedure are Cut and Paste, Flip Horizontal or Vertical, Rotate, Trace Edges, and Move Objects.

GRABBER

Lets you reposition the MacPaint canvas so you can see any part of it through the window.

TEXT

Selects the text entry mode. First decide where you want to begin your text on your imaginary page or canvas. Move the cursor to this location and click the mouse to set the insertion point. Now you can begin typing in text on the keyboard.

PAINT BRUSH

Gives you a paint brush for freehand painting on the window or canvas. If you hold down the shift key, you can use the paint brush to draw straight horizontal or vertical lines. Choose from 32 different paint brushes by double-clicking on the paint brush or go to the Goodies menu to Brush Shape.

PAINT BUCKET

This function is used when you want to fill in a particular area. You first choose a pattern from the pattern palette. Position the paint bucket in an enclosed shape on the window. Click the mouse and the entire area will be filled in with the pattern of your choice. *THE AREA THAT YOU WANT FILLED MUST BE ENCLOSED BY AN UNBROKEN BORDER OR THE PAINT WILL LEAK OUT INTO OTHER AREAS OF THE SCREEN.*

PENCIL

Gives you a fine pencil for freehand drawing and writing. This function is useful in touching up graphics objects with the Fatbits command in the Goodies menu. As with the paintbrush, if you hold down the shift key, the pencil can be manipulated to draw straight lines.

SPRAY PAINT

Spray paint is a function that allows you to cover the screen with different patterns. You simply hold down the mouse button as though it were a real can of spray paint.

LINE

Allows you an easy way to draw straight lines. Select the line tool from the menu and after moving the cursor to the window, press the mouse at the point where you want the line to begin. Move the cursor toward the end of the line. Release the mouse button when you want the line to stop.

ERASER

Like a chalkboard eraser. Move the eraser out to the window and hold down the mouse button while you erase. If you wish to adjust a drawing bit by bit, you can go to Fatbits in the Goodies menu.

If you want to use another type of application like MacDraw, you would go to File menu, pull down to Quit. Desktop will appear. You can then choose any application that is on the Desktop such as MacDraw, Cricketgraph, or put in another disk with other applications like Page-Maker. If you are operating with a computer that has a hard disk drive, you will have as many as 10-20 different applications possible to choose, open, and activate.

PREPARING THE PHOTOGRAPH

You enter the photo into the computer by using the Photoshop program for photoimaging. Give a title to your file and place all photo info for each project on a disk labeled specifically for that use.

You can always change these details later but it is best to have a size equivalent to the

needs of the final project so you know how well you are matching the requirements of the page. By making these choices now you will be able to conceive how the final document will look. What you don't want to have is a photograph that requires much cropping because the memory will retain all of the cropped information thus making the file larger and taxing the precious memory. More memory requires longer printing time and time equals money.

Photoshop- Tools

High contrast photograph

INSERTING A PHOTO

When you want to add or alter a photo, a letter, or an entry you need to highlight the space where the change is desired. Press the mouse button and it will change into an insertion point. Deleting is useful if you are removing a photo and replacing it with another photo or text.

You will use this function when you want to change a photo's location, resize, remove or move photographs around in your text . You have the option of storing portions of the photo in the clipboard so it can be inserted later. Place the insertion point at the exact letter or space where you want to place a photo. Press and hold down the mouse button to select and move photo. Release the mouse button when you come to the point at which you wish the selection to end. Only the selected portion will remain blackened. If you want to simply remove due to an error or change of mind, you can press the space bar and the photo will disappear.

Windows- -Tool box-Styles-Colors

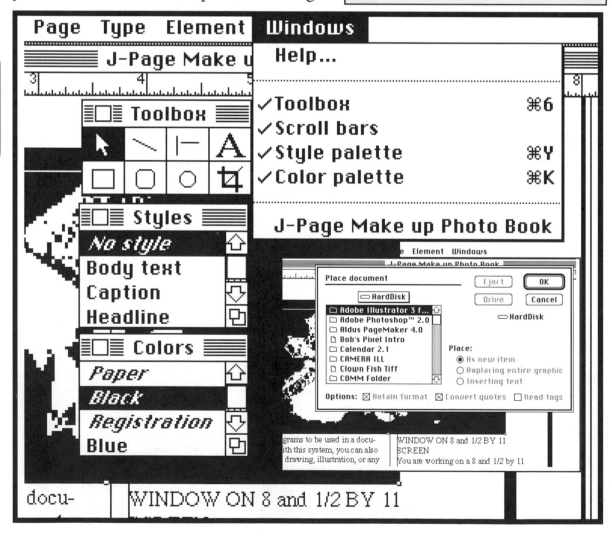

155

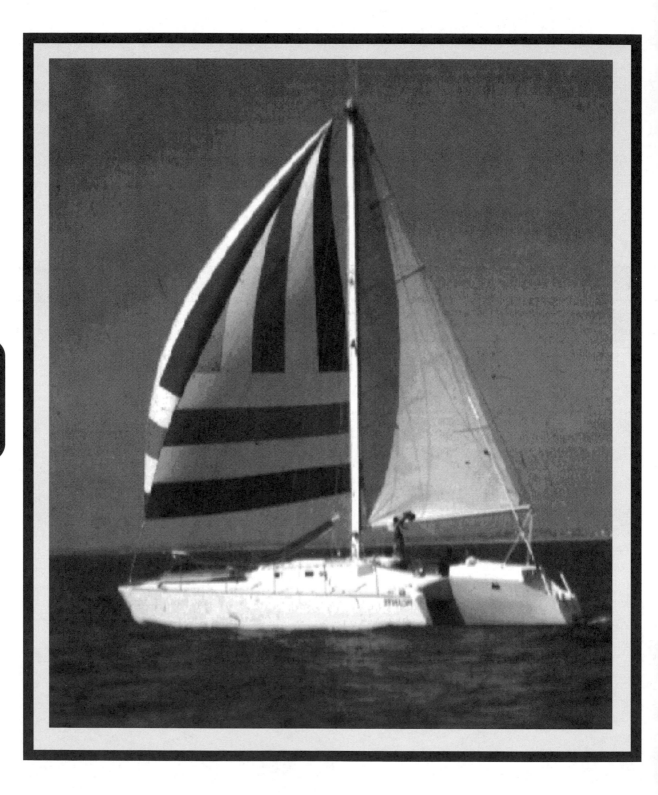

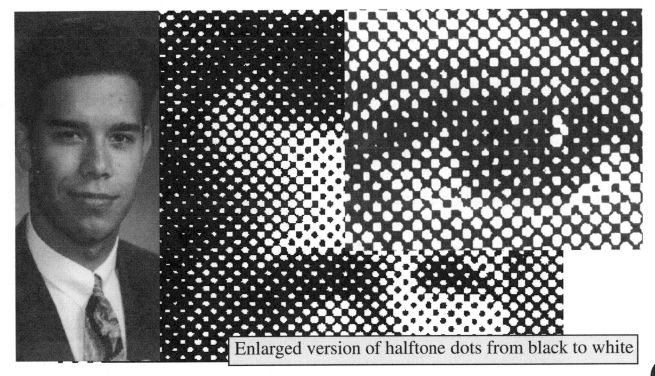

Enlarged version of halftone dots from black to white

CHAPTER X, PIXELS TO HALFTONE

Gray scale perception does not always match reality. Printing presses and imagesetters see everything in black and white. To understand reproduction you need to understand how monochrome devices like presses and imagesetters create the illusion of shades of gray, then of the whole spectrum of living color. Like computers, offset presses are binary. They express themselves in ink on or ink off. To fool the eye into seeing shades of gray, printing presses use a halftone process where ink is laid down in regularly spaced dots of varying sizes with small dots for light shades and large dots for dark. Half-

157

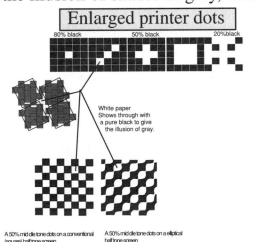

Enlarged printer dots

80% black 50% black 20%black

White paper
Shows through with
a pure black to give
the illusion of gray.

A 50% middle tone dots on a conventional
(square) halftone screen

A 50% middle tone dots on a elliptical
halftone screen

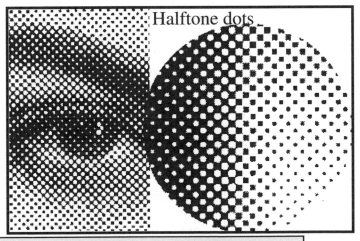

Halftone dots

Halftone dots printed on a laser printer showing how the pattern changes

tone negatives are produced by photographing the original artwork through a screen grid of fine, regularly spaced opaque lines running at 90-degree angles.

The holes in the screen act like pinhole lenses, producing dots on the film that are proportional to the amount of light reflected from the original art. Light areas or high lights, reflect the most light and produce the largest dots on the negative. Dark areas or shadows, reflect the least light and produce the smallest dots. The middletones produce varying dot sizes in between the extremes. While the dot sizes vary, the distance between the centers of the dots remains constant. When a positive is made from the halftone negative, the highlights have the smallest dots, the shadows have the largest, and the middletones have varying intermediate sizes - and the eye sees shades of gray.

Printed dots do not land on the paper in a random pattern. Halftone dots repeat on an angle called the screen angle which in black-and-white reproduction is most often at 45 degrees. Dots placed at this angle most easily deceive the human eye and brain into seeing grays. The most important key to a good electronic halftone is gray-scale. This is exactly what it sounds like: a scale of grays. Continuous tone images (photographic prints, charcoal sketches, pencil drawings) contain black, white or 256 gray scale.

A halftone tries to reproduce these varying densities of the original. Density is the

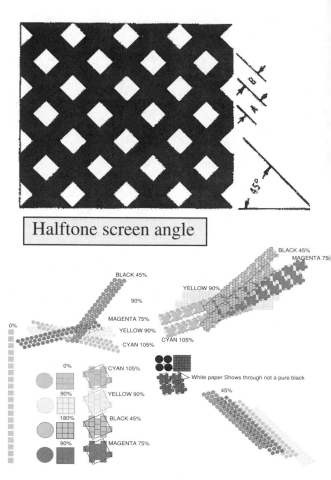

Halftone screen angle

Computer generated halftone screen angles

light-stopping ability of any material. A white surface, for example, has much less density than a yellow or black surface because white reflects a much greater amount of light. Black ink on white has a far greater density range than dark blue ink on yellow.

Sometimes the density range in the original is greater than can be produced in the reproduction. Densities are assigned specific numbers based on the amount of light they reflect. A pure white that reflects 100 percent of the light hitting it has a density

158

value of 0.0. A very dark black in a photographic print has a density range of 2.00. If one photograph had all these densities, the copy density range would be the difference of the highlight subtracted from the shadow or a CDR (copy density range)of 2.00. Printing color uses the same halftone principle, only multipled times four. To fool the eye into seeing full color rather than shades of gray, the print industry uses four-color process printing. The four-color process prints four superimposed halftones, one each of the three subtractive primary colors of cyan, magenta, and yellow plus a

black plate. In theory, you can reproduce the full range of printable color using varying intensities of cyan, magenta, and yellow: By adding 100 percent of each, you should get black. In practice, overprinting 100 percent of each color produces a muddy brown and completely saturates the paper so black is added as a fourth color.

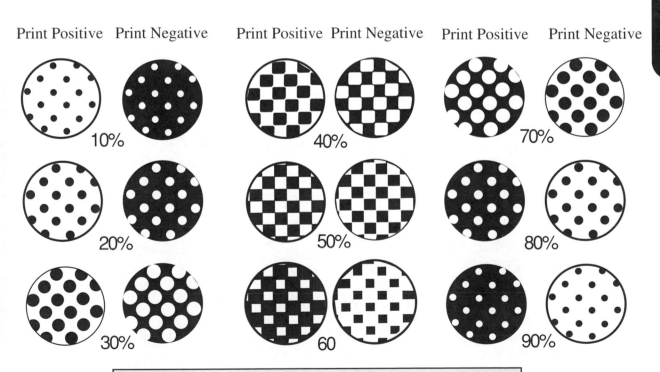

| Print Positive | Print Negative | Print Positive | Print Negative | Print Positive | Print Negative |

Percentages of gray scales, negatives and positives

SCANNERS AND HALFTONES

The number of bits your scanner uses to describe and store the information captured for a single photo determines the number of gray levels it can reproduce. If the scanner uses only one bit per sample to describe the value, it can define the value only as on or off, black or white. But if your scanner allocates more bits to each sample, it can store more information. That means more combinations of on and off. A single bit (line art) scanner can only give you two gray levels (black and white); a scanner with two bits gives four gray levels; three bits give eight and so on. An eight-bit scanner will give 256 possible combinations which is enough capability to plot a single gray value on a gray-scale from 0 to 256. Input resolution refers to how small an area of the photograph your scanner can sample and describe. That is, how many different values in a given measure (usually a linear inch) can the scanner detect and register. The average black and white desktop scanner these days has a rating of 600 samples per inch, though you can often lower this setting. A scanned image of one-inch by one-inch will have 360,000 samples of information.

Gray scale model

Kodak-Photographic gray scale

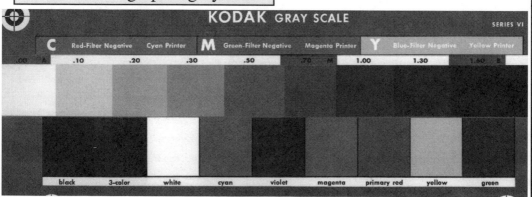

160

than is available with a conventionally made halftone. The scanner can create special effects like mezzotints, vertical lines, horizontal lines, or wavy lines at the same time it is screening a regular halftone. Film halftones shot with graphic arts cameras give the best halftones simply

Column scanner

You change the gray scale in a halftone by changing the size of the dots. You change the resolution, just as with laser printers, by putting more dots in the same amount of space. The finer DOT or screen size the better the resolution. Newspapers generally work with 60 or 90-line screens, resulting in clearly visible grains. Magazines and books, using better paper, use finer screens such as 133- and 150-line.
I use a densitometer to read the highlight and shadow ends of a photo. I then make a judgment about areas of the photo that would benefit from detail enhancement. The scanner can actually see detail in a photo that the eye can't detect, and this detail can be enhanced to show up in the printed reproduction. In a "flat" photo, I can increase the contrast and, in general, which gives a more accurate reproduction

because of the nature of film and offset printing. They let you produce grains of any size from full grains (appearance of black), down to very tiny grains (appearance of gray), to no grains at all (appearance of pure white).

8 1/2 by 14 paper inch tray

8 1/2 by 11 paper inch tray

Laser printer

LASER PRINTER HALFTONES

If you want to simulate a halftone, use a concentration of the laser printer dots to make up a halftone grain. Laser printers print dots within a matrix. You cannot change the size of a dot but by turning the laser printer dots on and off, you change the size of the halftone grain. The dot patterns used to create the grains, the number of dots to a grain and how they are grouped determines the size and shape of the halftone grain. Suppose you use a five-by-five matrix of dots to make up your halftone grain. This gives you wide flexibility in gray scales because there are 25 dots to turn on and off in sizing the grain. But at 300 DPI, a five-by-five matrix only gives you 60 grains to the inch (300 divided by five)—not very good resolution even by newspaper standards. You can decrease the size of the halftone grain, using fewer dots to make it up, and that increases the resolution, but then you lose

gray scales—there aren't as many dots to turn on and off.

What this all means is that you can't do much of a halftone at 300 DPI. Either you have lots of gray levels or you have a really fine screen. You must go to a print out device with more dots like a 2400 photo printer. The higher screen frequency gives you more lines (dots per inch) and a finer halftone.

DOTS PER INCH - GRAY TONE

With the computer there is a tradeoff because higher screen frequencies actually produce fewer gray levels. How many gray values you'll actually get depends on a mathematical relationship between the screen frequency and your printer's resolution. Simply divide the resolution of your printer by the screen frequency and square the value. Traditionally, screen frequencies range from 55 to 175 LPI. When printing to paper or film on a Linotronic, I suggest the following screen frequency settings to get the most gray values and the finest quality:

65—85 lines per inch for a document that is to be printed in a newspaper

85—100 lines per inch for a document that is to be "quick printed"

100—133 lines per inch for a document that is to be printed on an offset press.

When in doubt, consult the printer.

162

Screen frequency (LPI)						
Printer resolution (dpi)	Available gray tones					
	50	75	90	100	120	150
300	36	16	11	9	6	4
600	144	64	44	36	25	16
1000	256	178	123	100	69	44
1270	256	256	199	161	112	72
1693	256	256	256	256	199	127
2540	256	256	256	256	256	256

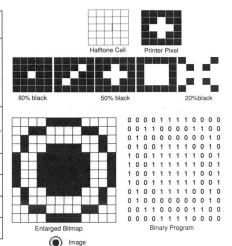

Halftone Cell Printer Pixel

80% black 50% black 20%black

Enlarged Bitmap Binary Program

Image

Computer generated gray scale **Computer generated dot**

PHOTOS FOR SCANNING

You should try to scan black and white glossy photos for halftones. If your photo lacks contrast, you can automatically enhance that by making the highlights a bit whiter and the shadows a bit darker but there are limits to what the computer can do here. It's best if the contrast is already in the photo to begin with. Photos will usually fall into one of five categories: high key, low key, normal key, high contrast, and low contrast. High key is a photograph that has the majority of the detail in the lighter tones, such as an engine layered in chrome or the soft white of a bride's dress. A high key photograph needs to have full density reproduction in the lighter areas. If an area must be reproduced without good density distinction, it must be in the shadows to maintain the truest reproduction.

The low key photo has the majority of its details in the shadow areas and requires very accurate placement of the shadow dots with the flash exposure. This is one of the hardest types of copy to accurately reproduce by halftone. Getting good results normally requires printing highlights totally. Normal is the separator's dream. It does not have details concentrated in either the highlights or the shadows. To reproduce normal key copy, certain tones in the extreme highlight and shadows may not be reproduced with complete fidelity. This is not a major problem because the detail is in the mid-tones.

High contrast has extreme contrasts ranging from extreme highlights to extreme shadows. The classic example of high contrast copy is a bride standing next to a groom. To accurately reproduce this requires good dot definition in both the highlights of the bride's gown and the shadows of the groom's tuxedo. To reproduce the extreme highlights of the pure white gown requires a loss of definition in the shadows of the black tux.

Low contrast is generally found in normal key copy. This is a lot easier than high contrast. Low contrast copy has little contrast in the midtones, the area of most of the detail in the photograph. Photos should be selected with good contrast and clarity of focus in mind. They are the most important factors for good-looking reproduction. The printer cannot improve an out of focus photo, and it will likely actually be a bit worse after it is printed.

Textured finish photos can sometimes cause a problem with what looks like a moire pattern in the halftone. Color photos can be used for black and white halftones although the contrast in a dark blue or dark red area may not show up well. The camera sees colors differently than the human eye. It is best if your photo can be reproduced at the same size or smaller. However, if it is in good focus to begin with, it can usually be enlarged up to 200% before the clarity is affected. You should not write on the back of a photo. The indentation it leaves will often show up in the printed halftone. A better way to identify a photo is to write on a overlay or type a label then tape it to the outer edge or corner of the photo.

RESCREENING

The reason that you need to rescreen is because the scanner cannot read individual dots with enough accruacy to create an exact reproduction losing the grey scale. When you don't have the original photo, you can rescreen in order to reproduce a printed picture of high quality. Use a rescreening lens to defract the light, making the existing dots disappear and turn the screened reproduction back into a continuous tone photo. From that point it is scanned and stripped like a regular, conventional halftone.

COPY DOT

If you have a scanner that is sharp enough to pick up "dot for dot", you do not need to recreate a halftone by rescreening. This alternative reproduces a previously printed halftone dot for dot.

The printer shoots the page that contains the pictures. The existing dots in the pictures are reproduced as if they were type. If you started out with a nicely printed picture, done on enamel, this can give a pretty good reproduction. If it was done originally on a soft, uncoated paper, then the edges of the original halftone dot will be fuzzy and you will lose some if not most of the dot's edges. This may cause the printer to completely lose a black dot in an area high light (white) and shadow (dark) may print as solid black because a small white dot of detail may fill in. Usually the reproduction of the middle tones in a copy dot will come out satisfactory if it was well printed to begin with.

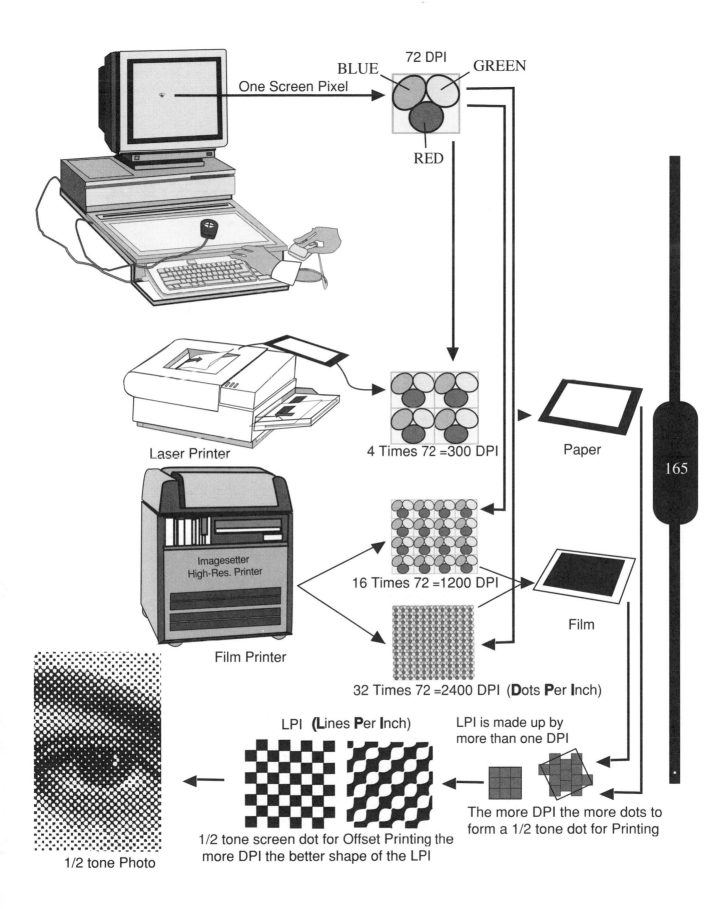

One Screen Pixel

72 DPI

BLUE GREEN

RED

Laser Printer

4 Times 72 =300 DPI

Paper

Imagesetter
High-Res. Printer

16 Times 72 =1200 DPI

Film

Film Printer

32 Times 72 =2400 DPI (Dots Per Inch)

LPI (Lines Per Inch)

LPI is made up by
more than one DPI

1/2 tone Photo

1/2 tone screen dot for Offset Printing the
more DPI the better shape of the LPI

The more DPI the more dots to
form a 1/2 tone dot for Printing

165

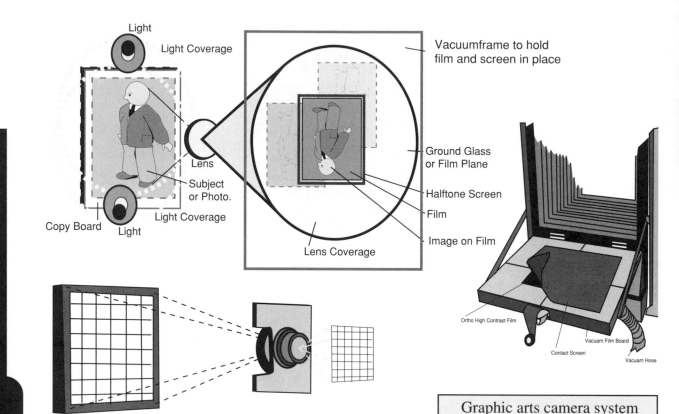

Light

Light Coverage

Vacuumframe to hold
film and screen in place

Lens

Subject
or Photo.

Light Coverage

Copy Board Light

Lens Coverage

Ground Glass
or Film Plane

Halftone Screen

Film

Image on Film

Ortho High Contrast Film

Vacuam Film Board

Contact Screen

Vacuam Hose

Graphic arts camera system

Rescreen will provide a somewhat better reproduction than a copy dot at all ends of the spectrum .

HOW TO PRODUCE DOTS

Traditionally dots were produced by placing a halftone contact screen over film on a graphics arts camera back. The dots are as crisp as the formations on the contact screen. The choice of about 100 screens is up to the printer's discretion. With a scanner there is no screen. The dots are computer generated from digital impulses that either expose an area (square) or do not, generating dots with edges similar to a stair step. The effect is what can make computer drawn lines look like saw teeth.

If not carefully managed, these stair-step dots can create distracting moiré patterns. A solution is to place the halftone on the scanner covered with a sheet of clear plastic, thus creating a softer focus. This helps to diminish the tendency of the scanner to produce serrated edges.

SCREEN RULING

This refers to the number of lines of dots per inch measured along the screen angle (dot diagonal). Typical rulings range from 55 to 300 lines per inch. The more dots, the greater the resolution of detail, but also the greater the risk of losing control of tones. When more dots are present per

inch, a slight increase in size (dot gain) causes a greater color shift in the reproduction. Knowing this, you should always stay clear of higher line rulings if the art does not contain sufficient detail to justify them.

Fewer dots per inch will make print colors easier to control. An 85-line-rule separation, for example, is twice as hard to print as a 55-line one.

TONAL RANGE

Tone reproduction is a very complex issue, both in terms of how the percentages are selected and how these percentages are affected by the printing process. In simplistic terms, the highlight dots are the smallest printable dots appearing in highlight (white or near-white) areas. Shadow dots are much larger in size, taking up the greatest percentage area. Black areas indicate solid coverage. The difference between the highlight and shadow areas

makes up the range of tones. When dot size can be controlled very definitively, a greater range, such as the 3 percent to 92 percent used in many offset reproductions, can be used.

DOT PLACEMENT

Right alongside the issue of tone reproduction is the matter of the calculated adjustment of dot size on film to reproduce the correct size. This is where your separator needs to know more about your printing capabilities and the printing process in general. If a publication requires a great number of halftones, such as with this book, the photoready copy produced from a laserwriter would produce poor halftones in the finished product. The document is best run on an imagesetter.

DOT SHAPE

Halftone contact screens are available in square, round, elliptical and special-texture effects (straight lines, wavy lines, mezzotints, etc.). The square dot is the most common, but the elliptical dot is what I prefer for my printing applications. Conventional square dots produce a harsh jump in density where the 50 percent halftone dots connect. This area is where midtones appear and the results are an abrupt jump in tone, rather than a gradual transition. This jump is caused by the connection of the four corners of the dots.

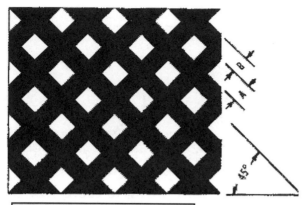

Half-tone screen angle

SCREEN ANGLE

The angle is measured from the base of the screen to a line formed through the diagonally opposite corners of the dot pattern. The screen pattern is less apparent at a 45-degree angle. Therefore, 45-degree angle screens are used for black and white work. When more than one color is used the screen angles must be changed for each color to prevent moiré. Moiré is an undesirable pattern resulting from repetitive overlapping dots close to the same angle. Because of this, the standard offset angles of 90 degrees yellow, 75 degrees magenta, 105 degrees cyan and 45 degrees black cannot be used if moiré is to be avoided. While many alternative angles can be used, the following angles are suggested for best results: 30 degrees yellow, 45 degrees magenta, 15 degrees cyan, and 75 degrees black.

DUOTONE

A duotone (duograph, duotype, or a duplex print) is a two-color print. Very pleasant color combinations are possible in printing by means of the duotone method. It is possible to produce an appearance of more than two colors by printing one color of ink over another. It is a more economical method of adding color to prints than printing with 4 or more colors. Duotone printing is the intermediate stage in the mastering of the technique of four-color separation and single-color halftone printing. This type of printing is not limited to halftone work but can be done by computer and photographically from line copy, shaded copy, or from halftone copy, either from black-and-white or from a colored subject. Duotones imply the making of two photographic negatives of the subject, one negative for each color to be printed. One of the negatives serves for the key plate. The other negative represents the tint or lighter color which is often printed first. The key plate or key print is printed over the tint.

The negative for the lighter color may have a little more contrast and carry the highlights quite well. In this way, the second color of the duotone gives" sparkle" to the colored reproduction. or halftones made from two or even three colors. The colors used in duotone are normally black and one other color. The most elegant

results are achieved if the second color is also dark, such as dark brown, dark blue or dark green. You can get interesting results using black plus magenta. In duotones, one of the halftones is made unusually high contrast in order to pick up the highlights and shadows while the other concentrates on picking up the middle tones. When halftones are printed on top of each other, not only are all the resulting contrasts intensified, but the uninteresting black halftone is made to appear colorful. Most important, the highlights in the original photograph are reproduced as highlights in both the halftones so the final result doesn't become muddy. By using two halftones or duotones, the contrast levels are doubled giving a full range of grays.

DOUBLE-DOT HALFTONE

Multiple dot halftones are a very sophisticated subset of duotone printing. One variation is a duotone made in two shades of black which yields an elegantly rich halftone effect. In printing with black-and-white pictures, for example, the double-dot technique can be effective in producing vivid richness without too much colorfulness. An unlimited variety of color effects is made possible by the way the color balance is varied and the way each of the two segments is produced. The directions of the screens have to be positioned at special angles to each other to prevent moire patterns from messing up the picture. To ensure that your investment in true duotones pays off, make certain that the pieces are carefully printed on good stock.

TRITONES

Tritones follow the same principles as duotones except that they use three colors superimposed on top of each other in three halftones. The third color makes it possible to create subtleties impossible with two colors. Fake color offers a technique of printing a transparent color over opaque or transparent colors to produce a darker tone over each of the colors printed. It is a method of darkening the other printed colors. For example, if a poster is printed with three different colors and then overprinted with a correctly mixed transparent color or a "fake color," it becomes possible to obtain more colors with one printing. The printing screens for this type of printing are generally prepared by hand. It can also be done on computer using a paint program.

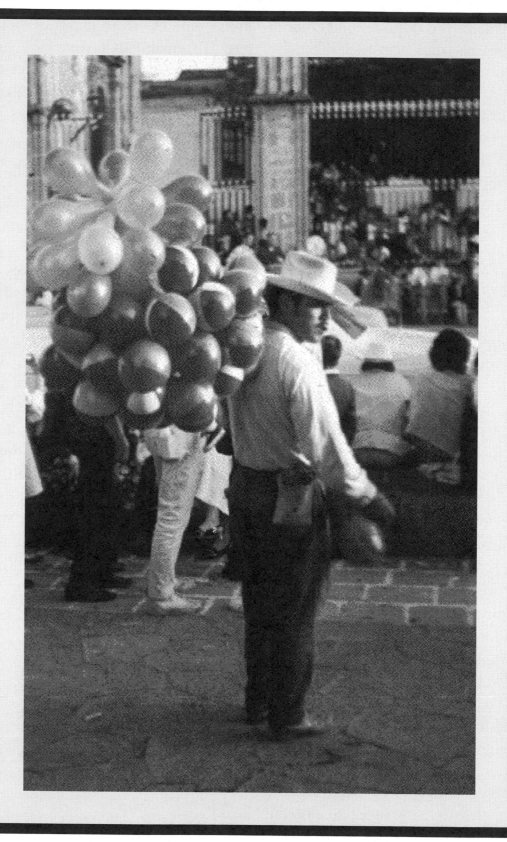

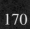

Four COLOR Process screen Angles

BLACK 45°

MAGENTA 75°

YELLOW 90°

CYAN 105°

BLACK 45%
90%
MAGENTA 75%
YELLOW 90%
CYAN 105%

BLACK 45%
MAGENTA 75%
YELLOW 90%
CYAN 105%

0%

0%
90%
180%
90%

CYAN 105%
YELLOW 90%
BLACK 45%
MAGENTA 75%

White paper Shows through not a pure black

45%

YELLOW

MAGENTA

CYAN

BLACK

CHAPTER X, COLOR SEPARATIONS

Photographers come from all sorts of backgrounds. Some are news people. Some begin as wildlife chasers. I was a sculptor who slipped into photography unannounced while taking slides of my work. I was captivated by the artistic side of photography and very quickly I was spending as much time in the darkroom as

in the field. As an artist I took up residence in the darkroom. But this was not reality in the world of commercial publications where 90% of the photos printed are in fact reproductions. Most people are shocked to realize that what they see in magazines and newspapers are not photographs. The photographer actually had little control over this phenomenon. As they say, "that's show business". For me, the computer, software, and image printers became my darkroom giving me a measure of that elusive lost control. Computer and company are my new palette. You cannot have too many palettes. By putting images through the computer, the photographer determines the final image of his photographs. The halftone dot is the foundation of all reproduced photographs, as discussed in the previous chapter, and you can become master of your halftones via the computer. Halftones are just one vital step in the making of the four-color separation.

To make a color photograph into a printed reproduction one must convert the color image into four black and white films that will be printed separately with cyan, magenta, yellow and black The final photo will be effected by any one of several variables: paper, ink, press, size of dot, and type of separation. The variations of real world inks and papers and the modification of the image by the printing process itself must be taken into account. Like a great magic act, the screening of

continuous tone color is most successful when you don't notice how it's being done. The trick may involve an intricate set of deceptions, devices, or accomplices but if any of them become visible, the act's a bomb. It's the same with making and overlaying the four CYMK screens that make a color photograph printable. If you can see those tiny dots combining into patterns that are visible to the naked eye, you've got a bad separation. Very unmagical.

An example of how personal color interpretation can run amok occured in one of my photography classes. A student brought me a photo which was strangely green and told me it was his finest color photo. He saw that photo as the way he saw the world, through color blind eyes. We assume that everyone sees the world as we do. To the naked eye, a published photograph appears to be full of continuous tone colors. But the colors in that photograph are a collection of color separation dots that create the impression of various colors.

GET A LOUPE

One of the first items of equipment you'll need for process color is a tester or loupe. This is a magnifying lens of about 10 power, usually mounted in a small, collapsible frame. The loupe will enable you to see the halftone dots used in four-color process. It's also extremely useful for

checking positives, exposed screens and your printing quality. Get one even if you don't plan to do a lot of four-color process; it's that necessary. Now, loupe in hand, let's see what four color process printing is all about. Pick up any magazine, calendar, postcard or junk mail flyer. Look at one of the color photos using your loupe. You'll see a varied pattern of small dots of color.

80 Line Screen

133 Line Screen

173

If you look in the light areas of the photo, you see very small dots, widely spaced. Looking in the darker areas, you see larger dots more closely spaced. No matter where you look, though, the dots will be in a regular pattern, a yellow dot, a cyan (or bluish green) dot, a red (or magenta) dot, and a black dot. Each of those colored dots is a halftone dot just exactly like the dots in a black and white reproduction.

We have seen that full-color photographic images can be reproduced using cyan, magenta, yellow, and black in various proportions. The four screens of these color ingredients are then combined, producing a vast array of colored dots. How these are laid over each other becomes a critical factor in how the combination works. They can't just be placed one on top of the other or the darkest dots would overwhelm the lighter ones. Instead the rows of dots are splayed, each color slightly rotated so it won't get in the way of the others. If you look closely at any printed art through a loupe, you can see the magenta dots running in one direction, the cyan in another. The art is not rotated, only the dot pattern is.

Color separation films can be either positive or negative, depending on the platemaking process in use. Negatives are much more common, especially in the U.S., so the separation films will be referred to as "separation negatives" in this book. In

174

The four colors to make a color separation

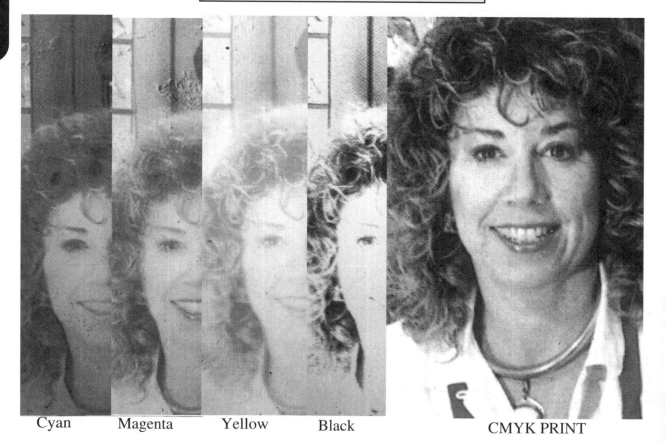

Cyan Magenta Yellow Black CMYK PRINT

principle, the color separations could be made by simply exposing a series of sheets of film through complementary filters: the negative for cyan would be exposed through a red filter, the one for magenta through a green filter, and the one for yellow through a blue filter. A screen placed in front of the film would break the image into half toning dots. This is the principle of producing color separations in a graphic arts copy camera.

Camera separations are rare these days. Separations from high end machines like Hell, Scitex and Crossfield systems ac-count for only a small percent of the market, and separations from desktop computers account for even less. Most separations are done on drum scanners, the workhorses of the separation industry.

The rotation for making a color separation

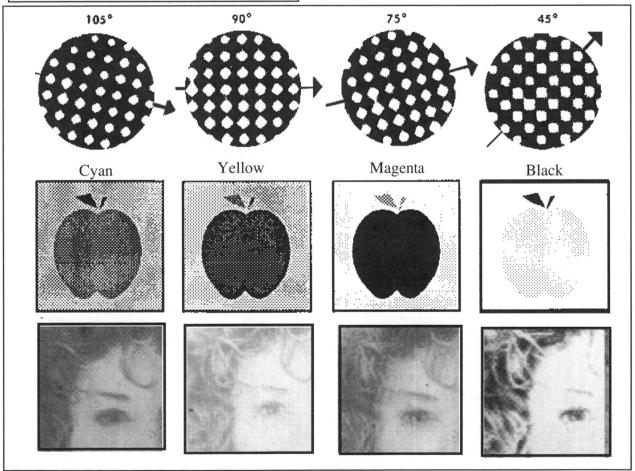

CONVENTIONAL SCREEN ANGLES

Traditionally, screens were made with a camera, shooting art through the line screen. The screens were mounted on a stand so they could be fully rotated by the camera operators who could thus choose any angle desired. Over a period of time it became clear that a particular set of angles seemed to work best. Standard angles were adopted. The yellow screen was set a 90 degrees, perfectly horizontal, while the black screen was positioned diagonally at 45 degrees. The "grain" of the magenta dots was set at 75 degrees, running horizontally uphill moving from left to right, while the cyan grain was shot at 105 degrees running horizontally downhill. This splay has a nice symmetry. The three darker ingredients are all separated by 30 degrees each, while the yellow, which is so light it causes less problems, is only 15 degrees from its neighboring screens. There are certain problem separations or printing techniques which may require varying these

176

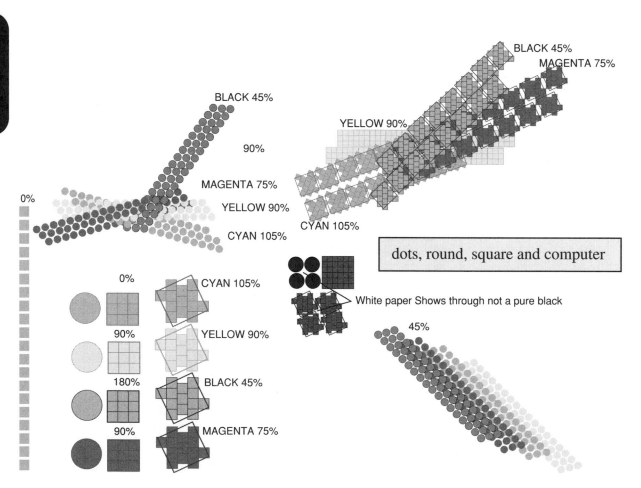

The rotation for making a color separation

BLACK 45%
MAGENTA 75%

YELLOW 90%

CYAN 105%

BLACK 45%

90%

MAGENTA 75%
YELLOW 90%
CYAN 105%

0%

dots, round, square and computer

White paper Shows through not a pure black

0%
90%
180%
90%

CYAN 105%
YELLOW 90%
BLACK 45%
MAGENTA 75%

45%

angles slightly; for the most part these so-called conventional angles remain the ideal ones. The problem came in the 1970's, when the publishing industry went away from cameras and onto digitized scanning and separating. The halftoning process went onto a big bitmap with individual pixels combined to form a single halftone cell. This is called a rational system because only whole pixels can be used. Camera pixels can be different sizes but a computer pixel is one size. Because digital halftoning has to use whole units of this pixel grid, it does not precisely deliver these conventional angles. Ask it to render a 16-square dot at 0 degrees and it would shine But tell it to make the same dot at a nice, conventional 10-degree angle and things get uncontrolled. Unhappy with their early, rational systems, Hell and Scitex pressed on and, around 1980, introduced systems that used so-called irrational angles. Hell and Scitex both evolved their systems independently and today share most of the patents on irrational screening.

> Step by step from computer to separation

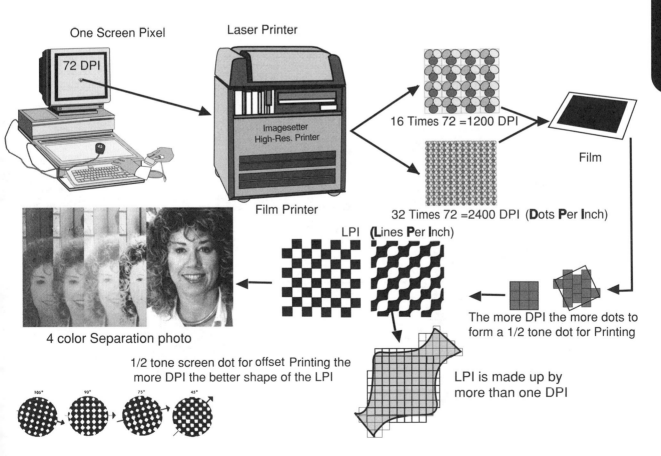

One Screen Pixel

72 DPI

Laser Printer

Imagesetter
High-Res. Printer

Film Printer

16 Times 72 =1200 DPI

32 Times 72 =2400 DPI (**D**ots **P**er **I**nch)

Film

LPI (**L**ines **P**er **I**nch)

The more DPI the more dots to form a 1/2 tone dot for Printing

4 color Separation photo

1/2 tone screen dot for offset Printing the more DPI the better shape of the LPI

LPI is made up by more than one DPI

COLOR PROOFING

Color proofing is an essential and important step in the making of color separations. The reason for making a color proof of a set of separations is to show someone how the printed reproduction will look. A good deal of time and money are resting on the accuracy of your color proof. Generally, the most accurate color proof is a press proof.This is a scenario that the average photographer or desktop publisher is likely to be involvedwith-demanding a press proof. But unless the press proof is made with the same press, plates, ink and pressmen that will be used to print the job, there is no assurance the printed reproduction will match the proof.

One category makes use of pre-sensitized

COLOR BALANCING USING A COLOR MONITOR (T.V.) COLOR BALANCING VIEWING KIT

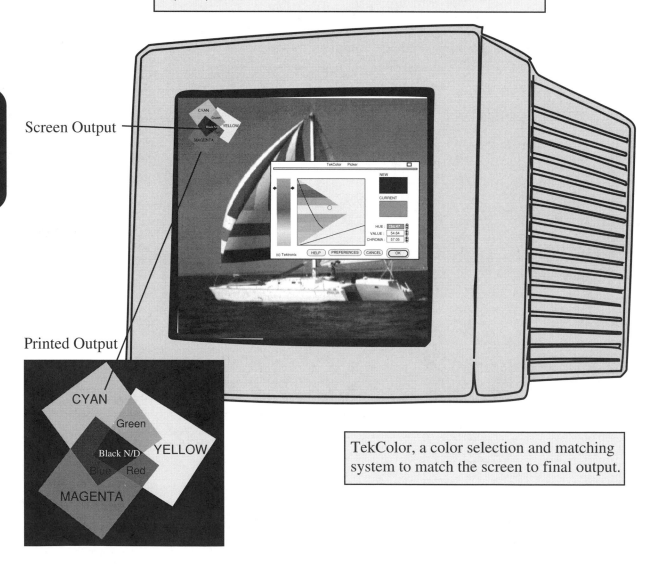

Screen Output

Printed Output

TekColor, a color selection and matching system to match the screen to final output.

CMYK- Four color acetate sheets printed from neg originals then placed in register for proofing.

light sensitive dye: coated clear polyester film. A film is made for each process color. After exposing each process color proof through its appropriate halftone negative, it is processed to remove the nonimage areas. Then all colored layers are placed in register, one over another, and fastened to a white sheet of paper to form a layered sandwich. The second category of pre-press color proofing consists of transferring the process color pigments to a white substrate one at a time. Each layer is exposed with the appropriate process color negative, developed, washed and dried. Then the next color is applied, exposed, developed, and dried. When all four process colors have been transferred, the proof is finished. When evaluating these proofs, the viewer does not have to look through several layers of clear film that can dull. Your choice of proofing method should be based on its accuracy in reproducing the color reproduction on the press sheet.

COLOR BALENCING USING KODAK PRINT VIEWING FILTER KIT

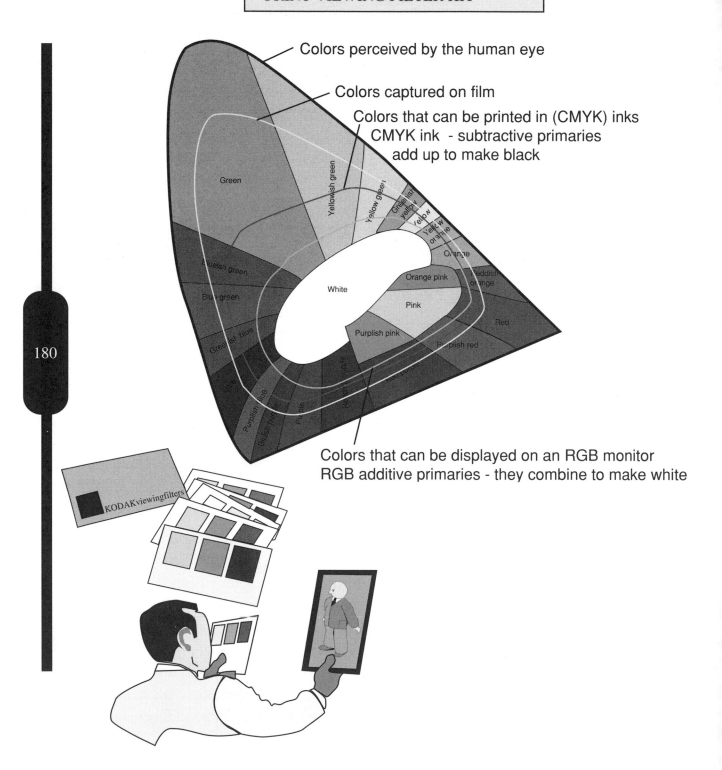

Colors perceived by the human eye

Colors captured on film

Colors that can be printed in (CMYK) inks
CMYK ink - subtractive primaries
add up to make black

Colors that can be displayed on an RGB monitor
RGB additive primaries - they combine to make white

180

KODAKviewingfilters

Green

Yellowish green

Yellow green

Greenlish yellow

Yellow

Yellow orange

Orange

Bluelsh green

Blue green

Greenish blue

White

Orange pink

Reddish orange

Pink

Red

Purplish pink

Purplish red

A MOIRE PATTERN

Several different factors cause moire patterns such as mis-registration between color plates which can occur at several different stages in the production process. The first generation of PostScript imagesetters wasn't designed for color work and their film-handling mechanisms weren't accurate enough to produce the tight registration necessary for color separations. Inaccuracies in the printing press itself can also cause moires. But the main culprit is the screen-angle technology used in most PostScript imagesetters.

Moires drastically limit the usefulness of PostScript-based devices for color work. "Moires are a serious problem, especially at lower resolutions such as 120 or 150 lines per inch (LPI). As a result, you are

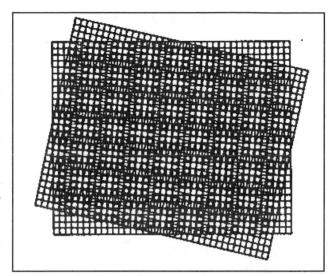

either aware of the limitations of the technology and will accept a certain amount of moire or you can choose to use higher resolutions, such as 175 or 200 LPI, where the problem is much less pronounced. New developments in PostScript screen-angle technology promise to erode that advantage and make most PostScript color separations moire-free.

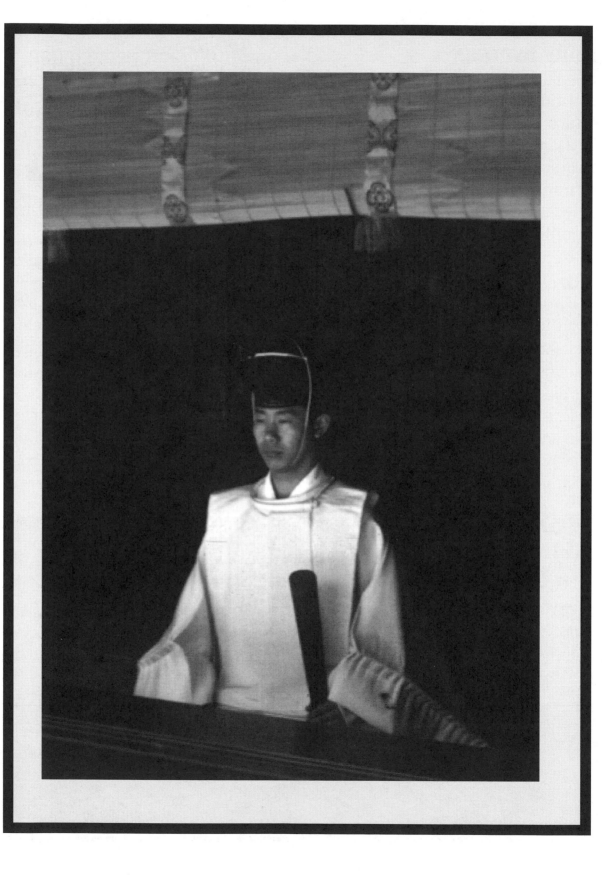

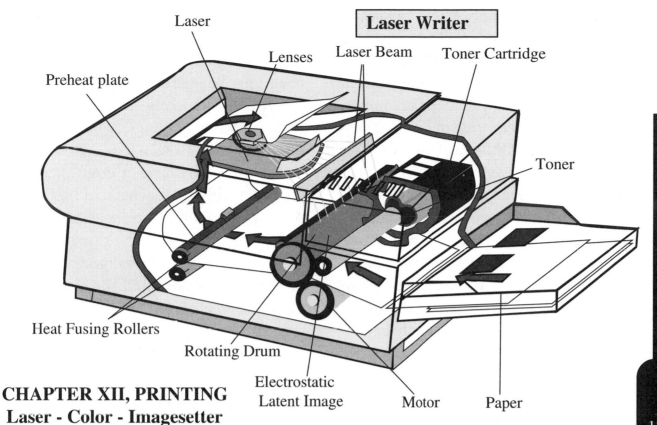

Laser
Lenses
Preheat plate

Laser Writer

Laser Beam
Toner Cartridge

Toner

Heat Fusing Rollers

Rotating Drum

Electrostatic
Latent Image

Motor

Paper

CHAPTER XII, PRINTING
Laser - Color - Imagesetter

There are many things which I can tolerate or begrudgingly bear but a cheap, poor quality printer is not one of them. The idea of characters or lines lying on a page like flattened snakes is offensive. My argument for a good printer is that the brain must translate computer -generated characters into English in the form in which they were learned, at typeset quality. The more deviation from basic letter recognition that the brain must deal with, the more tiring the project. People fall asleep in front of TV sets but can read several hundred pages of a book at a single sitting. Low quality type of any kind is hard work which the brain tends to avoid.

Fortunately, typeset quality is now avail-

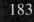

able in personal printers. With the introduction of Apple's LaserWriter in early 1985, near type set quality print with professionally designed fonts was available and affordable for the first time. Designs could be created on a computer and produced on a printer that generated high

quality, high-resolution text and graphics at a resonable cost. This innovation launched what we now call desktop publishing. The laser printer is related in basic mechanics to the photocopier, however, this computerized cousin has one important difference. Unlike a photocopier which receives its image from light reflected off an original document, a laser printer creates its images from data generated by a computer. Xerography, a reprographic technique first used in photocopiers, is also the imaging process used in laser printers. At the heart of both copiers and laser printers is an optical photo conductor drum. The digitized laser light, pulsing on and off at the rate of several million times per second, is bounced off a rotating mirror and onto the electrically- charged drum. The pulsing light writes the image on the drum as a pattern of electrical charges. The laser beam "etches" an image on this positively charged surface, neutralizing the areas it strikes. When the drum is brought into contact with a positively charged flux of black toner, the neutral areas accept a film of toner where the laser image has struck and reject it elsewhere.

Paper rolled across the drum receives a negative charge momentarily attracting the positively charged toner particles and

the image is transferred. The point of contact is very hot, ironing the toner particles to the paper's surface. The laser's beams are so precise and linear, it can be controlled accurately thereby producing incredibly fine graphics. A laser printer's output results from a collaboration between an engine and a controller. The engine, being the mechanical half of the duo works much like a photocopier. The controller determines the printer's typographical features, the range and quality of the fonts, styles, and the sizes it can produce. The controller also guides the

Inside a Laser Writer

engine's imaging mechanism, telling it where to apply the toner powder that forms the image. And because describing the appearance of a page requires complex calculations. the controller also helps determine printer speed. In most printers, the controller is housed within the printer's case and contains its own microprocessor

and memory chips. Some less-expensive printers use the Mac's processor and memory as their controller. Most use commands written in PostScript, a programming language created by Adobe Systems for describing the appearance of pages. A PostScript controller is a powerful computer in itself. It typically has 2 megabytes of memory or more, a micro processor, and ROM chips containing the PostScript language interpreter as well as a selection of font outlines, mathematical formulas the controller can use to create text in virtually any size and orientation. Digital type is the most important comparative factor between printers. Outline fonts, combined with PostScript's wide array of graphics-manipulation commands (called operators), give PostScript printers tremendous typographic versatility. A billboard size graphic can be reduced to fit on a postage stamp, then filled with a gray pattern with a shadow behind it. Manipulations like these are easy in PostScript. Every page must ultimately be described as a bitmap, each corresponding to one dot on the page. A full page bitmap for a 300-dots-per-inch printer is roughly 1 MB in size. All that data has to be stored somewhere. PostScript printers store it in the controller's page buffer, a 1 MB area of printer memory. PostScript printers must translate font outlines into bitmaps in the type sizes needed for the page. Some printers can't use Adobe's downloadable fonts, which are encrypted in a format

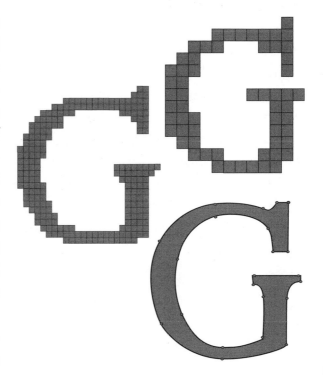

G - Bit-mapped - Antialiasing - Object oriented

only an Adobe interpreter can read. This can be a serious drawback if you plan to take your documents to a service bureau that uses Adobe fonts. Laser printers provide 2MB or 3MB of memory, divided into two areas: the page buffer and the font cache. A larger font cache means faster performance and more room for downloadable fonts. Many printers also accept memory expansion options. Some printers can accept an optional hard disk. A hard disk attached to a printer stores downloadable fonts, making them available and eliminating down loading time. A hard disk also acts as an extension to the font cache.

IMAGESETTERS

Computer publishers have increasingly turned to PostScript-based imagesetters for jobs that require more than the 300-DPI resolution of the typical laser printer. This, in turn, has led to a proliferation of service bureaus that offer output on such machines as the Linotronic or Compugraphic. The history of the PostScript imagesetter begins in 1986, with Linotype's introduction of the Linotronic 100 and 300 imagesetters and the RIP 1. Three years earlier, Linotype had signed an agreement with Adobe Systems giving the PostScript developer rights to use typefaces from the German manufacturer's extensive type library. As part of the deal, Linotype won the right to incorporate the page description language into its laser-driven phototypesetters. The basic technology remains the same. A PostScript file is produced with a desktop publishing or graphics package and downloaded from a personal computer to the raster image processor (RIP). Here, the PostScript language commands are converted into an electronic array of tiny dots. This information is passed to the image recorder, where a laser beam etches the dots onto photosensitive film or paper. The photosensitive film or paper is then removed from the recorder and sent through a chemical processor, which pro-

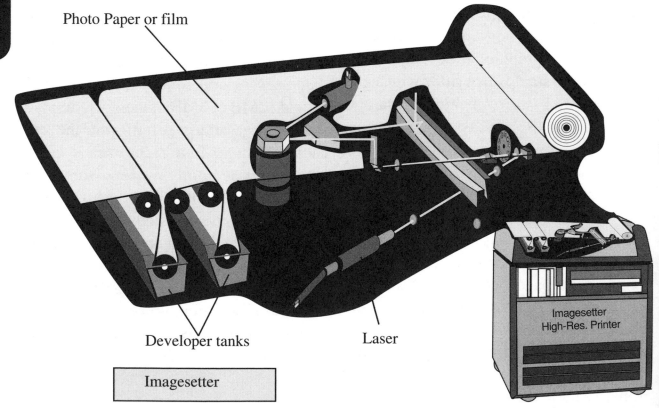

Photo Paper or film

Developer tanks

Laser

Imagesetter High-Res. Printer

Imagesetter

duces the final output in much the same way a photo-processing lab develops photos. With the availability of low-cost grayscale scanners and image-editing software—along with advances in the imagesetters themselves users can now produce high-quality digital halftones in a cost effective manner.

COLOR PRINTING

Printing inks are made of particles of colored pigments suspended in a transparent medium. The particles reflect certain wavelengths and absorb others. This has the effect of removing only a limited number of colors from the light. Light that hits the colored ink will be reflected from several particles before exiting. If you mix inks whose particles have different absorption, then most of the light will encounter both types of particles and both colors will be removed from the reflected light. This is called "subtractive" mixing, because all the wavelengths that are subtracted (absorbed) by the individual pigments are also subtracted as a mixture. The same kind of subtractive mixing occurs when transparent inks are printed on top of one another. This is exploited in the four-color printing process. Each of the three colors yellow, cyan and magenta removes a portion of the spectrum of the light that falls on it. Yellow removes the blue portion, cyan removes a portion centered on orange, and magenta removes the green portion. By using these colors in various proportions, a specific group of colors can be extracted from reflected light. In this way, subtractive mixing can create the appearance to the eye of nearly any desired color.

In theory, all of the colors in a photograph can be reconstructed using this three-pigment approach. However, real world inks aren't perfect. Some saturated colors are lost in the printing process and blacks come out muddy making it necessary to add black. The three pigments can't recon-

Colors perceived by the human eye

Colors captured on film

Colors that can be printed in (CMYK) inks
CMYK ink - subtractive primaries
add up to make black

Green

Yellowish green

Yellow green

Greenish yellow

Yellow

Yellow orange

Orange

Bluish green

Orange pink

Reddish orange

Blue green

White

Pink

Purplish pink

Red

Greenish Blue

Purplish blue

Purplish red

Colors that can be displayed on an RGB monitor
RGB additive primaries - they combine to make white

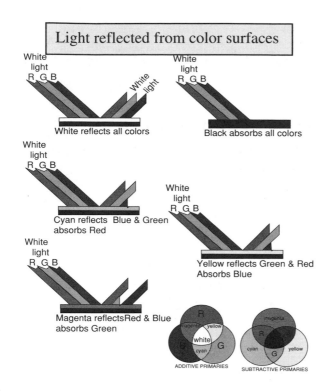

White light reflects all colors

Black absorbs all colors

Cyan reflects Blue & Green absorbs Red

Yellow reflects Green & Red Absorbs Blue

Magenta reflects Red & Blue absorbs Green

ADDITIVE PRIMARIES

SUBTRACTIVE PRIMARIES

188

dots are printed in patterns called screens. Your eye blends the screens into a full color image.

The major problem with the use of screens is interference patterns called moires. To minimize moires, the four color halftone screens are traditionally printed at angles usually of 45, 75, 90, and 105 degrees—to each other. The rotation creates a pattern of colored dots that works well to create the illusion of a full-color image.

Although you can vary the color of a dot somewhat by using more or less ink, you can't really control the ink's density the way you can control brightness on the computer's television monitor. Four-color, process lithography (the type of printing used to reproduce the color photographs in this book) gets around the problem by varying the size of the dots of ink instead of their density. Each dot is formed from hundreds of miniscule droplets of ink. The dot can be as large as necessary to create a specific color. Most color print-

struct the spectrum originally present at each point, but when printed in the proper proportions, together with black, they can create a color that matches the original shade.

Almost all traditional color printing uses this three-color mode! In halftoning the

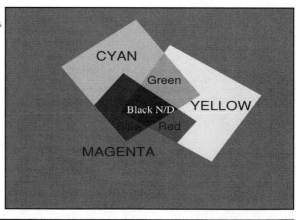

ers, however, rely on a technique called dithering, in which adjacent dots are printed in different colors. The human eye perceives this block of variously colored dots as a single color. The wider the range of colors you need to present, the more

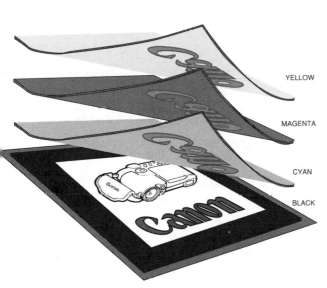

Example of Four Color Reproduction: when each is printed one on top of the other, it creats a full range color picture.

YELLOW

MAGENTA

CYAN

BLACK

dots the printer must use for each color.

COLOR PUBLISHING

It is amazing how quickly new technology is embraced in the world of digital imaging. It is as if these new tools are breaking shackles to free some long imprisoned creativity. Flatbed scanners, slide scanners, 24-bit color displays, color calibrators, compression products, color printers and color image-editing software are quietly revolutionizing how images find their way to print. Desktop publishing pack-

ages like QuarkXPress, PageMaker and DesignStudio now offer the ability to produce color separations, either by themselves or in conjunction with color separation software. Together, these products

Image Writer- dot matrix

promise a cost-effective way of producing pages that once required million-dollar prepress systems.

The imagesetter, with its high resolution and ability to produce output on film, is a key component in most desktop color-publishing strategies. Many service bureaus are adequate for producing grayscale halftones, but often choke on memory-intensive color images. The major limitation is dot repeatability. To produce process color on a printing press, you must provide separations corresponding to the four primary colors: cyan, yellow, magenta and black (CYMK). When these primaries are combined in various percentages, they can produce nearly any

color visible to the eye. The press operator then runs the pages through the press four times, once for each separation for this to work; however, each dot on each of the four separations must be positioned with a high degree of precision or distortions will occur. The major problem was the feeding mechanism used to pull the paper or film media through the image setter. Most imagesetters use a roller feed mechanism that, while adequate for monochrome output, cannot guarantee a precise alignment of dots from one separation to another. With these limitations in mind manufacturers have introduced new imagesetters whose feeding mechanisms are much more precise than those found in earlier models. Unlike earlier roll-fed imagesetters, the color setter uses a rotating drum with registration pins—similar to the tractor feed sprockets on a dot-matrix printer—along with a vacuum mechanism to hold the film in place.

There is a whole spectrum of software that can bring the monitor or color display to match color printers. Each printer has a limited ability to match a full spectrum of color.. An ImageWriter might be great for printing a few copies of a memo with highlighted words, but it can't create camera ready color art. Likewise, a printer that creates acceptable camera-ready art might not be suitable for low-volume publishing or for creating colorful presentations. Today's color printers fall into four categories: impact dot matrix, ink-jet, thermal transfer, and film recorder. Some color

printers support QuickDraw and PostScript interfaces; some (most notably film recorders) print QuickDraw documents saved in PICT format; others support the same video interface normally used to connect a color monitor. Each pixel on a MacIntosh color display consists of three tiny dots—one red, one green, and one blue. Combining red, green, and blue light in varying amounts can create any color visible to the human eye. The Video Card

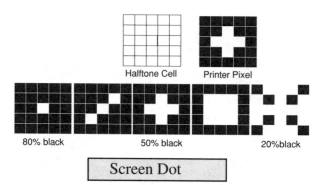

Halftone Cell Printer Pixel

80% black 50% black 20%black

Screen Dot

for the Mac can select one of 256 shades for each of these three primary colors, resulting in a palette of 256 by 256 by 256 or 16,777,216 possible colors. All color printers, with the exception of film recorders, work similarly except that they combine yellow, magenta, and cyan pigments to create a rainbow of colors on the printed page. Since the black that results from combining yellow, magenta, and cyan often appears muddy, these printers usually add a pure black layer as well. But the difference between the way colors are created on screen and the way they are created on paper is more than just a matter of red/green/blue or cyan/magenta/yel-

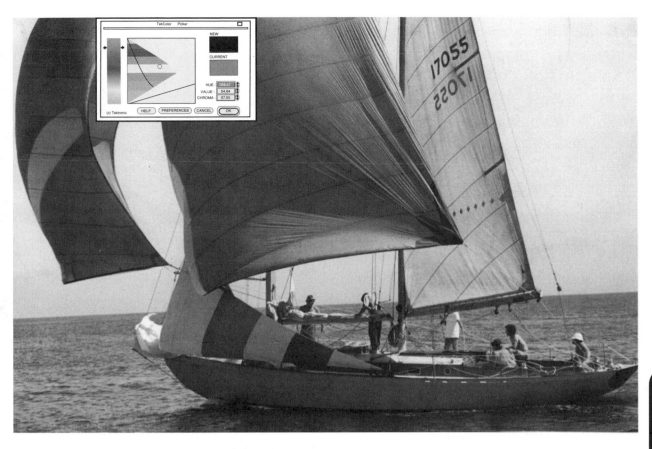

low. Because monitors continuously vary the brightness or intensity of a color to create different colors when you adjust the brightness controls on a monitor the colors change. With a color printer, a dot is either there or it isn't ; although you can vary the color of a dot somewhat by using more or less ink, you can't really control the ink's density the way you can control the brightness on a display tube.

DOT MATRIX

ImageWriter owners might be surprised to find that they have a color printer that can be used to produce color from any computer. An ImageWriter with a four-color ribbon lets you print any of seven colors. If you just want to add some red ink to your financial report then the 144- DPI ImageWriter or another dot matrix printer that supports color, might be just the ticket. Macintosh uses QuickDraw which supports seven colors: red, green, blue, yellow, magenta, cyan, and black. Dot matrix printers use plain paper and can typically print hundreds of pages from a single ribbon. ImageWriter LQ owners can also get the same seven-color capability at a somewhat higher resolution: up to 216 dots per inch. Still, the low resolution and aucity of colors make the ImageWriter unsuitable for generating color proofs.

INK -JET

A Spray of Color Ink-jet printers span the widest range of capability, from ImageWriter replacements to high-end color proofing systems . Typical low-end color ink-jet printers, like Hewlett-Packard's PaintJet color printer, print at 180 DPI . Like dot matrix printers, ink-jet printers can add spot color to charts and graphs but lack the variety of colors and the resolution necessary for prepress proofing, low-volume publishing, or generating camera-ready art. One advantage ink-jets have over dot matrix printers is that ink-jets can print on transparencies, although the output is not as good as a thermal printer's. Ink-jet printers can also print on plain paper, but the jets on some printers tend to clog with paper debris

When I was in high school art class we were able to do a project by drawing designs with crayons on a sheet of paper. We then used an iron to press our designs onto a T-shirt. This process has been resurrected in the high-technology world as thermal-transfer printing.

Thermal-transfer printers offer medium resolutions of 200 DPI to 300 DPI through dithering. These printers produce acceptable overhead transparencies quickly and work well for proofing output that will be finalized on a film recorder. Dithering, makes the output unsuitable as camera-ready art.

Ink Jet printer and ink cartridge

THERMAL PRINTERS

Thermal printers print more quickly than impact or ink-jet printers, requiring about one minute per page. Most thermal-transfer printers work alike, some support QuickDraw and others support PostScript. PostScript compatibility for color printing, however, is important only to users who generate color separations electronically on a Linotronic or similar PostScript-based phototypsetter.

Although future color printers will probably use laser technology, today's reigning king of color printing is the thermal-wax-transfer printer. This kind of printer doesn't produce prints as gorgeous as the

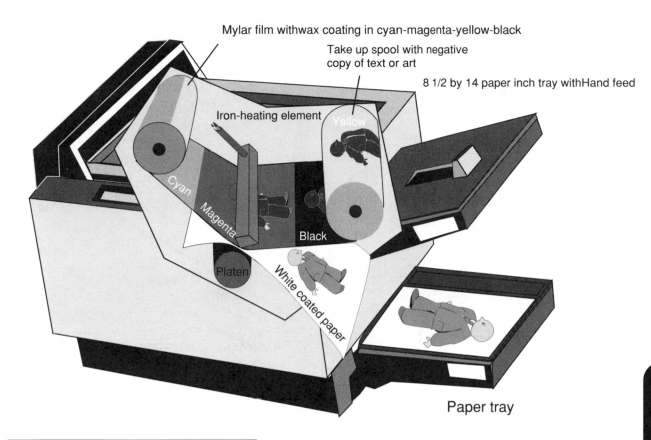

Mylar film withwax coating in cyan-magenta-yellow-black

Take up spool with negative copy of text or art

8 1/2 by 14 paper inch tray withHand feed

Iron-heating element

Yellow

Cyan

Magenta

Black

Platen

White coated paper

Paper tray

Thermal wax color printer

continuous-tone beauties from laser or dye-sublimation printers,but its ease of use, low media costs, and PostScript abilities have made it the workhorse of color printing. After a file is RIPed, it's passed to the printer's thermal-wax engine, where a thermal print head melts dots of colored wax (supplied on ribbons). The wax is then transferred by mechanical pressure onto smooth paper between the print head and a platen roller. The paper is peeled away, the unmelted wax remains on the ribbon, and the melted wax sticks to the paper. A mirror image of the printout always remains on the ribbon after the printout is completed, so be sure to dispose of used ribbon so no one can see your final image with a mirror. After wax of one color has been transferred to the paper, the print engine grabs the trailing edge of the paper and pulls it back for two or three more color passes. Ribbons come on rolls with alternating sheets of three or four colors: cyan, magenta, yellow, and sometimes black. Black, a combination of cyan, magenta, and yellow can be used as a fourth primary to add emphasis and image definition. You need only the three primary colors to create millions of colors.

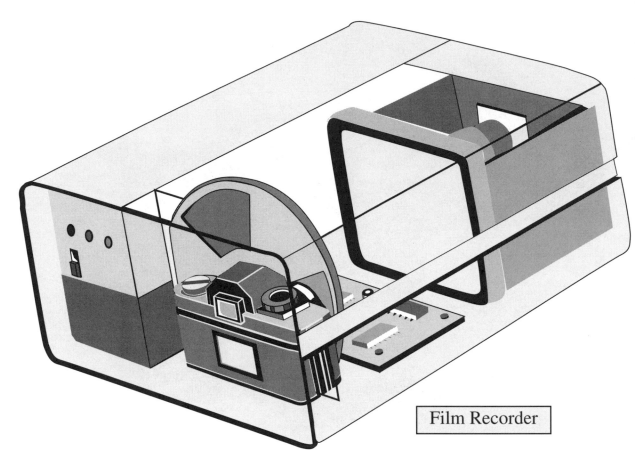

Film Recorder

B&W T.V.Tube

FILM RECORDERS

The film recorder captures the subtlties of light on a monitor displaying 16 million colors.

If you want high-resolution hard copy of images that use a lot of colors, the only real alternative at this time is a film recorder. Film recorders can deliver a wide range of colors for each individual pixel. Film recorders, which produce 35mm slides, are capable of very high resolution: typically up to 4000 by 2700 lines on a single 35mm frame. Compare that with the 640 by 480 pixels of a standard Apple color monitor. Film recorders also support large palettes of colors without dithering.

Each slide is exposed three times once in red, once green, and once in blue from a B & W T.V. tube because the image will be sharper.

The poor man's version of a film recorder: you can photographically transfer images off a high resolution monitor, in complete darkness, at 1/15th of a second shutter speed using a 35 mm camera.

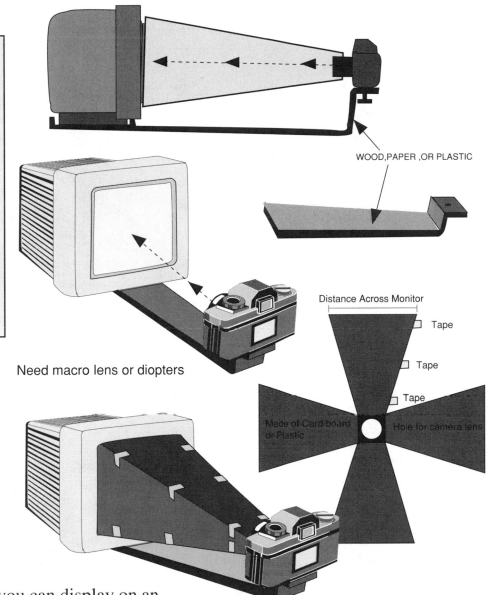

WOOD, PAPER, OR PLASTIC

Need macro lens or diopters

Distance Across Monitor

Tape

Tape

Tape

Made of Card board or Plastic

Hole for camera lens

In short, anything you can display on an Apple high-resolution video display, you can create, at higher resolution and with better color, using a film recorder. Commercial color-processing houses always accept 35mm film for generating professional-quality color separations; the colors from slides are generally richer and more saturated with color, making them better for color presentations than transparencies.

These gorgeous renderings come at a price. It takes several minutes to expose a single frame, and usually you have to get it processed before you can see the results. (Polaroid's instant slide film can give you immediate slides.) For top-quality presentations or camera-ready art, film recorders are really the only choice, but they are slow and expensive to use.

Four Color Webb Offset Press

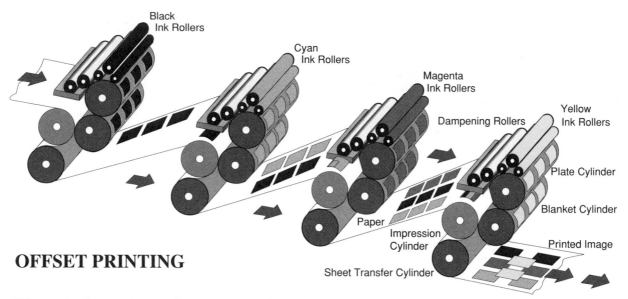

Black Ink Rollers

Cyan Ink Rollers

Magenta Ink Rollers

Dampening Rollers

Yellow Ink Rollers

Plate Cylinder

Blanket Cylinder

Printed Image

Paper

Impression Cylinder

Sheet Transfer Cylinder

To cutter and Folder

OFFSET PRINTING

The printing process is not a precise science with a single set of rules and controls suitable for every condition. A change in the ink density may solve one problem but cause another. If you are making color separations, talk to the printer who is ultimately responsible for the final reproduction. That person will be able to an-

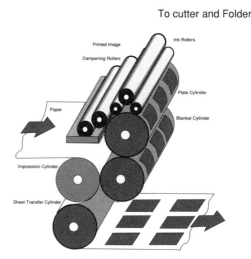

Printed Image

Ink Rollers

Dampening Rollers

Plate Cylinder

Blanket Cylinder

Paper

Impression Cylinder

Sheet Transfer Cylinder

Offset printing head

swer questions about how much compensation is appropriate for a particular press, and in what way you can best handle any anticipated problems.

ELECTRONIC COLOR STRIPPING

In the traditional prepress world, the act of assembling separations is done by hand.

Ark light for exposing plates

Two station offset printing press

Each film negative is individually put in place in a step referred to as stripping. This is a labor intensive and very exacting job which requires all films to be precisely put in place to avoid any error in registration. One of the more obvious advantages of electronic page assembly is its precision. Electronic stripping allows a number of images to be placed onto the "page" at once, but without diminishing the individual control over each image separation. Film and stripping costs are reduced and the images can be combined with popular page layout software routines. The commercial printing industry, which has been slow in getting into electronic publishing, is now realizing that digital prepress is the key to its future. Desktop computers and PostScript imagesetters, a rare sight a few years ago, are now standard in most printing shops. These digital printers are one-stop shops for their cus-tomers, turning PostScript files into printed brochures, newspapers, magazines and books. They can automate labor-intensive tasks like stripping, using programs which produce complete signatures straight from the desktop. They can take advantage of new direct-to-plate technologies that allow production of printing plates without the intermediate steps of producing camera ready mechanicals or film.

The Linotronic 530, one of the first PostScript imagesetters aimed at large format output, offers a maximum imaging width of about 18 inches.

ColorSetter XL offers up to 50 x 40 inches. A recent trend is direct-to-plate technology. Several companies, notably 3M and Polychrome, offer plate materials to make printing plates directly ready for press, eliminating the photographic stage. The Heidelberg GTO sheetfed press with a digital interface, uses plates that can be imaged directly from PostScript files created with standard desktop publishing packages. The GTO-DI (Direct Imaging) offset printer is the foreruner to the future of short-run color printing. Most prepress houses offer traditional film based proofing systems like Matchprints or Cromalins, but these can be used only after film has already been generated. Color PostScript printers like the QMS ColorScript can produce color proofs.

.

Color and black and white offset printers with four printing heads

Densitometer

A Kodak color print cube

CHAPTER XIII, DENSITOMETRY AND CALIBRATION

Densitometry is the measurement of light reflection or light transmission by an instrument that assigns numbers to what the human eye can see. The use of a densitometer is crucial to the person who does your color separations and offset printing. If you are going to be involved in color printing, it's good to have some understanding of densitometry. A densitometer actually measures optical density, or the light stopping ability of a material. The higher the density of a material, the less light reflected or transmitted. For example, densitometers can measure a press sheet or photograph to detect how much light is reflected, or measure film to ascer-

tain how much light is transmitting through it.

The surface light of the measured(printed) material comes from many angles and directions. This is determined by measuring the amount of red, green, and blue light reflected from the printed area, in relation to the amount of light reflected by a white surface. For example, a density of 0.00 indicates that 100 percent of the light falling on the white sample is being reflected. A density of 1.00 indicates that 10 percent of the incident light is being reflected. An opaque ink has particles that result in incident light being absorbed or

scattered. Let's look at dot area or dot gain. The printing process prints pictures with dots as well as with solids. If one starts with a 50 percent dot on a negative, the dot as printed may be equivalent to a 70 percent dot. That is a dot gain of 20 percent. It seems that as our technology now stands, it is just about impossible to print without some dot gain. Dot gain is especially important in printing skin tones because the eye recognizes believable skin tones, thereby rejecting green skin. If you know the dot gain, then you have a check on the inks, paper, press, and plate making. Densitometers can measure the dot area of a color bar swatch on the negative, determine the dot gain on the plate itself and on the printed sheet. There are many color bars on the market. The choice depends on the aspects that you deem important for your operation. The best ones have solids and halftones.

202

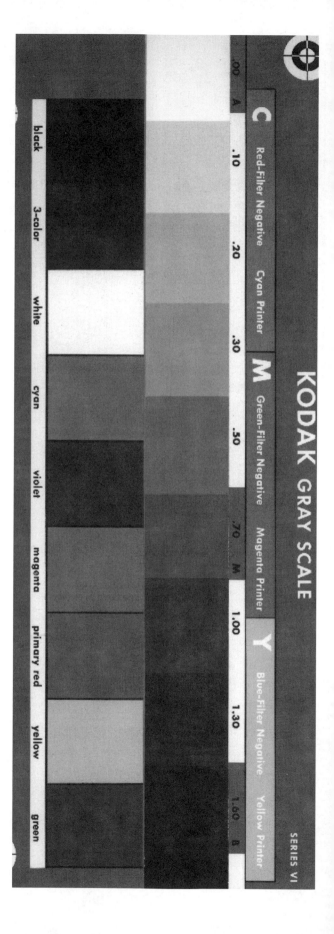

Kodak Gray Scale

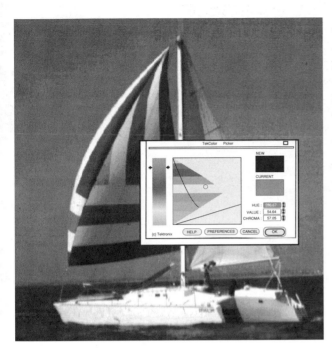

TekColor Screen color matching system

THE CALIBRATION of THE MONITOR

Calibration is important in the best of all possible worlds. You should know about it and you should know how to do it. I don't do it when I don't have to because I like working with extra brightness and color saturation on my monitor allowing me the option of relying on my final proof prints for my printed copy. Calibration is not close enough to the finished printed page that we can use the image on the monitor as living proof of a printed image. The colors on a monitor are created by electron beams shooting onto the surface of the screen.

On-screen, these beams form individual pixels, each capable of displaying the full gamut of 16 million colors on a high-resolution monitor.

The lowest intensity of these beams produces black on-screen and, theoretically, full intensity produces an all-white screen. There are differences from machine to machine as a result of normal manufacturing variation or component aging. Intensity of the electron guns generally diminishes over time. The practical result is that 50-percent intensity in all three colors (red, green, and blue) may yield three different results on the screen.

Finally, the general environment in which the monitor is placed can make a big difference. The amount of light in a room, the changes in indirect illumination during the day, and the amount of light that reflects directly off the screen can make profound changes in the perceived colors. Even the color of a shirt reflected off the screen can alter color. The basic technical solution is to create a feedback system so that the colors displayed on the screen can be compared to settings in the software.

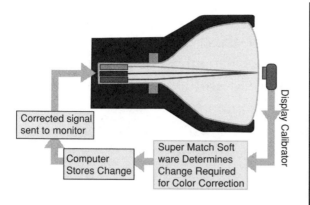

Corrected signal
sent to monitor

Computer
Stores Change

Super Match Soft
ware Determines
Change Required
for Color Correction

Display Calibrator

SuperMatch display calibrator

SUPERMATCH DISPLAY CALIBRATOR

SuperMatch performs both calibration and color matching to color printers, scanners, and film recorders based on the TekColor standard. Traditional printers have been skeptical of using the monitor for serious color work, no matter how high its quality. Some people think that the gap between what is seen on the tube (projected RGB) and what is seen on paper (reflected CMYK) is so vast that no match is possible. Perhaps the biggest factor that calibration software hasn't yet been able to account for is the subjectivity between observers. What you see and what I see on the page may differ significantly.

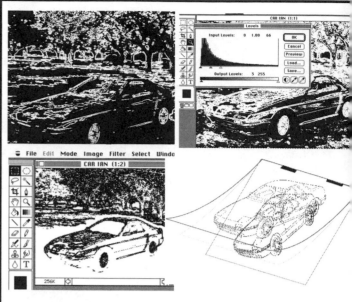

FROM PHOTOS TO ILLUSTRATIONS

Often photographs themselves don't outline important details the way illustrations can. It's a simple process to base an illustation on a photograph when you want to emphasize someting or illustrate a book.

1. Scan photo on slide scanner or flatbed.
2. Bring into Photoshop or pixel editing program, open photo.
3. Bring photo to full size 1 to 1
4. Turn photo to grey scale (mode)
5. Sharpen edges
6. Find edges (filter under stylize) - trace contour (which ever works the best) then invert (Image <map invert>)
7. Max contrast (brightness and contrast) or (curve)
8. Erase lines and shapes that will not be in final drawing.
9. Make print (laser printer) sometimes you must copy over the lines using tracing paper.
10 Save as PICT FILE
11. Draw using as a template for Adobe Illustrator.

My son Ian's wheels

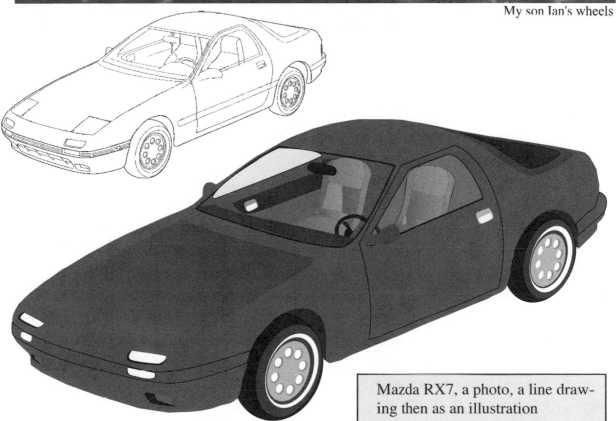

Mazda RX7, a photo, a line drawing then as an illustration

CONCLUSION, BEYOND THE DARKROOM

From the very beginning, my first experience in a darkroom had me hooked for life. The shimmering image emerging through the developer by the glow of a safelight was exciting and I have been chasing the perfect image ever since.

But what is the perfect image you may ask? The elusive answer may be as simple as the question-answer proposed by the Zen monk of the inquiring student. The sound of one hand clapping. The perfect image is the image you want, nothing more. Nothing less. And it's the "less part" that is frustrating to all photographers.

To get the desirable image, means that the photographer must exact a measure of control. If I am going to hang a 16 by 20 print on a gallery wall, it will be on silver paper but if that same image is headed for a 16 by 20 book, it will have to go through the stage of pixelization.

It is not that we are questioning the demanding darkroom procedure and its results but that we are striving to maintain the integrity of those exquisite photographs as they make their way toward publication. The computer is photography's handmaiden in the preservation of its art.

Electronics do not have to be the enemy of art. Just as I was finishing this book, the Los Angeles Times published an article about a 74-year old artist who had, in her youth, unsuccessfully attempted to make linear compositions with mechanical pens while studying art with Maholy-Nagy at his New Bauhaus school in Chicago. After an interim of 40 years, she was finally able to execute her geometric landscapes by painting with pixels.

I feel somewhat like the reborn artist. If someone were to ask me, and I'm sure many of my traditional photographer friends have wanted to, why do I go through all of these electronic gyrations and pixelizations and spend money on equipment when I can still make beautiful photographs in my well-equipped darkroom? And again I have to answer the question with a question. Aren't you always searching for the more exquisite image, elusive to every artist? Perhaps it's within the grasp of just one more pixel.

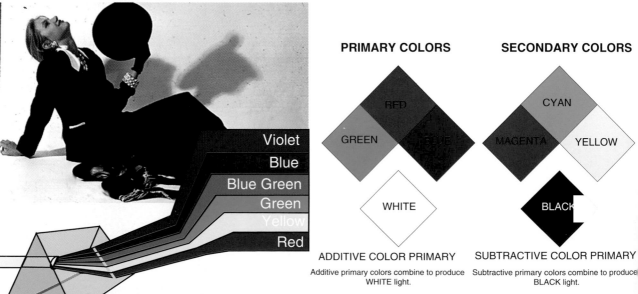

PRIMARY COLORS

RED
GREEN BLUE
WHITE

ADDITIVE COLOR PRIMARY

Additive primary colors combine to produce WHITE light.

SECONDARY COLORS

CYAN
MAGENTA YELLOW
BLACK

SUBTRACTIVE COLOR PRIMARY

Subtractive primary colors combine to produce BLACK light.

Violet
Blue
Blue Green
Green
Yellow
Red

White light broken into primary colors using a prism

Robert Pearsall

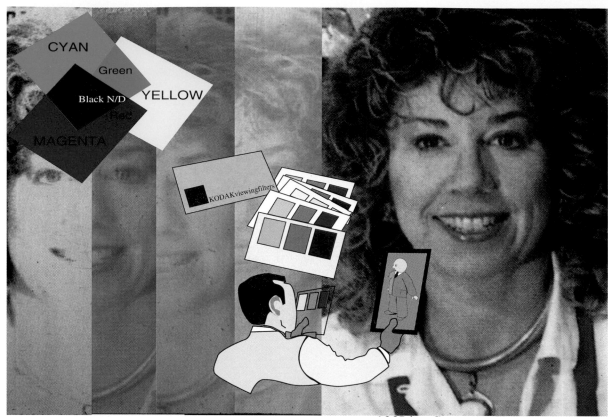

133Line Screen CMYK PRINT

Terms and Definitions

Absorption - The assimilation of light rays by the medium they strike.

Additive Colors - Primary colors of red, green, and blue

Adobe - Adobe Systems, Inc. is a software company that produces the Postscript command language for laser printers.

Aldus - Aldus is a software company that produces products such as Pagemaker, one of the pioneer programs for page layout desktop publishing.

Analog Monitor - An analog monitor is one that displays an unlimited range of brightness for each primary color, from fully on to fully off. As a result, a vast range of colors can be displayed.

Analog to Digital Converter - An analog to digital converter is a device the changes data from analog to digital form, making it possible to feed them into a computer.

Analyzer - An electronic device used to determine the amount of filtration needed for color balanceand white photography

Antialiasing - Ordinarily, vertical and horizontal lines appear straight when drawn on computer screens, but lines in other directions have a stairstep appearance because the line is drawn by turning on pixels that are arranged in as square grid. Antialiasing is a way of smoothing out this stairstep affect.

Aperture - The lens opening that admits controlled amounts of light into the camera

Apple - Apple is one of the largest personal computer manufacturers. The Apple II, introduced in 1977, was one of the earliest popular microcomputers. The company was founded by Steve Jobs and Steve Wozniak, who began work in a garage.

Archival - The quality of performance and durability

ASA - American Standards Association, the system designed to rate the speed or light sensitivity of photographic materials

Baud - A baud is a unit that measures the speed with which information is transferred. The baud rate is the maxium number of state transitions per second.

Bellows - Accordian-pleated, light-tight, and collapsible unit, that in certain cameras connects the lens to the back of the camera

Bit - Bit is a shorthand term for "binary digit." There are only two possible binary digits: 0 and 1. Bits are represented in computers by two state devices, such as filpflops.

Bit-mapped Graphics - Bit mapped graphics offer a method of displaying pictures on a computer.

Bitstream - A bitstream is a series of bits transferred from one part of a computer system to another.

Bleed - In color processing, the seepage of dyes beyond image boundaries

Board - A printed circut board is sometimes called a board or a card. Many computers, such as the IBM-PC, contain expansion slots where you can add additional boards to enhance the capability of the machine.

Bracketing - The technique of making exposures under and over the norm, in addition to the normal exposure

Brownout - A brownout is an extended period of insufficient power line voltage. It can damage computer equipment.

Buffer - A buffer is a holding area for data. Several different things are called buffers.

Bulb - Exposure setting allowing the shutter to remain open as long as the release is pressed

Bus - The bus is the main communication avenue in a computer. It consists of a set of parallel wires to which

Cable Release - A flexible cable-like plunger which permits the release of the shutter without touching the camera

Cache - A cache is a place where data can be stored to avoid having to read the data from a slower device such as a disk. For instance, a disk cache stores copies of frequently used disk sectors in RAM so that they can be read without accessing the disk.

Cadmium Sulfide Cell - A receptive agent which functions as a light indicator in some exposure meters

Camera - A light-tight box fitted with a lens and shutter

Camera Ready - A piece of artwork or a printed page is camera ready if it is ready to be photographed and offset printed.

CC Filters - Color compensation filters made of gelatin and optically corrected, used in balancing the color of the light available for exposing film and paper

CD-Rom - CD-Rom stands for compact disk read only memory, which refers to the use of compact disks similar to audio compact disks as a computer storage medium.

Circle of Confusion - A tiny round cluster of light rays

Clip Art - Clip art is artwork that can be freely reproduced.

CloseUp - Focus occurring at no more than 1 1/2 to 4 feet in front of the camera

Coating - A thin transparent film of magnesium flouride, or other material, applied to the lens elements

Color Sensitivity - The response of photographic emulsions to different wavelengths of light

Color Temperature - A means of describing continuous spectrum light in terms of its warmth or coolness and measured in degrees Kelvin

Complementary Colors - In the additive system, two hues which, combined, reflect all wavelengths and produce white; in the subtractive system,two hues which, combined, absorb all wavelengths and produce grey.

Composite - Image created when two or more negatives, or parts of, have been printed as one

Composite Video - A composite video signal is the kind of video signal used in a T.V. set. The whole signal is transmitted on one wire. By contrast, an RGB signal has seperate wires for red, green, and blue.

Contrast - Differences in brilliance or density in black

Conversion Filters - Filters which help correct film sensitized to one type of light for use in a different typeof light

Coprocessor - A coprocessor is a seperate circut inside a computer that adds additional functions to the CPU or handles extra work while the CPU is doing something else.

Cut - To "cut" material is to remove it from the document you are editing and to place it into a holding area.

Definition - Fitness and clarity of detail

Densitometer - Instrument for measuring the silver deposits in any portion of a developed photograph

Density - In a negative, the light stopping power of a blackened silver deposit

Depth of Field - Zone extending in front of and behind the point of sharpest focus

Depth of Focus - Small zone in which the focal plane can be moved away from a focused lens

Desktop - The opening screen of a window-oreinted operating system is called a desktop because it is a blank space on which various objects can be placed.

Desktop Publishing - Desktop publishing is the use of personal computers to design and print professional quality typeset documents.

Diaphragm - A device for regulating the size of the light admitting aperture

Diffraction - Optical phenomenon of light rays bending around the edge of an opaque object

Diffusion - Scattering of light rays in all directions

Digital Computer - A digital computer represents information in discrete form, as opposed to analog computer, which allows representations to vary along a continuum.

Dipswitch - A DIP switch is a miniature switch or a set of switches often used in computer equipment. DIP, or dual-inline package, means that the switch is same size and shape as an integrated circut.

Dithering - In computer graphics, dithering is the representations of intermediate shades of gray by a pattern of tiny black and white specks. Dithering is used to represent shades of gray on a printer or a screen that cannot reproduce them directly.

Document - A document is a file containing a text or a drawing to be printed.

Dodging - Technique of briefly shielding a part of a print during exposure in order to lighten that area

Dot Matrix Printer - A dot matrix printer forms characters as patterns of dots. These printers are generally speedy and inexpensive.

Download - To download is to transmit a file or program from a central computer to a smaller computer or a computer at a remote location.

DRAM - Dynamic Random Access Memory is a computer memory that requires a refresh signal to be sent to it periodically. Most computers use DRAM chips for memory.

Emulsion - Coating of gelatin in which the silver salts are suspended, making film and paper photosensitive

Exposure - Effect of light on photosensitive materials

Exposure Meter - Instrument used for measuring intensity of light

F-Number - Aperture size

Fax - A fax or a facsimile machine, transmits copies of paper documents over telephone lines by converting the appearance of the document into an electrical signal. Some computers have the ability to send and receive FAX signals.

Fiber Optics - A fiber optic cable carries light rather than electrical energy. It is made of a thin fiber of glass. Large amounts of data can be carried by a single fiber optic cable.

File Server - A file server is a computer that provides file access for other computers through a local area network. This saves disk space because each computer no longer needs it's own copy of all software that it uses. Also, it enables seperate computers to share and update a single set of files.

Film - A thin, flexible transparent material coated on one side with a light-sensitive emulsion

Filter - Glass, gelatin, or acetate material which can be placed in front of the light source thus affecting the exposure

Fisheye - Extremely wide angle lens which produces barrel distortion

Flare - Extraneous light reflections inside the lens cause this haloed effect

Flash - A brief intense light source

Flat - Term describing low value contrasts

Focal-Plane Shutter - Type of shutter which allows the film to be exposed progessively through a slit of adjustable size

Focus - Point where light rays converge to form a clearly defined image of the subject

Fog - Veil-like density in the negative or print derived from light leaks or chemical action

Font - A font is a collection of characters with a consistent size and style.

Frame Grabber - A frame grabber is an accessory that takes the image from a video camera and digitizes it, creating a bitmap image.

Gradation - Range of values from white to black

Graphics - Computer graphics is the use of computer output devices, such as screens and plotters, to produce pictures.

Graphics Card - A graphics card is a video card that can display graphics as well as text.

Gray Card - Kodak Neutral Test Card, used in the control of tonal and color quality of photographs

Gray Scale - Printed rendition of the gray card arranged in a gradation of ten zones

Greeking - Greeking is the use of random letters or marks to show the overall appearance of a printed page without showing the actual text.

Grid - In various draw programs and paint programs, a grid is a feature that allows lines to be drawn only in certain positions, as if they were drawn on the lines of graph paper.

Grounding - In any electrical device, "ground level" is the voltage level to which all other voltages are compared. In most computers, the ground level is connected to the ground pin of the power plug, and the power line then connects it to the earth itself, thereby assuring that the ground level for all machines is the same.

Halftone - Use of a screen of dots to simulate the continuous tone or gradation characteristics of photographs

Hard Card - A hard card is a type of hard disk that is built into a card that can be plugged into a slot inside the computer.

Hard Disk - A hard disk is a storage medium using rigid aluminum disks coated with iron oxide.

Hewlett Packard - Hewlett Packard, located in Palo Alto, California, makes a wide variety of electronics instruments and calculators, as well as microcomputers, work stations, and the laser jet series of laser printers.

Highlights - Brightest portions of the photo

Hue - Color

IBM - International Business Machines is the industry's largest computer manufacturer. IBM makes other office equipment as well as computers, which it started manufacturing in the 1950's.

Image - Two-dimensional representation

Incandescent Light - Light before it has been reflected by the subject

Infinity - The area furthermost from the camera in which objects are seen by the lens in sharp focus

Infrared - Wavelengths that are only detected by specially sensitized photographic materials

Ink Jet Printer - An ink jet printer forms characters by firing tiny dots of ink at the paper. Advantages include speed, high resolution, and silence. An ink jet printer is often an economical alternative to laser printer.

Internal Font - An internal font is a description of a kind of type

to be printed on a printer. Unlike soft fonts and font cartridges, internal fonts are permanently built into the printer, where they reside on ROM chips.

Iris - see diaphragm

Justification - Justification is the insertion of extra space between words in lines so that both the left and right margins are even and smooth.

Kelvin - W.T. Kelvin devised a system used for measuring the color temperature of light sources

Kerning - Kerning is a reduction in the amount of space between certain combinations of letters in proportional - pitch type.

Lamp - Artificial light source

Landscape - Landscape orientation refers to paper oriented so that it is wider than it is high.

Laser Printer - A laser printer uses a laser beam to generate an image, then transfers it to paper electronically.

Leading - Leading is the insertion of extra space between lines of type.

Leaf Shutter - Concentric arrangement of overlapping metal leaves, also referred to as a diaphragm shutter

Lens - Transparent material or materials capable of gathering and selecting light rays reflected from the subject

Letter Quality - A letter quality printer produces print equal in quality to that of the best typewriters. All laser printers and daiseywheel printers are letter quality.

Light - Wavelike pulsations from the sun forming the visible part of the electromagnetic spectrum

Light Pen - A light pen consists of a light sensitive detector and is used to control pictures on a computer terminal.

Light-Tight - Capable of excluding all light

Liquid Crystal Display - A LCD is the type of display used on most digital watches, calculators, and laptop computers.

Macro Lens - lens capable of extending the focal distance, achieving the image magnification required for f close-up photography

Memory Chips - Memory is often added to a computer simply by plugging RAM chips into sockets.

Modem - A modem is a device that encodes data for transmission over a particular medium, such as telephone lines, coaxial cables, fiber optics, or micro waves.

Monitor - A monitor is a device similar to a television set that accepts signals from a computer and displays information on its screen is known as a monitor. The monitor itself does no computing at all.

Monochrome Monitor - A monochrome monitor is a computer monitor that can display only one color.

Motorola 68000 - The motorola 68000 is a microprocessor which is an integrated circut containing the entire CPU of a computer, all on one chip, so that only the memory and input-output devices need to be added.

Mouse - A mouse is a computer input device that is used by rolling it around on your desk and pressing one or more buttons. Graphical user interfaces such as Microsoft Word and the Apple Macintosh operating system are built around the mouse.

Negative - Ususally a transparent film where the subject's value tonalities have been reversed from light to dark and dark to light

Network - A network is a set of computers connected together.

Opaque - Resistant to the passage of light

Optical Character Reader - An optical Character reader is a device that can recognize typed or handwritten characters on paper.

Over-Exposure - Excessive light striking photosensitive materials

Overlaid Windows - Overlaid windows can overlap; when they do, one window hides the parts of the others that are behind it.

Pagemaker - Pagemaker, produced by the Aldus corporation, was one of the pioneering programs used for desktop publishing when it was introduced for the Apple Macintosh in 1984.

Paint Program - A paint program is one type of program for drawing pictures on a personal computer. The user draws with the mouse pointer, and commands are provided for drawing circles, lines, rectangles, and other shapes.

Palette - A palette is a set of colors chosen from a much larger set, for instance, the Mac can display more than 16 mil. different colors, but the user must choose a palette of no more than 256 to use at one time.

Panchromatic - Sensitive to the wavelengths for all colors in the visible spectrum

Paste - To "paste" material is to transfer it from a holding area into the document you are editing.

Photosensitive - Responsive, or CCD cell chemically, to light

Pixel - A picture on a CRT screen is made up of tiny elements called pixels. You can draw pictures on the screen by controlling the color of each pixel.

Point - In typesetting, a point is 1/72 of an inch. The height of type is usually expressed in points.

Polarized Light - Light which occurs in a single plane and is responsible for glare

Pop-up Menu - A pop-up menu or pull down menu is a menu that appears when a particular item in a menu bar is selected.

Portrait - Portrait Oreintation refers to paper oreinted so that it is higher than it is wide, like a portrait painting. Most printers print with the paper in the portrait oreintation.

Positive - Opposite of the negative; tonal values are identical to the original

Postscript - Postscript, developed by Adobe Systems of Palo Alto, California, is a graphical command language for laser printers.

Presentation Graphics - A presentation graphics program allows users tom create business presentations that integrate drawings, charts, and text.

Print - Positive state of the image when printed on paper, or the process of making a print

Print Spooler - A print spooler is a prgram that stores computer output in memory so that the user's program can finish creating the output without waiting for the printer to print it. The spooler then sends the stored output to the printer at the proper speed.

Prism - Transparent triangular shape which reflects white light

Ragged - A ragged margin is one that has not been evened out by justification.

Rangefinder - Optical device which permits the photographer to see the subject exaclty as the camera will

Reflection - Re-direction of light rays due to their striking a surface

Refraction - The bending of light rays passing obliquely from one transparent material through another

Register - Superimposing images so that they align prefectly

Resolution - The resolution of a printer or screen is a measure of the sharpness of the images it can produce.

Resource - On a Macintosh and under Microsoft Windows, a resource is a modifiable part of an application program or of the operating system. Resources include menus, icons, and fonts.

Restore - To restore a window is to make it go back to it's previous size after being either minimized or maximized.

Reversal - Converting a negative to a positive, or a positive to a negative

Saturation - Intensity, brilliance, or purity of color

Scalable Font - A scalable font is a font that can be used to print characters of any size. Many of the newer laser printers include scalable fonts.

Scale - Values arranged in sequence from light to dark; or the process of enlarging or decreasing the print size in relation to its negative

Scroll Bar - The scroll bar on a window enables you to scroll the window, i.e., look at different areas of the data that the window is displaying.

SCSI - The small computer system interface (SCSI) is a standard way of interfacing a computer to disk drives, tape drives, and other devices that require high speed data transfer.

Secondary Colors - Yellow, magenta and cyan light

Separation - The process of breaking apart red, green and blue values of a particular subject

Serial - To transmit data serially is to transmit it one bit at a time over a single wire. Serial transmission is the normal way of linking computers to terminals and is often used to link microcomputers to printers.

Serial Port - A serial port is a connection by which a computer can transmit data to another device using serial transmission, that is one bit at a time.

Shutter - Mechanical system which controls the length of exposure

Silicon - Silicon is the primary material used to make semiconductor devices.

SIMM - A single inline memory module (SIMM) is a tiny printed circuit board to which several memory chips are attached. It plugs into a slot on a larger printed curcuit board and is handled as if it were a single integrated circuit.

Slot - A slot is a socket in a microcomputer designed to accept a plug in curcuit board.

Soft Focus - A sometimes deliberately blurred or out of focus image

Spectrum - The portion of the electromagnetic spectrum which is visible; light

Spot Meter - Exposure meter used to measure light reflected from a small area of the subject

Stop Down - Adjusting the camera to a smaller aperture

Strobe - Repeated and rapid electronic flash

Style - A style of type is a particular size, either plain, boldface, or italic.

Tape Drive - A tape drive is a device that converts information stored on magnetic tape into signals that can be sent to computer.

Telephoto Lens - A lens whose focal length exceeds 200 millimeters

Terminal - A computer terminal is an input-output device whereby a user is able to communicate directly with a computer .

Thermal Printer - A thermal printer prints by heating spots on the paper with an array of tiny, fast acting heating elements.

Three Dimensional Graphics - In CAD/CAM systems, it is frequently helpful to be able to see representations of three dimensional objects that can be viewed from different angles.

TIFF - Tag Image File Format (TIFF) was developed by Microsoft, Aldus, and several other companies as a standard format for recording bit mapped images on disk. TIFF files can store images of any size with any number of colors, using several kinds of data compression.

Tiled Windows - Tiled windows devide the screen into sections without overlapping one another.

Time Exposure - Shutter is caused to stay open until the photographer releases it, allowing for indefinite exposure time

Tonality - Range of grey values in a print

Transparent - Medium which permits the passage of light without diffusion

Tungsten - Material in the filament of incandescent bulbs

Ultraviolet -Range of wavelengths invisible to the eye but detectable by certain photographic materials

Value - Scale of white through grey to black

Viewfinder - Device on or in the camera used for framing the image

White Light - Illumination in which all wavelengths of the visible spectrum are present, including daylight and tungsten incandescence

Wide-Angle Lens - Lens which allows great depth of field and broad viewing area

Window - A window is an area of the screen set aside for a special purpose.

WORM - WORM is acronym for write once, read many times, which refers to to a type of optical disk where a computer can save information once, then read that information, but cannot change it.

Zoom Lens - Lens capable of variable focal length

Index

218

220

223

T

225

SUPPLIERS

Samy's Camera------------------800-321-4726
MacWarehouse------------------800-255-6227
Hardware That Fits------------800-364-3487
Mirus Co.-----------------------408-944-9770

SUPPLIER	EQUIPMENT	ESTIMATED PRICE
Hardware That Fits	Macintosh Quadra 950 (8/150)	Package
	Raster Ops 20 in.Trinitron Monitor	price
	Raster Ops 24 xLi cord	
	Keyboard	7,889.00
MacWarehouse	Bernoulli 90	600.00
MacWarehouse	Photoshop Program	595.00
Mirus Co.	Software for Mirus	595.00
Samy's Camera	Canon Video Floppy Diskette VF-50	100.00
Hardware That Fits	Microtek Scanmaker ll	949.00
Hardware That Fits	Microtek Slide Scanner	1, 565.00
Samy's Camera	Canon Camera RC 570	3, 899.00
Samy's Camera	Canon Camera RC 250	425.00
Hardware That Fits	Color Printer Raster Print 300	7, 395.00
Hardware That Fits	Laser Printer	1, 500.00
Hardware That Fits	Ink Jet Color Printer	900.00
Mirus Co.	Slide Printer (35mm)Mirus	6, 000.00

226

The Olive Press P.O. Box 194, Lake Hughes, Ca 93532

The Olive Press
P.O. Box 194, Lake Hughes, Ca 93532

Fill this out and hear about future updates to this book & other publications from The Olive Press publishing company. _____

Name _____

Company/Title or University_____

Address _____

City/State/Zip_____

Please give us any additional comments. _____

227

NOTES

228

NOTES

229

NOTES

230